Rosé Revolution

Rosé Revolution

Rasmus Emborg
– & –
Jens Honoré

Interlink Books

An imprint of Interlink Publishing Group, Inc.
Northampton, Massachusetts

The rosé revolution

Rosé was, in fact, the world's first wine. In the old days, winegrowers were forced to pick, press, and ferment red grapes as quickly as possible to avoid the wine going bad—and the result was a pink wine. A rosé.

But over the years, the pale wine was looked down upon as a secondary product ignored by experts and pigeonholed as an indifferent thirst quencher that enjoyed the same level of street cred as a bland juice. Well might the wine contribute to a lovely relaxing atmosphere on a terrace in the sunshine. But it didn't deserve to keep company with its sibling red and white wines, and certainly not when it came to talking about terroir and grape variety, steel tanks, or barrel aging.

Despite their commercial success, rosé classics like Mateus in its rotund bottle and sweet blush wines like White Zinfandel furthered a perception of rosé as the ugly duckling in a lake of beautiful swans. And in a male-dominated wine world, it didn't help that the wine was primarily bought and consumed by women.

And so it remained until the modern world entered its second millennium and the winds of change began to blow. The millennial generation, in particular, led a rebellion that gave the finger to the wine industry's perception of rosé as a half-finished red wine plonk, hailing the wine instead for its elegant pink hue, which they willingly let themselves be seduced by as they uncorked yet another bottle. For the new rosé drinkers, elegance equaled light, pale, dry wines with a crisp acidity. A new trend emerged that left the darker, sweeter rosés somewhat in the background—and which today is trendsetting in the rebellion that led to an actual revolution in the world of wine.

The rosé revolution wound its way from vines in the vineyards to vinification in cellars. It brought with it new sales channels and reached all the way to social media where hashtags, such as #roseallday, #yeswayrose, and #drinkpink have helped to spread the word of this photogenic wine in its transparent bottles with often artistically creative labels.

Rosé is no longer a by-product of wine production whose predominant goal is the best possible red wine. Nowadays, the wine is made on its own terms—and the grape variety, the location of the vineyard and the harvest time are determined by the winegrowers' ambition to make rosé wines that can reach both a wide audience and a spot on the top shelves among the very best wines.

It's become a much more contemporarily recognizable wine whose quality development has advanced by leaps and bounds. It appeals across the board and is increasingly drunk throughout the year. All this has contributed to rosé being the wine category experiencing the greatest growth in recent years. It has taken market share from red wines where years of focusing on heavy, high-alcohol wines helped to pave the way for a subtler and lighter wine.

Such success has given rosé producers financial muscle. They can go on investing in the continued development of quality, with the most ambitious producers competing directly to make the world's best rosé. For other producers, the challenge appears to be a different one—resisting the temptation to capitalize on rising demand by flooding the market with insipid rosé wine.

Its popularity is not diminished by rosé having gained in status as a mark of the good life—as it's lived in, for instance, Provence, the birthplace of rosé wine, and which, with its crisp wines, today sets the standard for rosés all

over the world. Rosé wine is inclusive, unsnobbish, and easy to approach—and this appeals to all who are looking for quality and good experiences but who don't necessarily want to make swishing noises every time they enjoy a glass.

In a hectic world, donning a straw hat and linen shirt, spitting out olive stones, and delighting in a glass of rosé is synonymous, for many people, with quality of life. Supported by the wine's attractive demeanor, this feeling is an important factor of the rosé boom seen by the world in recent years. In terms of marketing, rosé's image is helped greatly by both influencers posting their beautiful, photogenic rosé pictures on Instagram and TikTok and music and film celebrities producing their own rosé.

In this way, rosé wine has also become something of a pop culture phenomenon, affecting several current megatrends such as health and anti-stress, climate and sustainability. Conversion to organic wine production is dominant among many rosé producers. And in a world getting ever warmer, and in which conscious consumers think about both the climate and their own health, when more people are turning to a primarily plant-based diet— and consuming much less red meat—the demand for light, pale, and chilled, represented by the pink wine, is only increasing.

Thus, the rosé boom is much more than merely the new black. Rosé is authenticating itself as the third wine category, which acts as a versatile bridge-builder between red and white and is suitable for most occasions and meals. The wine has a broad reach—from the intellectual to the rap musician to the jetsetter in Saint-Tropez, from the novice to the general wine consumer to the wine nerd—and is riding a wave of popularity, market availability, and expanding recognition that looks set to continue for years to come.

At the core of this revolution are the winemakers, who, standing on the back of wine's history and local traditions, have helped advance the development of rosé wine. For the wine's popularity is founded on much more than happy people enjoying a glass in good weather, rather it's built on the dedicated professionalism of industry mavens driven by passion and enthusiasm for their craft. Experts who have the will and courage to both invest and experiment for a higher quality. And who also know that the story of a good glass of wine can be told—and sold—in new ways.

Equally, this book is no ordinary wine book. Like the wine, this book is easy to embrace. It's powered by personal narratives and imbued with the passion that drives leading producers and increasingly draws in consumers, yet it's easily accessible. The book doesn't tell you what wine you should drink. But it does make you more knowledgeable about what you are drinking and who's behind it. And hopefully, after perusing it, you'll have an even better experience next time you uncork a bottle of rosé—it may even make you want to visit the regions where rosé is produced.

We ourselves have journeyed around the world to visit some of the most significant producers of rosé wine. Both those who established the foundation for the rosé revolution—and those who caused its eruption. Each producer has an exciting tale to tell, which we share here in words and images. Each, in their own way, contributes to the fascinating story of the world's first wine.

Cheers!
Rasmus Emborg & Jens Honoré

Rosé is a much more recognized wine today and has come leaps and bounds in quality development—and which can be enjoyed with or without food.

Know what you're talking about

This is not a book written for wine nerds, but as some terms are used along the way, it's useful to have a little more understanding. Here are some of the most important ones.

Appellation

Most wine countries have a system of appellations, a quality seal for wines that meet several criteria regarding geographical origin, grape variety, yield per hectare, etc. The rules for each individual appellation are defined. The most well-known system is the French Appellation d'Origine Contrôlée (AOC). In Italy, the terms DOC and DOCG are used while Denominación de Origen (DO) is the standard in the Spanish appellation system.

The lees

This is the sediment of the wine, which consists primarily of dead yeast cells. The lees give the wine character, depending on how long the dead yeast cells, which are normally removed by filtering the wine, are allowed to sit in the wine.

Oxidation

This is when the wine is exposed to oxygen, something most rosé producers try to avoid. The wine can lose both fruit flavor and freshness if it's exposed to oxygen, which can also evoke a more yellow-brown color. To avoid oxidation many producers have, for instance, invested in temperature systems to ensure a cooling of the grapes before they are pressed as well as the grape juice during the fermentation process.

Malolactic fermentation

After the first fermentation where the sugar in the grape juice is converted into alcohol, a new process occurs in which the hard malic acid in the wine is converted into milder lactic acid. This makes the wine softer and rounder. Many rosé wine producers choose to block this malolactic fermentation to keep the wine's acidity level up. This is typically done by adding some sulfur.

Terroir

The geographical expression of wine that comes from the French word for earth, *terre*. The term covers all the conditions in the vineyard that are important to the taste of the wine: weather and wind conditions, the composition of the soil, the slope of the field, and the exposure to the sun, as well as the overall climate in the area in which the vines are located. Which cultivation techniques are employed is also of importance—for example, whether the vineyards are sprayed with chemicals or whether they are grown according to organic or biodynamic principles.

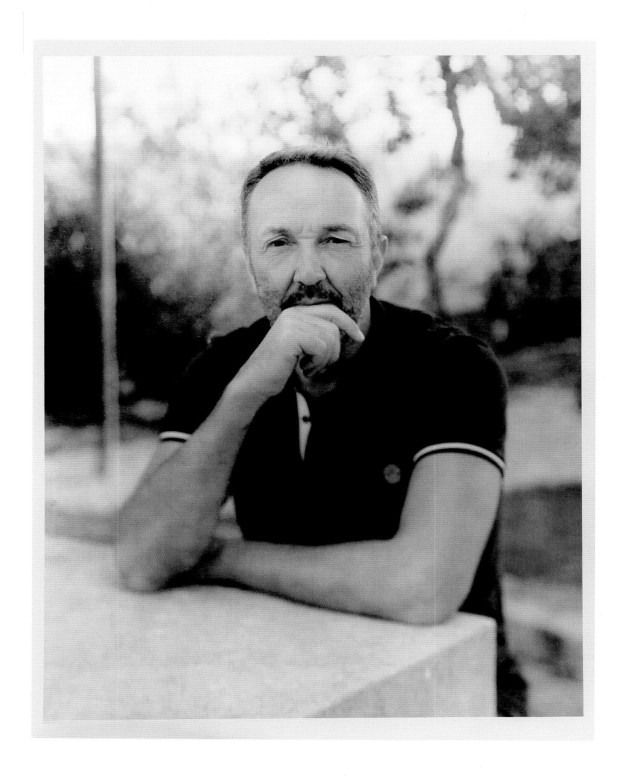

DOMAINES OTT → JEAN-FRANÇOIS OTT

The first star

The story of rosé begins in the South of France. Marcel Ott was the first producer of rosé wine as we know it today and lends his name to one of the most iconic rosé brands, which is a point of reference for the entire wine world.

It's a small road that leads to something great, to the place where it all started.

We've turned off the country road that cuts through the western part of Provence—in the hinterland between the Mediterranean and the mountains. We drive through lush vineyards, olive groves, and vast meadows of lavender waving like a purple sea.

Any road markings have long since disappeared, and the road is now so narrow we have to slow down when we meet oncoming traffic. Tall pine trees and cypresses lining both sides form an avenue guiding us to our destination. On the way up a hill, the trees come to a stop on one side of the road, revealing a view of new rows of green lushness on reddish-brown soil.

At the top of the hill, almost as if out of the blue, our attention is caught by a remarkable sight. Surprising and symbiotic at once. A monumental edifice embedded in a hillside and constructed of massive square stone blocks stacked on top of each other.

It could be the lair of the villain in a James Bond movie. But it's the new emblem for one of the world's most iconic producers of rosé wine.

The structure stands out. But given its color is the same as the ground on which it stands, and with its harmonious architecture, the striking building blends nonetheless naturally into its surroundings, contributing to the beauty so characteristic of the entire area. Completely understated yet simultaneously quite superior. A beauty that need do no more to prove itself. Even the rust on the patinated metal gate into the property exudes exclusive class.

"Château de Selle" is inscribed on the gate that leads us onto a gravel path. The crunching sound of car tires on stones reveals our arrival, but no one stops us until a thick iron chain bearing a "Privée" sign blocks the way to another large building at the bottom of the property. It's only to here and no farther that outsiders are given permission, but we've been granted passage to stroll the last few yards down to the old castle.

Three stories high, eight large windows across—and with hundreds of years behind it. Vines run wild on the dusty façade, the light blue shutters haven't been painted for many years, and several of them hang askew. It's easy to see and understand why guests are not normally allowed access.

But the château bears witness to a long history, a history we have come to know better. And it's precisely here—in the middle of the old castle and the futuristic building with the stacked stone blocks, in the meeting between tradition and innovation, between the past and the future, conservative virtues and fashionable trends—that the story of rosé wine was born.

From dream to reality

It was here, in the heart of Provence, close to the town of Draguignan, that Marcel Ott found himself when he was looking for a place to make wine in the early 1900s. The young man was actually from Alsace, had just finished his studies in agriculture, and sought south to fulfill his dreams.

In truth, he had ambitions of going all the way to Algeria, but he stopped along the way to help southern French winegrowers replant their fields in the years after the phylloxera pest ravaged Europe and destroyed the vast majority of European vines.

At the time, Provence was a region reinventing itself as a tourist destination on its way out of a long downturn. The coastal towns boasted new boardwalks and hotels in the contemporary Belle Époque style, and the vibrant landscape attracted painters, such as Cezanne, Renoir, and Monet.

Out in the countryside, however, things were still bad. But Marcel Ott saw through the poverty. He saw the soil with its red clay, calcium, lime, and sandstone. He saw the high slopes where the fields lay sheltered from the winter frost. He experienced the mild winters, the earlier spring, and the hot, dry summers when the sun shone almost all the time. And he felt the mistral that quickly dried the vines after rain, thereby protecting them from being attacked by fungus.

It was here that he would make his dream come true. The dream of making his own wine. But not just any wine. He wanted to make rosé. And in 1912, he bought Château de Selle.

Back then, more than a century ago, rosé was nothing special. It was a residual product from red wine production. When making more concentrated red wines, the farmers often let some of the juice run off from the red grapes very early on in the fermentation process. Typically, this meant the juice had only fermented with the grape skins—known as maceration—for a day. So, it hadn't yet acquired any genuine color, flavor, or tannins from the skins, which in turn, gave more of these elements to the juice left for production of red wine.

Provence

↓

43°11'23.2"N

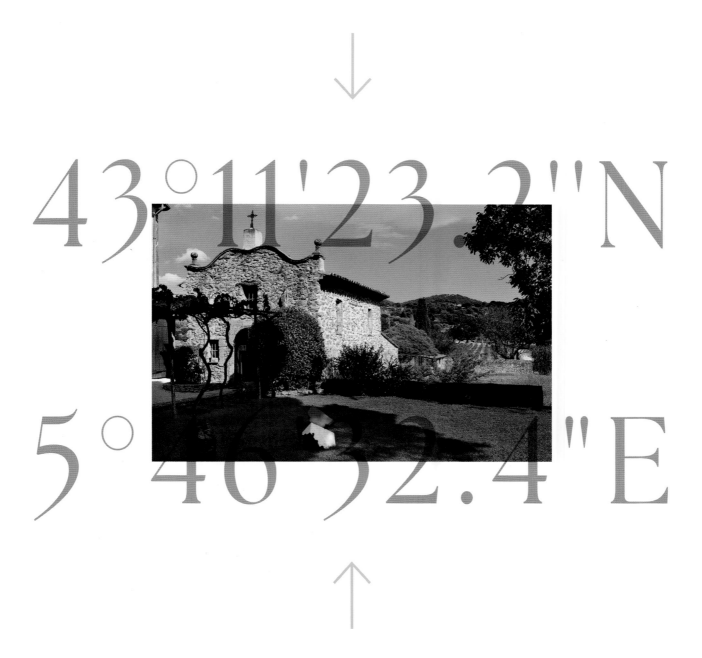

5°46'52.4"E

↑

15³⁵ CET

But this initial juice wasn't to be wasted, so it too was made into wine—rosé wine. The wine didn't get much attention though as the quality was low, and the semi-red, slightly flat wine was primarily used to quench the thirst of the many farm workers toiling in the fields.

Marcel Ott wanted to change that. He wanted to make rosé a wine in its own right. To establish it as a serious wine category on an equal footing with red and white wines.

His plan to bottle rosé wine—and put the name of his own castle on the bottles—was completely unheard of at the time and was met with ridicule. But he didn't care. And far from the cheerful life on the Côte d'Azur, from where there would be a great demand for his wines many years later, he embarked on his mission.

The young Ott went to work systematically, benefitting greatly from the theory learned during his agricultural studies as he tried, step by step, to optimize all processes in wine production. His ambition was to make a wine that preserved the fruit flavor, acidity, and freshness of the grapes. A white wine made from red grapes. It was precisely for this reason that he loved rosé himself—because, for him, it was the wine in which the taste of the grapes was most clearly expressed.

Marcel Ott quickly realized that it all begins in the field. That you can't make good wine from bad grapes. And so he removed vines with cheap grape varieties that gave a high yield from his farm and planted new vines with varieties such as Grenache, Syrah, and Cinsault, which continue to supply juice for many of the world's best rosé wines to this day.

And when Marcel Ott got the grapes into the winery, he invented new techniques that have formed the school for popular contemporary Provence rosés. The greatest breakthrough was his decision to press the grapes immediately, thereby avoiding maceration where the skins from the grapes are included in the initial fermentation. Instead, he only allowed skin contact to occur under slow and gentle pressure. His rosé was clearly not a residual product, and with this method he created the first versions of the completely light and elegant rosés that have been in vogue all over the world for the last few decades.

"All this energy was the beginning of everything," says Jean-François Ott.

The fourth generation of the Ott family, he is now at the head of what is probably the world's most exclusive rosé dynasty. Rosé aristocrats in a motley world of quality producers, celebrities, and vintners. They don't produce the most wine. Nor do they make the most money. But it's their brand, Domaines Ott, that the rapidly growing rosé world has as a point of reference.

Thanks to Marcel Ott, the world's first true producer of rosé wine as we know it today.

"My great-grandfather was a little bit crazy and very enthusiastic. No one drank rosé at the time. But he liked the wine, and he saw a niche in the market."

Modern man with a heavy heritage

We meet Jean-François Ott at Château Romassan in Bandol in western Provence. Open and welcoming, he's dressed in white sneakers, jeans, and a blue polo shirt. He has a gray beard and a big smile on his face.

On our way out onto the terrace behind the castle, we pass his 750cc Honda motorcycle from 1986. It has just been painted red with gold-colored rims. It's his faithful steed that carries him smoothly through the many traffic jams on the busy country roads when he travels between the three domains in the area that now bear the Ott name.

In 1936 Marcel Ott bought another estate, Clos Mireille, right on the Mediterranean coast, and twenty years later, the family dynasty expanded again with Château Romassan. This is where Jean-François Ott grew up as a boy in the 1970s and 1980s, and this is where he lives today—half the time with his three children who share their time between their father and mother. A glance inside the castle reveals an entire room filled with Lego bricks.

Jean-François is a modern man bearing a heavy heritage on his shoulders. He cherishes his family history. Lately, he's been going through the family archives. He wants the Ott story to be handed down to both the new generations in the family and to the thousands of rosé-happy guests who delight in visiting every year. With great enthusiasm, he shows us a picture of the purchase agreement signed by his great-grandfather in 1912 when he became the owner of his first estate. The two t's in Marcel Ott's signature form a star.

With good reason, Jean-François Ott feels the weight of the responsibility of running the family business at the highest level in a market where competition continues to get ever tougher. But he can't imagine doing anything else. He nurtures the same love for Provence as his great-grandfather did and is driven by the same ambition to make the best rosé. And together the two factors give the work meaning for Jean-François Ott.

"Today, rosé is made all over the world, but Provence is still the best place to make rosé," says Jean-François Ott. "My cousin and I have lived on the three estates since we were children. It's in our blood. Making wine is second nature for us."

He is both proud and grateful that his great-grandfather saw a niche in the market. But it certainly wasn't a niche that opened up right away when Marcel Ott began his wine production at the beginning of the twentieth century.

 "There aren't just of wine there a great rosé takes time and effort as a 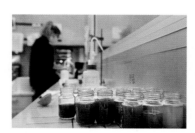 great red

two colors are three. And the same to produce or a great white."

→ Jean-François Ott

Help from Brigitte Bardot

It wasn't just in the vineyards and in the wine cellar that there was hard work to be done. The work of selling the wine was just as hard. The locals weren't inclined to change their habits—and they were accustomed to good wine served in bottles being either red or white; to them rosé was an insipid thirst-quencher, poured from growlers.

Among the foreign tourists in Provence, there was a greater demand for Ott's bottles, and they helped to earn rosé a reputation as a wine best drunk on holiday and in good weather early on. But the boom in British and American tourists, in particular, traveling to the southern European sun with plenty of money in their pockets, ceased with the great economic depression of the 1930s, and this had an impact on the demand for rosé in Provence too.

Marcel Ott realized the French market was too limited for him, so he began to send his wine abroad. The first export bottles went to New York in 1938, followed soon after by countries such as the UK, Switzerland, and Germany where the pink wines had an exotic nuance that appealed to certain groups.

He experienced far greater success with exports than with domestic sales, and right up until the 1970s, seventy-five percent of Domaines Ott's rosé wine was sold outside of France. Not least to New York where the name Ott adorned the majority of the bottles of rosé sold in the city at the time. Today, it's at most one in a hundred, despite Domaines Ott producing and selling more than ever before.

But in France too, time began to work on Marcel Ott's side, who, in spite of the uncertain economic period, made progress in the vineyards and enjoyed increasing recognition from his local colleagues. And together with a group of other young winegrowers—including the owners of Château Sainte-Roseline and Château Minuty, today among the largest producers of rosé wine in Provence—he formed a trade organization in 1933 where members could share experiences and help each other.

After World War II, holiday life on the Côte d'Azur took off again. Foreign tourists returned, and French wage earners were given the right to paid vacations at the same time, which meant many Parisians and people from other cities in the north could holiday in the south. Tourism became vital for the development of Provence wines, and rosé became associated with summer holidays and the good life, and in this way, rosé wines helped bring prosperity back to Provence.

Throughout the years, Marcel Ott was at the forefront in the fight for rosé to be acknowledged as an equal to red and white wines. Inspired by the classification system for the far more recognized wines from Bordeaux, they succeeded in getting twenty-three Provence domains classified as "Cru Classé" in 1955. Domaines Ott got both Château de Selle and Clos Mireille on this prestigious list, which came to serve as a seal of approval. Though a great many good contemporary wines aren't on the list, and to put it a tad crudely, the greatest significance of the classification nowadays is that it enables producers to charge a slightly higher price.

But in the beginning especially, the Cru Classé stamp helped to send the signal that rosé was not just rosé. That some rosé wine was better than others. Similarly, Domaines Ott has tried to stand out over the years by

bottling their wine in a special bowling-pin-shaped bottle, designed in 1932 by Marcel Ott's son—and the brother of Jean-François Ott's grandfather—René Ott.

The wine in the distinctive bottle attracted attention when the film *And God Created Woman* was shot in Saint-Tropez in the same year the classification system was introduced. The film was French actress and sex symbol Brigitte Bardot's huge breakthrough, and she subsequently chose to settle in Saint-Tropez. It also led to a bit of a breakthrough for both southern Provence and rosé, which became associated with a more unrestrained and carefree lifestyle.

The film crew established a café directly on Pampelonne beach where they could eat and drink—and their tipple of choice: Rosé. Today, the Club 55 beach café is a cosmopolitan rendezvous of actors, sports stars, businesspeople, and other wealthy people looking to enjoy a day at the beach, including a sumptuous lunch accompanied by a dry, fresh, and elegant rosé, perhaps from one of Ott's three domains.

Enjoying over a century of history gives Domaines Ott a very special position in the wine world today. But being ahead of its time has also had its price. It wasn't actually until well into the 1990s that the Ott family realized the serious niche for a high-quality rosé wine for which consumers were prepared to pay a decent price. They very much had to create their own market for high-end rosé, and that demanded a few tricks along the way.

"In the first many years, nothing came easily," says Jean-François Ott. "It probably took my great-grandfather twenty years to get the grapes he wanted to make a good wine. And then it was about becoming well-known. Therefore, he also planted some vines of white grapes at Clos Mireille and made a white wine, which was actually the wine he became known for first. It was much easier to sell to the restaurants because the patrons wanted white wine with their fish. But my great-grandfather told the restaurant owners they were only allowed to buy one box of white wine if they also bought two boxes of rosé."

The absolute festive season

Back at Château de Selle, we follow a tractor with two large, red plastic boxes on the bed. It's coming from the winery, which is part of Domaines Ott's new headquarters, and crosses the country road with vineyards for as far as the eye can see on both sides. Others could easily get lost in the fields, but the tractor driver knows the way down to Plot 40.

In the distance, a myriad of faces can be seen sticking up above the green leaves on the vines. As we arrive at the plot, we witness what at first looks like complete confusion but quickly transforms into an impressive operation carried out by about thirty people, each of whom knows their job. The harvest is underway.

It's September, the absolute festive season in the wine world. The result of a year's hard work must be brought in. It's a time of high adrenaline, euphoria, and frazzled nerves. A wrong decision can have serious consequences for the wine to be released the following year.

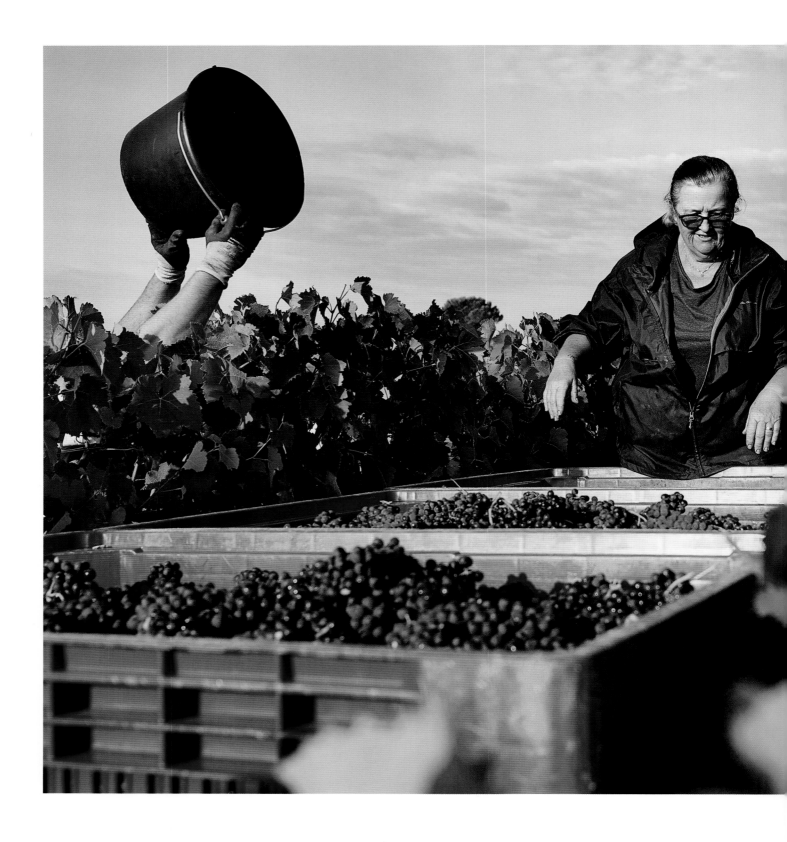

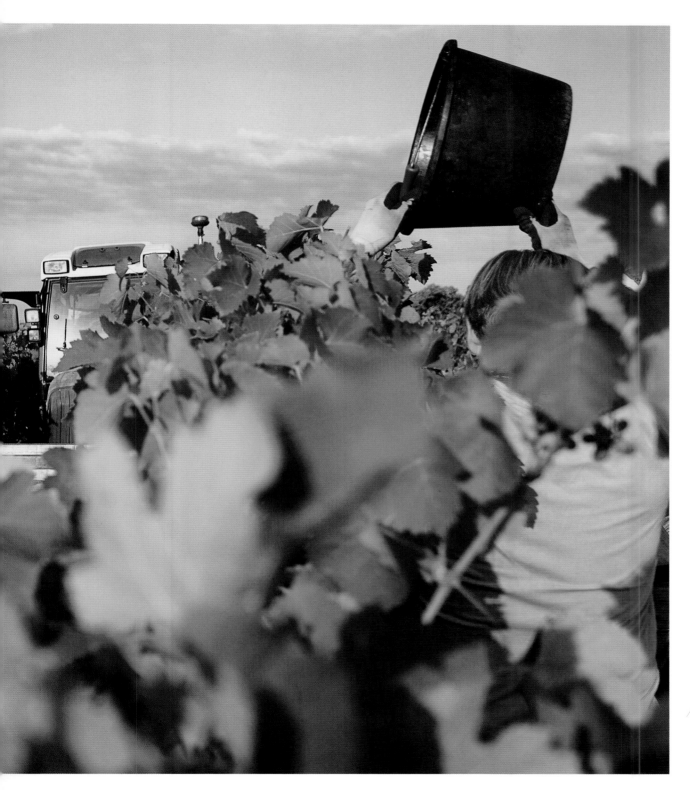

Harvesting is the absolute festive season in the wine world. The result of a year's hard work must be brought in. It's a time of high adrenaline, euphoria, and frazzled nerves.

The freshly picked grapes wait to arrive in the cold room where the grapes are cooled. It counteracts oxidation and contributes to a fresher and fruitier rosé wine with a very pale shade.

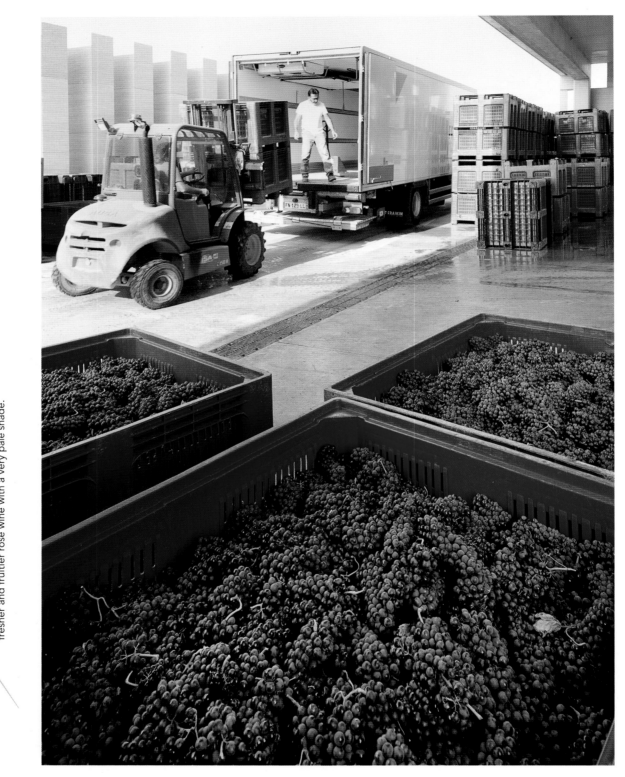

The time is now. Not yesterday, not tomorrow. Right now the grapes in this parcel with ten-year-old Syrah vines have just the right ripeness. The right balance between sweetness and acidity. Which is why the many men and women of differing ages and nationalities are approaching the task with impressive discipline and efficiency. There is still a slight chill to the air. Ideally, they need to be finished before it gets too hot.

Four rows are harvested in parallel at a time. With a pair of scissors in one hand, the workers use the other hand to remove leaves in the way of the grape bunch needing to be cut. The grape pickers then move forward with their buckets. Some bend to reach the grapes, others kneel, which leaves marks on their skin from the angular limestone on the ground. When the bucket is full of grapes, the pickers exchange it for an empty bucket from one of the men who run back and forth along the rows. They collect the buckets and pass them on to a woman who stands in the middle of everything on the bed of a tractor just narrow enough to drive between the rows.

As she reaches for the buckets, a flower tattoo is glimpsed on her forearm. In the back pocket of her jeans, she has a mobile phone, which she uses to coordinate with colleagues at the winery. She's like a conductor with her orchestra. Like a general with her army. It's she who sets the pace and determines the course of the battle.

It's on her orders that the tractor rumbles into action, marring the fresh air with smoke from the vertical exhaust pipe. Once the red plastic boxes are as full as possible without the grapes starting to press under their own weight, the woman jumps off the tractor that is driving back to the winery and hops aboard the next tractor already waiting with new empty boxes.

Domaines Ott has a total of 260 hectares of vineyards, and every single bunch of grapes is picked by hand. This is a vital difference to many other producers who pick completely or partially with machines—and just one of many examples of how all processes are optimized here with a view to making the very best wine. This is also why there's no blade of grass or weed between the vines. This allows the vines to absorb the modest amount of precipitation that falls for themselves. And it's also primarily for the sake of the grapes that any use of chemical products on the fields is banned—and by the way, it always has been, even long before growing produce organically became trendy.

"The quality comes from the vineyards. You can't hide that," says Jean-François Ott. "In the end, eighty-five percent of the work of making a good wine happens outside. We spend 600 hours per hectare every year in the vineyards. That's exactly the same as the best Bordeaux wines and the best wines in the world—and we make rosé!"

The large red boxes of grapes are unloaded at the winery and collected by a man in a forklift that beeps as it reverses. He drives onto a scale to see how many grapes are in each box. The target is a quarter of a ton. The first weighs 264 kilos, the second 260 kilos. Further proof the woman in the field with the tattooed flower on her forearm is good at her job.

The pallets are then driven into a cold room the size of a small warehouse where the grapes are cooled down to fifty-seven to sixty degrees Fahrenheit (fourteen to fifteen degrees Celsius). Refrigeration is one of the long-revered secrets behind the popular Provence rosés. Both before the grapes are pressed and during the fermentation process. The lower temperature counteracts oxidation and contributes to a wine that's fresher and fruitier

and gives the very light shade—like the color of a salmon or onion skin—that's so sought after by rosé drinkers the world over.

It's approaching ten in the morning. Activity in the production cellar, which has three levels and hides under the sand-colored building with its stacked stone blocks, is intensifying. The second press of the day is being prepared, and just like in the vineyard, everyone knows their job. Thick red hoses are mounted on the bottom of empty steel tanks, which are ready to be filled with the freshly squeezed grape juice. At the middle level, the cylindrical press is emptied of the extruded grapes from the last press. And at the top, the conveyor belt that is to transport the grapes toward the press, is washed down.

All the while, a young man with a thin beard, thick glasses, and a Pink Floyd shirt is standing in a lab room right next door. He measures the sugar percentage and pH value of samples from the latest press, which began at seven in the morning and ended less than thirty minutes ago.

At ten o'clock it's all go again. The door to the cold room with the grapes opens and a forklift emerges with the first red pallet of whole bunches of grapes, which are carefully tipped onto the conveyor belt. With immense concentration, a man removes individual green stalks that have come in with the harvest in the field. He helps the grapes on their way on the belt toward a grinder that crushes the skins, using the same method as in the old days when grapes were stamped on in a vat with bare feet.

The crushed grapes run from there into the wine press where they are alternately subjected to a minute of light pressure and rest for over two and a half hours. Like a hand opening and closing again and again. It's during this phase that the juice and skins are in contact with each other—and it's here that an important part of the character of the forthcoming rosé wine is created.

From the press, the juice flows in a steady stream farther down to large tanks of finely polished galvanized steel, shining like a row of beacons. The fermentation process that converts the grapes' sugar into alcohol can now begin.

The philosophy is to stress the grapes and juice as little as possible during the entire process to get a wine that takes as much flavor as possible from the grapes. This has been Domaines Ott's philosophy ever since Marcel Ott started in 1912. And that's why the new wine cellar is designed with three levels under a hillside, so the grape juice isn't exposed to pressure but can flow naturally—from the grinder to the press to the steel tanks—with the help of gravity and nothing more.

The wine should taste of the grapes

Back at Château Romassan in Bandol, Jean-François Ott stands with a glass of grape juice he's just tapped from a tank with the juice from Grenache grapes picked last week. It's the part of the job he loves the most. His goal is the same as his great-grandfather's—ultimately, the wine should taste as much of the grapes as possible. And therefore all the focus is on the juice in the grapes.

"When you make red wine, you work on the skins of the grapes, but when you make rosé, you work on the pulp of the grape," he says.

The grapes are pressed gently to get only the juice from the inside of the grape. This is the best juice, without bitterness. It also means that only sixty percent of the grape juice is used for Domaines Ott's wines, which for that very reason bear the name Coeur de grain—the heart of the grape.

This year's juice has a little less fruit than last year's, but the balance is good, is Jean-François Ott's verdict. Based on samples of the sugar content, he expects an alcohol percentage of thirteen percent, which is also marginally lower than last year. Then again, there's a little more acidity, which is probably due to the slightly cooler spring.

He is satisfied. Customers need to be able to recognize a wine from Ott's estates year after year as this is not a place of large-scale experiments, rather there is maximum focus on avoiding making mistakes. This has contributed to Domaines Ott's reputation as a classic, conservative winery.

But the wine from this year doesn't have to be a true copy of the wine from last year. The most important thing is that the quality continues to develop. In that way, Domaines Ott can maintain its position at the top of the rosé hierarchy—and likewise Marcel Ott's descendants can contribute to the rosé category gaining an even stronger foundation. Neither of the two should be taken for granted, points out Jean-François Ott.

"We have focused on making rosé for 120 years in Provence, and that certainly gives us a little advantage that all other producers in the world don't have. That's good. There is no doubt that our competitors make us run faster and work harder. But we are still a bit ahead, and we'll do everything we can to make it stay that way," he says.

"That is why it's absolutely crucial we continue to protect the quality of the grapes and the quality of the wines. We must continue to work on developing quality and making sure that consumers experience the wines getting better year after year. Because if we aren't skilled, then we run the risk of consumers starting to say there are far too many rosé wines now and they aren't very good. That would be terrible for the market and for the producers of rosé. Therefore it's not enough to talk about the special Provençal lifestyle, we also need to talk about the wine."

Thus, rosé wine's grand old man also bears a warning for the entire industry. For instance, Jean-François Ott warns of the danger of focusing exclusively on color. The pale rosé, typical of Provence, is currently in high demand all over the world, but a pale rosé is not always a good rosé.

"Everyone who buys a bottle of rosé sees the color first. And many people think it's good just because it's pale, but that's not always the case. I know my wine turns pale because I press cold grapes. It's like making tea with cold water. But to be honest, I don't focus on the color that much. I smell it, I taste it—that's what matters," he says, adding, "Today, there are many producers who make good rosés that are darker. But in the eyes of many consumers, it's an expression of poor quality because it reminds them of the time when rosé was a residual product from red wine production."

Despite the success of rosé wine causing some alarm bells to ring, Jean-François is first and foremost happy that several major players have entered the field in the past ten to twenty years. Domaines Ott's own production is heading toward one million bottles per year, but there are competitors who produce more than ten times as much.

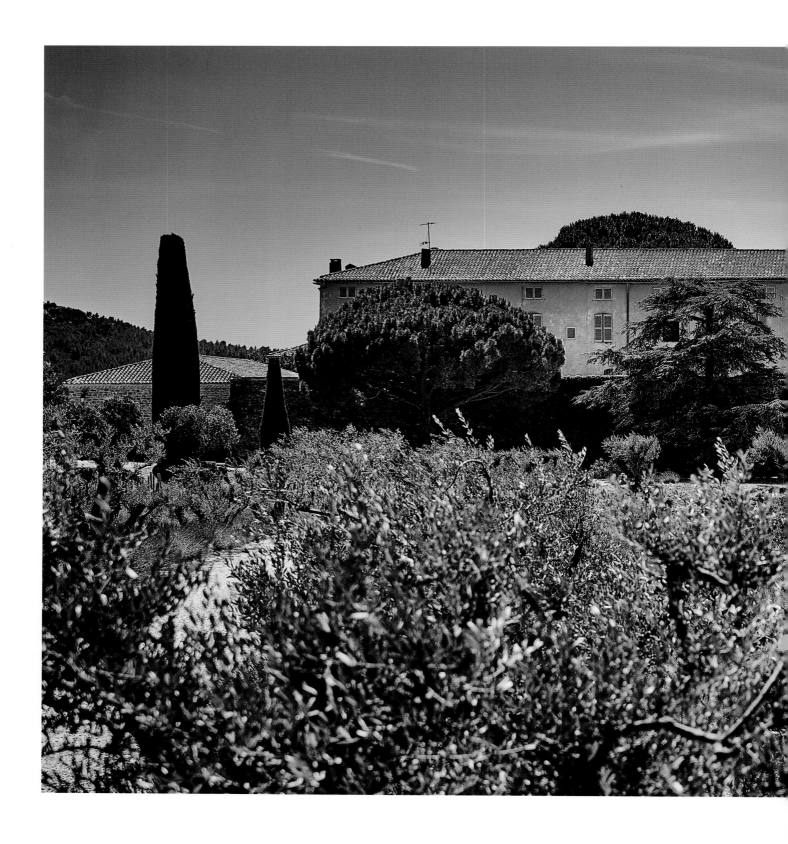

The first star

Château Romassan in Bandol is one of the three domains of the Ott dynasty. It's also home to Jean-Francois Ott, great-grandson of the founder, Marcel Ott, who heads the exclusive rosé brand today.

"Etoile" is Domaines Ott's top wine. The rosé wine is a blend of the best grapes from the three domains and is among the best—and most expensive—rosé wine in the world.

The first star

With a large production and marketing muscle to boot, they spread knowledge of rosé and nudge consumer habits. And according to Jean-François Ott, it's to the benefit of the entire industry that several large Champagne houses, known for producing high-quality wine—and at a high price—have also delved into the rosé world.

The world's best rosé?

The increasing interest of Champagne houses in rosé had a large impact on Domaines Ott because back in 2004, Marcel Ott's descendants were at a crossroads. At that time, the company was owned by his four grandchildren—including Jean-François Ott's father—a new generational shift was needed. The fourth generation, however, consisted of a group of nineteen cousins, who, in principle, had to divide the company between them—and at the same time pay the French state forty percent in inheritance taxes. Therefore, they chose to open the door to potential investors. Many voiced their interest, and the choice fell on the family-owned Champagne house Louis Roederer, which today owns ninety percent of Domaines Ott. Jean-François Ott owns the last ten percent.

Flexing Roederer's fiscal muscle, they have been able to finance the new headquarters at Château de Selle—with a winery, offices, and tasting room for the many visitors. Price: twelve million euro. And it's also with full support from Roederer that the Ott family is trying to develop the rosé category—by taking up the challenge from several competing rosé producers to make the world's best rosé.

For the first time, in 2019, Domaines Ott made a wine that was a blend of the best grapes from their three domains, which are spread over two appellations in Provence—Côtes de Provence and Bandol. From Château Romassan in Bandol, the Mourvèdre grape gives a good body to the wine, Château de Selle contributes an aromatic elegance from the Grenache grape while the same grape from Clos Mireille has taken on the character of the daily Mediterranean breezes and offers a salty crispness.

Entitled "Etoile," the name is a reference to the star formed by the two t's in Marcel Ott's signature—and which has been an important part of Domaine Ott's identity since almost the beginning. Because when Marcel Ott wanted to register his company in 1935, the French authorities announced he couldn't register it under his own name. That's why he chose to put a small asterisk after Ott, thereby creating the "Domaines Ott*" brand.

For Jean-François Ott, "Etoile" is a tribute to both Provence and his great-grandfather's pioneering efforts in rosé wine. Production is limited, and with a price of around €120 euro per bottle, it's certainly one of the most expensive rosé wines in the world.

"I can't say it's the best in the world. That's a matter of taste. But I can say that for me it expresses exactly what I feel about our three estates. It's our contribution to making the world see rosé as a serious wine and to making people understand that rosé wine is also about grapes and terroir—not just about blending some grapes together," says Jean-François Ott, adding with a smile, "There are not just two colors of wine, there are three. And a great rosé takes the same time and effort to produce as a great red or a great white."

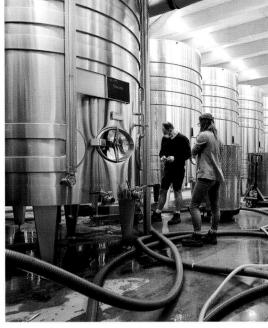

Jean-Francois Ott is the fourth generation of the Ott family. Rosé aristocrats in a motley world of quality producers, celebrities, and vintners. It's their brand, Domaines Ott, that the rapidly growing rosé world has as a point of reference.

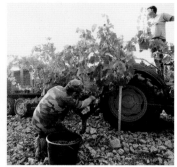

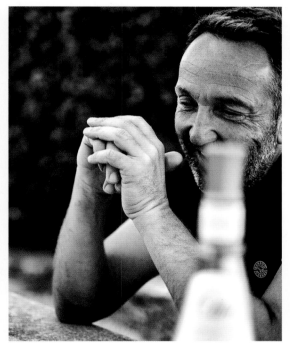

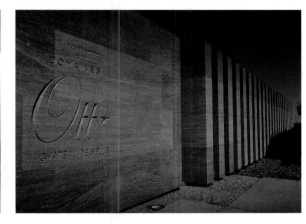

How rosé is made

No, rosé wine is not a mixture of red wine and white wine! The wine is made from the same grapes as red wine—the blue grapes. Here are the three different ways to produce rosé.

The saignée method

Saignée means "to bleed." In this method, the juice is allowed to bleed from a tank of blue grapes that have been pressed and which will ultimately become a red wine. The juice then ferments on its own without coming into contact with the grape skins, and the result is a wine with a light color. The remaining juice keeps its grape skins and becomes a stronger red wine. This method is largely used by producers who primarily make red wine, so the rosé wine is more of a by-product. This method is being used less and less as more producers are making rosé on the wine's own terms—which means that everything from the choice of grape variety to the location of the vineyard to the time of harvest is determined based on what produces the best rosé wine.

Short maceration

Maceration is the period of time when the freshly pressed juice from the grapes remains with the skins of the grapes, which are soaked in the juice. It's the skins that give color, tannins, and flavors to the wine, the character of which largely depends on how long they're with the skins that have been macerated during fermentation. The longer the skins remain in the juice during fermentation, the redder the wine, but if they're left in for only a short time, it becomes a rosé wine. Maceration typically lasts between two and thirty-six hours, occasionally even longer—but generally it's getting shorter and shorter as more producers go for making very light rosé wines.

Direct press

Here, the grapes are pressed immediately after they've been harvested. They are subjected to slow pressure, typically lasting several hours, and it's during this period that the juice absorbs some color, flavor, and tannins from the skins. This method produces very pale and less powerful rosé wines. It's widely used in Provence.

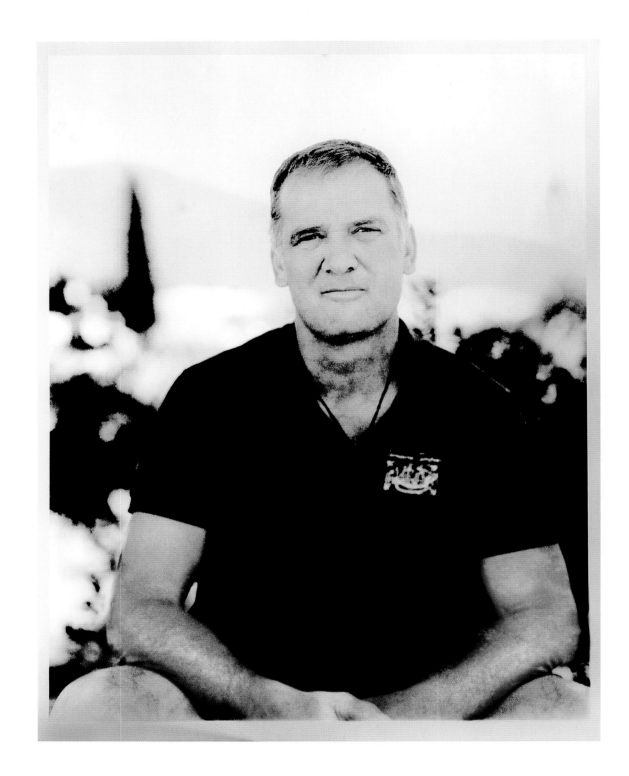

DOMAINE TEMPIER → DANIEL RAVIER

The spirit of Bandol: Joie de vivre

The Mourvèdre grape helped make Bandol wines world famous. At the center is Domaine Tempier, originally a wedding present for a young couple who let their love be driven by the pairing of food and wine.

Véronique Peyraud dashes a little more olive oil over the open mussels lying on a rack in the home-built brick BBQ in the garden just outside the kitchen.

About thirty minutes ago, she set a few old vines and some dry branches from the spring pruning alight with newspaper and a single match. The mussels are now grilling in the glowing charcoal from the wood and emitting a sweet and spicy aroma into the windless late summer air.

The mussels will be done soon, and then some little redfish will get their turn on the BBQ. Véronique Peyraud has wrapped them in fresh leaves she picked from a vine of Mourvèdre grapes. And from the vegetable garden right next door, she's cut some fennel flowers, which are packed in with the fish.

She looks at her watch. They need five minutes on each side.

"The food is almost ready. Will you run down to Daniel and ask if he has time for lunch. And ask him to bring some wine!"

After spending the morning inspecting the grapes of Domaine Tempier's vineyards in the area, we find Daniel Ravier in his head office in the large yellow farmhouse, which has been the physical center—the beating heart—of one of the most renowned wineries in Provence's smallest appellation, Bandol, for almost a hundred years.

Tempier's director smiles and nods—today he has time to eat lunch. He's not as busy as he had expected. It's the middle of the harvest season, so the diary is cleared of everything else. But he has decided to put the harvest on hold for a few days as the remaining grapes are still not quite as ripe as he would like them to be.

Bandol

↓

43°11'01.1"N

5°46'22.4"E

↑

8^{15} CET

The spirit of Bandol: Joie de vivre

This is his twenty-second harvest since joining Domaine Tempier—and one of the most challenging. After a season with a mild winter, which was followed by frost in the spring, and then less rain than usual, the grapes have an uneven quality and less juice in them. The decision regarding the right time to harvest is even more complex than usual—and yesterday he chose to give the many pickers, who were ready to continue with the harvest, a break.

Daniel Ravier bears a bottle of wine in each hand when he comes in five minutes later. Dressed in his usual attire—hiking shoes, loose canvas shorts, and a blue shirt—he makes his way through the garden and straight into the kitchen where the food is being served on a long wooden table covered with a colored oilcloth in a Provençal microcosm of ceramic dishes, plate shelves, copper pots of various sizes, patinated chopping boards, and an open fireplace.

Before he even sits, he grabs one of the grilled mussels, which he eats straight from the shell. His reaction is immediate: "Uhm... joie de vivre!"

He's right—the mussels are a good reason to be happy about life. They haven't been prepared with anything other than olive oil—and the smoke from the burned vines. But rarely has so little tasted of so much. And the experience is made complete with a glass of the latest vintage of Domaine Tempier's rosé, produced from Mourvèdre, Grenache, and Cinsault.

The meal continues with the grilled fish, a tomato salad, another fish and then, naturally, the obligatory cheese course. Everyone around the kitchen table knows the compliments for the meal shouldn't only be sent to Véronique Peyraud, who prepared the food, and Daniel Ravier, who's behind the wine.

Thanks must also be directed to the special spirit that has rested over Domaine Tempier for almost ninety years—and to the married couple who originally created it. Both humility and gratitude are great in those who continue to use the particular Tempier values as their compass in life to this day.

"People think I've done a good job here. But it wouldn't have been possible if it weren't for everything that happened in the seventy years before I arrived," says Daniel Ravier, who was hired at Domaine Tempier in 2000. "It makes me very humble because I know I'm depending on everything that happened. It's like putting together a puzzle where most of the pieces were already in place. My task has first and foremost been to make the pieces fall into place."

Unlike Domaine Tempier's general manager, Véronique Peyraud—and her six siblings—are bound by blood to Domaine Tempier. She is the youngest, born in 1956, and puts it in her very own way:

"This is what we've been brought up to do. These are the memories of our parents. It's a culture that's about getting to know the good things in life. To value them and preserve them. It's the love for this house, for the food, and for the wine. It's the love we taste."

A great love

Lucie "Lulu" Tempier was only eighteen when she fell in love with Lucien Peyraud, who was four years her senior. Her father imported leather in the port city of Marseille, but for generations the family had owned a small vineyard in the town of Le Plan du Castellet in Bandol, close to the French Riviera and about twenty-five miles east of the Tempier family's hometown. When Lulu and Lucien married in 1936, her parents gave them Domaine Tempier as a wedding gift, and Lucien, whose education was in agriculture, had great ambitions to develop the small estate from the start.

It was in the years following the phylloxera devastation in Europe, and many of the winegrowers in Bandol were busy replanting the fields with fruit trees or with grape varieties that had a high yield and so could give a greater return in the short term. But Lucien Peyraud wanted to do things differently. His father-in-law had given him a bottle of wine made from Bandol's original grape, Mourvèdre, from the time before the phylloxera—and when he uncorked the bottle, the potential of the grape was revealed to the novice wine producer.

Mourvèdre is a small, thick-skinned, and somewhat difficult grape that is sensitive to cold, requires a lot of sun and heat, and sometimes has difficulty fully ripening. In good years, however, it can produce excellent wines, both reds and rosés, with a good body and notes of fruit and herbs—and a complexity that develops with age.

Very aware of this, Lucien Peyraud fought from the start for recognition not only for his own wines, but for the entire Bandol region, which he wanted to elevate to the level of France's better-known wine regions. A struggle that would eventually give him the status of Bandol's spiritual leader and ensure his reelection as president of the appellation for thirty-seven years.

Lucien Peyraud was able to bottle his very first wine in 1943. A yield of 5,000 bottles of rosé. And soon afterward, he and a few colleagues succeeded in getting Bandol recognized as an independent wine region. Lucien Peyraud's hard work and experiments with the Mourvèdre grape had convinced the French wine bureaucrats at the Institut National des Appellations d'Origine that Bandol's terroir was so unique and of such high quality, it deserved its own appellation.

The soil contained both clay and limestone. To the south lay the sea, drifting its breezes across the fields, and to the north the mountains protected the vines from the cold on the other side. Lucien Peyraud's own research had demonstrated that Bandol's terroir gave the Mourvèdre grape extra maturity, more fruit, and a good structure due to both the acidity and minerality from the limestone in the soil. Moreover, Mourvèdre was more resistant to oxidation and could therefore produce wines with greater aging potential.

At Lucien Peyraud's side stood his wife, a charismatic ambassador for Domaine Tempier, who, with her skills and finesse within Provençal cooking, made the family's wines one with both southern French cuisine and the lifestyle around the French Riviera. She knocked on the doors of restaurants and convinced them of the Tempier wines' capacity as a gastronomic dance partner. And not least that Tempier's rosé wine, with its ripe fruit, body, and structure, was the perfect accompaniment to both fish and other Provençal dishes with garlic, tomatoes, and olive oil as core ingredients.

Lulu Peyraud also acted as hostess for gatherings at the winery where a confluence of friends, locals, artists, and foreign connections enjoyed unique experiences with her food, Lucien's wine, and the very special atmosphere in the courtyard.

And so, Lulu and Lucien Peyraud were bound together not only by their love for each other, but also by their joint mission to let the symbiosis between her food and his wine be the driving force for their love of the South of France and the joy of life—*joie de vivre*—which today is an expression closely associated with Domaine Tempier.

And no one could have expected that the adventure the Peyraud couple embarked on in the shadow of World War II would ripple out from the yellow farmhouse in Bandol to large parts of the world many years later. Including the USA.

The American breakthrough

American wine guru Kermit Lynch has come to pick us up from a parking lot in the town of Le Beausset to guide us up to his house, which sits on a south-facing hillside at the end of a small, winding road named after the fact that this is the point where the wind turns. The house is only six miles from Domaine Tempier. From his favorite spot at the long wooden table on the terrace, we look out over his own vegetable garden, the area's many vineyards, and all the way to the sea, which is sending gusts of wind across the valley and back again to his sand-colored house with its red shutters.

Kermit Lynch thrives on windy weather. He lives on the west coast of the US during the second half of the year. From his base in the university city of Berkeley, outside San Francisco, he has been importing French and Italian wine for fifty years—and so has helped many Americans get to know wines from the old wine world.

Over the years, Kermit Lynch has also penned a few wine books, and he's not shy about creating a bit of a stir when, both as author and vintner, he makes known his views on how good wine should taste. The first requirement is for the wine to have its own expression—that the grape, terroir, and the winemaker's personality leave their mark on the taste. Otherwise, it's all immaterial, Lynch believes.

Therefore, he's also skeptical of the way much rosé wine around the world is produced today by typically blocking malolactic fermentation to maintain the wine's high acidity level. And the extensive use of industrial yeast, which often influences the taste of the wine more than grape variety and terroir.

But it was a very different story when Kermit Lynch had his first experience of a rosé from Domaine Tempier back in 1976. He remembers it clearly: His good friend Alice Waters from the now world-famous restaurant Chez Panisse served him a glass at her restaurant in Berkeley, California. And here, half a century later, the American wine aficionado still calls it "The best rosé I've ever had."

Alice Waters' connection to Domaine Tempier was established through the American food writer Richard Olney. He lived in Provence and was a great supporter of southern French country cuisine with its strong focus on seasonal ingredients and on pairing the food with good wine. He's the author of several books on French food, one of which is a direct tribute to Lulu Peyraud and her culinary skill.

Lynch and Waters were just establishing themselves in their respective fields—he as a wine importer, she as the founder of Chez Panisse. And with Richard Olney as an intermediary, Alice Waters was the first to visit Domaine Tempier and the Peyrauds.

Like everyone else, she was captivated by the wine, the food, and her host couple. She developed a close friendship with Lulu, in particular, and drew inspiration for much of her own menu from spending time with her in the kitchen. Time that turned out to be absolutely decisive for the image she chose for her new restaurant that had opened only a few years earlier. And that manifested itself in concrete terms as Chez Panisse's patrons were offered a glass of rosé from Domaine Tempier when they frequented the establishment.

This is what Alice Waters tells us from her home in California, sitting in her kitchen next to an open fireplace, which is built exactly like the kitchen at the winery in Bandol where Lulu Peyraud cooked her food.

"I started serving the wine to anyone who was invited to the restaurant. We always began with a glass of rosé. And then holding that glass kind of became my signature. The patrons liked it, but a lot of people were very prejudiced against rosé, and it took some time to get over that."

For many Americans, drinking rosé was a very special experience. Only few of them actually asked for a glass—and with good reason, says Kermit Lynch.

"At the time, the Californian winemakers' rosé was made using rotten grapes. You could make a rosé out of it because you didn't have the skin contact very long. So grapes in bad condition were used to make rosé."

As a budding wine importer, Kermit Lynch was also looking for something that could satisfy his own taste for authentic wines—and something that could help him establish himself as a wine merchant. With the wine from Domaine Tempier, he tasted a rosé made on its own terms and not the result of rotten grapes or anything else that had gone wrong in a production process intended to make red wine. So when Richard Olney recommended he make the trip himself to Domaine Tempier in Bandol, Kermit Lynch was easily persuaded.

However, he still remembers the uncomfortable feeling that hit him when he arrived at his hotel in Bandol and was told there was no reservation for Kermit Lynch. When the receptionist learned he was the "American," she informed him that Lulu Peyraud had dropped by the hotel to cancel the booking—because Kermit Lynch was to be a guest of the couple at their yellow farmhouse.

"I was pretty new to it at the time, and it rubbed me up the wrong way," says Lynch. "You stay with someone, and suddenly you're going to buy their wines. It's hard to say, 'Thanks for everything, but I didn't really like your wine.' That would have been tough. But, naturally, with them, everything worked out beautifully. I loved their wine, and I loved the family."

Thus, Kermit Lynch began importing wine from Domaine Tempier to the USA in the 1970s. He bought both red wine and rosé, but for the first long while he couldn't sell the rosé due to its bad reputation among American wine consumers. Kermit Lynch was left with no choice but to start handing out Domaine Tempier's rosé for free to his customers to get them to understand its qualities.

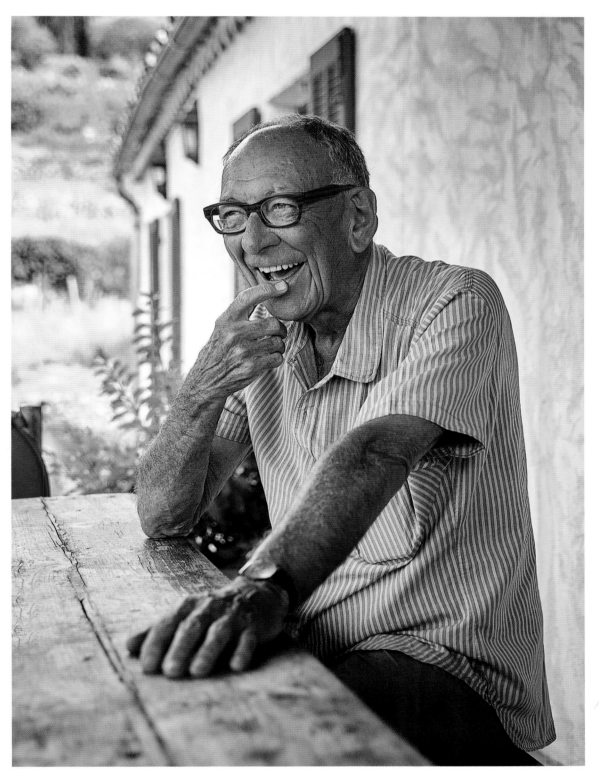

Kermit Lynch has taught many Americans to drink rosé. He began importing wine from Domaine Tempier to the United States in the 1970s. In the beginning, he distributed the wine to his customers free of charge.

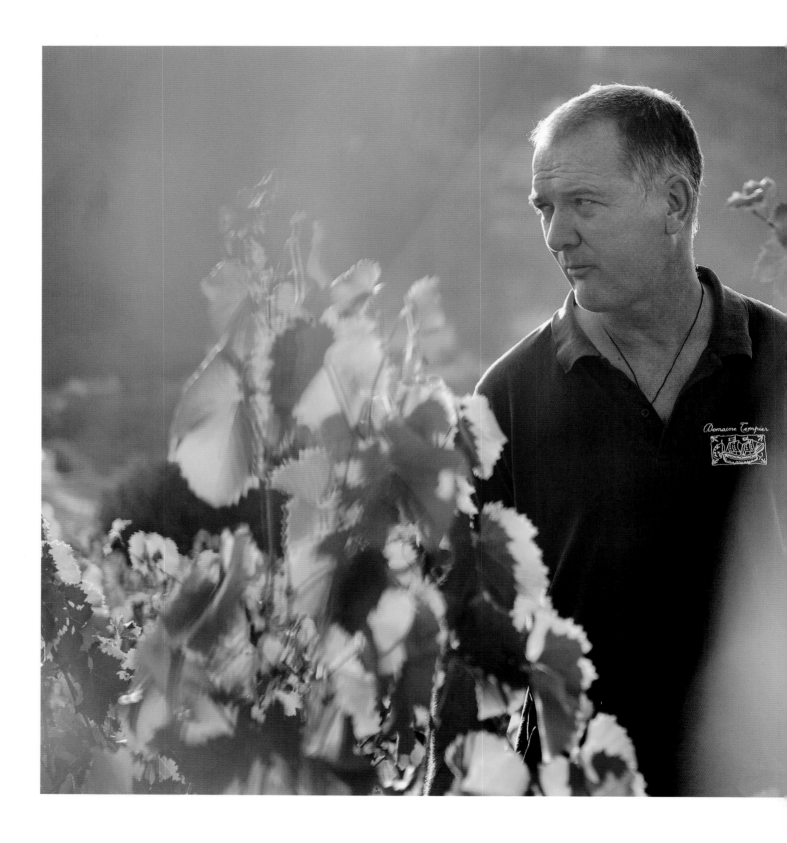

The spirit of Bandol: Joie de vivre

Maintaining an overview of Domaine Tempier's total of 150 plots, which are spread over sixty hectares, is a demanding task. Daniel Ravier goes to the vineyards every day approaching harvest.

At the same time, Alice Waters of Chez Panisse contributed her own marketing strategy by placing a magnum bottle of Domaine Tempier rosé on a table along with a large bouquet of flowers right at the entrance to her restaurant. And gradually it started to work.

"That's where it started—with me giving away some bottles and Alice always displaying the rosé in her restaurant. We both had some influence in our own way back in those days, and it spread. And after a while, there was a demand. It was great to turn people on to something that had such a hideous reputation."

Both Alice Waters and Kermit Lynch have maintained close contact with Domaine Tempier throughout the years. Lynch even chose to settle a few miles from his friends in the yellow farmhouse, and no producer has been more important to the man who built up a reputation as one of America's most important vintners—and who has been credited with being the man who taught many Americans to drink rosé.

Domaine Tempier's success in the United States has been underlined by the renowned wine critic Robert Parker, who deemed Tempier Bandol's most influential producer and their rosé "the best in the world." That success has also helped to inspire several Californian winemakers to produce rosé on the wine's own terms and to plant Mourvèdre vines in their fields. In fact, several producers have dedicated their Mourvèdre-based rosé directly to Lucien and Lulu Peyraud.

Alice Waters doesn't hesitate to call Lulu Peyraud her mentor and credits Domaine Tempier as the inspiration behind Chez Panisse, which with its focus on slow cooking and seasonal ingredients, rather than advanced cooking techniques, has had a major impact on the development of the Californian food scene.

"If I hadn't met Lulu and Richard, I think Chez Panisse would have been different. Lulu took me under her wing," says Alice Waters.

When Lulu Peyraud died in fall 2020, at the age of 103, Alice Waters hung a wreath of olive branches and marble grapes outside her restaurant and served rosé from Domaine Tempier to all her patrons, all the while proclaiming, "Tonight Lulu's friends are drinking Bandol rosé until we fall over!"

When Waters helped open a new restaurant in Los Angeles the following year, she had no doubt about the name: "Lulu." And yes, the restaurant offers its patrons rosé wine from Domaine Tempier. Says the world-famous restaurateur, "Somehow, every time I raise a glass, I always think of Lulu. So it's more than just a glass of rosé. It's saying hello to my friend."

It's hard to make a good rosé

With restless movements and a constant reflective expression on his face, Daniel Ravier moves through the rows of vines with a black plastic bucket in one hand. Between the leaves he spots the grapes he picks with the other hand. Some of the grapes he puts in the bucket while others he pops directly into his mouth. Domaine Tempier's wine master bites into the delicate blue fruits, tastes the juice, and spits both skins, pits, and juice onto the ground.

If the juice has some color, he knows the grapes are about to ripen. Later, both the ripeness and the pH value, which indicates the acidity of the grapes, are measured on the grapes that go into the bucket and are brought home to the vineyard. But Daniel Ravier relies primarily on what he tastes on the spot when he has to decide when the grapes on the various plots are to be harvested.

He started the twenty-five-person strong team of harvest pickers last week but yesterday chose to put the process on hold. Now he has to decide when the harvest should start again and which grapes should be picked first. Maintaining an overview of Domaine Tempier's 150 plots, spread over sixty hectares in a radius of six miles from the vineyard, is a demanding task. It's during this time that some of the year's most important decisions must be made.

He inspects the fields with one of his most experienced employees, and they have now arrived at a field of young Mourvèdre vines grown for rosé. After tasting a few grapes, Daniel Ravier is certain—they need to be harvested this week. The grapes have become riper, but the acid level has started to fall—as the grapes become riper, they become even less acidic, which can produce a somewhat flat rosé that doesn't have the freshness and elegance he would like.

Daniel Ravier knows his vineyards. He knows the young vines, which don't have such long roots, generally produce less acidity and struggle harder through a summer with high temperatures, lots of sun, and limited rainfall. He also knows the lower rows on the sloping fields get the most rain—because when the rain eventually comes, the precipitation falls in such heavy quantities the soil cannot absorb it before it runs down the slopes.

And he knows the battle for rain is so ferocious the neighboring olive trees are the reason why the first few rows of the plot of Grenache vines, which are next on the day's inspection list, have pale leaves and small grapes that have started to dry out.

After more than a few decades heading Domaine Tempier, Daniel Ravier has taken full control of the wine production started by Lucien Peyraud almost ninety years ago when he married Lulu Tempier and they received the vineyard as a wedding gift.

The couple had seven children, and when Lucien Peyraud retired in the early 1970s, two of their sons took over responsibility for production. When they themselves wanted to retire at the turn of the millennium, there was no natural heir in the family, so they searched among young, talented winegrowers with a flair for Bandol and Mourvèdre. Their choice fell on Daniel Ravier, who worked on a neighboring farm. But for Daniel, it wasn't an easy decision.

"It was very overwhelming to be asked. But after walking around by myself for two months, I couldn't understand why I had hesitated."

Daniel Ravier mentions a board of six members of the Peyraud family. For him, it's about preserving the authenticity of Domaine Tempier—being faithful to both the history and the terroir. In his time, new parcels have been acquired, production has expanded, and today rosé makes up more than half of the production. It's also the wine for which the estate is best known.

Tempier's rosé wine is made from the Mourvèdre grape. With its ripe fruit, body, and structure, it's a perfect companion to Provençal cuisine—here, mussels grilled over an open fire.

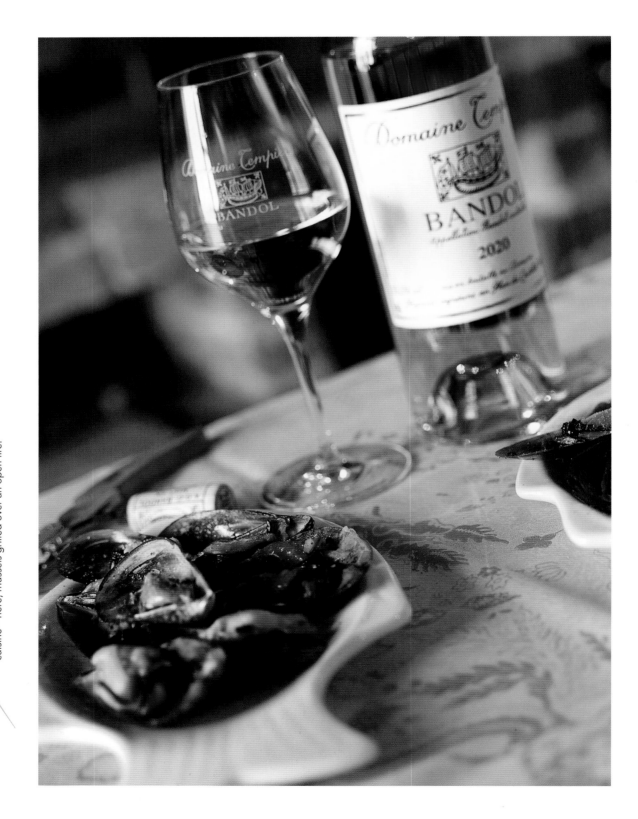

The spirit of Bandol: Joie de vivre

"I think rosé should be on an equal footing with the reds. As winemakers, in our minds we should do the same to both wines. Not the same process, of course, but approach them with the same philosophy," says Daniel Ravier, concluding that it's just as difficult to make a good rosé as it is to make a good red wine, maybe even more difficult.

"In a way, it's very easy to make rosé because you can get a lot of help from technology. But making a good rosé is very difficult. The color has to be right. The wine must be fresh, but not have too much acidity. It should be aromatic, but not overpowering. It should have structure, but preferably no tannins. You have to make a lot of decisions in a very short time frame, and you always have to keep those objectives," he says.

Daniel Ravier has a slightly ambivalent relationship with the rosé boom the world has experienced in recent years—with large producers investing heavily in both the production and marketing of their rosé wines, and with a demand that is steadily growing faster than the supply.

"Generally speaking, rosé has always had a bad reputation. So I'm happy to see that these big companies want to promote their wines because it affects the whole category positively. But my feeling is that it's moving a little bit too fast. Things need to be done with a purpose, deliberately, and with reflection. A lot of people are jumping on the bandwagon, and diving into the market like it's a big swimming pool, and I don't know if that's a good idea."

Essentially, Daniel Ravier knows in advance which grapes he will use for rosé. Typically it's grapes from higher-lying vineyards where the cool winds from the sea help to ensure the grapes don't ripen too quickly. And grapes from vines deliberately cultivated for a higher yield to avoid the wine becoming too heavy and concentrated and not having the right balance.

For the same reason, the rosé grapes are harvested earlier than those to be used for red wine. The goal is a completely dry rosé where the sugar in the grapes is fully fermented. If the grapes become too ripe, a higher sugar content will give the wine a correspondingly higher alcohol percentage, which risks making the wine heavy and unbalanced.

Moving the harvest forward several weeks

Daniel Ravier and his colleagues have one of the world's most beautiful workplaces. The surroundings are breathtaking—especially on a lush, sunny September day like today. But strolling around the fields of Domaine Tempier with them is about everything but taking in the scenery. We are witnessing agriculture being practiced in its purest form. With a goal to help nature do what it's best at. And with a growing concern about how nature is evolving with the climate crisis.

A look in Domaine Tempier's archives reveals that back in the 1960s and 1970s, the year's harvest began in late September. When Daniel Ravier started working at Bandol in the 1980s, the starting time had moved forward

a little to around mid-September. But since 2000, the harvest has more or less started in August—and that's some time ago now.

The rising temperatures cause the grapes to ripen faster. But grapes need time to develop complexity, and ripening too quickly affects the quality and makes it harder to preserve the characteristic freshness of rosé wine. When Daniel Ravier peers into the future, this is the greatest challenge he sees. And he's very aware that in the present time he has to make big decisions he himself won't see the effect of but that will be decisive for the Domaine Tempier's future for several generations to come: "I'm not sure what's the right thing to do, but I am sure I cannot afford to wait."

It's about everything from experimenting with new grape varieties to ensuring greater biodiversity in the fields. And it has to be done with methods and ingredients found in nature.

Domaine Tempier's production is organic—and always has been. Daniel Ravier has also introduced biodynamic principles in recent years. However, he has a somewhat ambivalent relationship with the certificates of approval that organic and biodynamic producers adorn their wines with.

"History has shown us that we can't trust the producers of chemicals who claim their products are not toxic. But I don't need someone to come and say to me: 'You're doing really well, here's a certificate.' I know we are doing well. This is what I have always done, and this is what Domaine Tempier has always done."

After the morning's inspection tour around the fields, we return and eat lunch in the old kitchen where Lulu Peyraud honed her cooking skills—just as her daughter Véronique has done with the mussels, tomato salad, and grilled fish—the signature Tempier spirit also rests over the table. Some things are as they have always been—and they shouldn't be changed. And then there's the obligation to ensure constant development and progress.

This applies not least to the wines. A Tempier wine must retain its distinct character. But the seasons are different, and for a wine that wants to reflect its terroir, this means, in turn, that no two vintages are the same, nor do the wines develop the same way. This applies to rosé too. The shared opinion among many is that a rosé should be drunk no later than two years after the harvest—a wise recommendation because many rosés don't have aging potential and quickly lose both fruit and freshness. Such is not the case with a Tempier rosé.

Smiling, Véronique Peyraud recalls when her father was on his deathbed, surrounded by the whole family, and he asked them to open one of his very first rosés from 1952, which they were to drink together.

"We thought the wine might be done. The scent wasn't that strong, but when we tasted it, it was clear that it wasn't. It had a different taste, but it was really good. I remember dried apricots and figs. It was incredible."

The touching anecdote doesn't only reveal something of the traditions and unity in a very special family, it's also testimony to the rosé from Domaine Tempier being something unique in a booming market. And it makes us all remember the tasting hosted by Daniel Ravier when we visited the yellow farmhouse in Le Plan du Castellet for the first time three months earlier.

An extraordinary sensual experience

The wine tasting is over. Or so we think.

Daniel Ravier has just presented us with the last three vintages of Domaine Tempier's rosé wine to close his tour of the wine cellar with its shiny steel tanks and rustic tanks made of cement, large wooden barrels, and tangle of thick hoses across the bare concrete floor. A trench runs through the middle to catch spills from the tanks as well as water from the frequent washing down of the facilities.

We've passed a tank holding more than 1000 gallons of rosé from the previous year yet to be bottled. We ask why, and Daniel Ravier answers genuinely that he wishes he could. But the blend hasn't succeeded as expected. The resulting wine is too heavy and lacks both the fruit and bitterness that, together with the acidity, should give the wine freshness, he says.

"It's not bad, but once you've drunk a glass, you don't want to drink another one. And that's what rosé is all about— wanting to drink another glass."

It's completely different from the wines we've been allowed to taste. We have reached the last room in the cellar where a large black-and-white photograph of Lulu and Lucien Peyraud, smiling with glass in hand, hangs. The wines are served on a modest oak platter, next to which is a large, dented plastic bucket we can spit into.

The 2020 vintage is fresh and lively, 2019 more complex, and the 2018 vintage has developed a distinct note of grapefruit—but they all share a common recognizability. The same with the color, despite not being exactly the same from year to year. As a whole, the Mourvèdre grape makes the wines more yellow than the classic Provence rosés, which have Grenache as the main grape and are typically more salmon colored.

"I don't care about the color. I don't make wine to get a certain color," says Daniel Ravier, but at the same time, he states he knows the pale color, which also characterizes his wines—primarily because the grapes are cooled down and pressed immediately without maceration—is in high demand among consumers.

That Domaine Tempier's rosé wines are in particularly high demand is underlined by the fact that the 2020 vintage, which went on sale in March, is already sold out now, just three months later. It contributes to a healthy financial situation and provides space in the cellar for the estate's red wines, which need to be aged before being released to market.

Still, he's also somewhat frustrated. Both about having to be ready with his wines as early as March to meet the spring's massive demand for rosé—even though he knows his wines would be even better if they could have a few more months in the tanks before being bottled. And he's sorry that in the coming years he won't be able to offer the vintage 2020 rosé to those Tempier customers who understand that the wines get better with age and would like to buy older vintages.

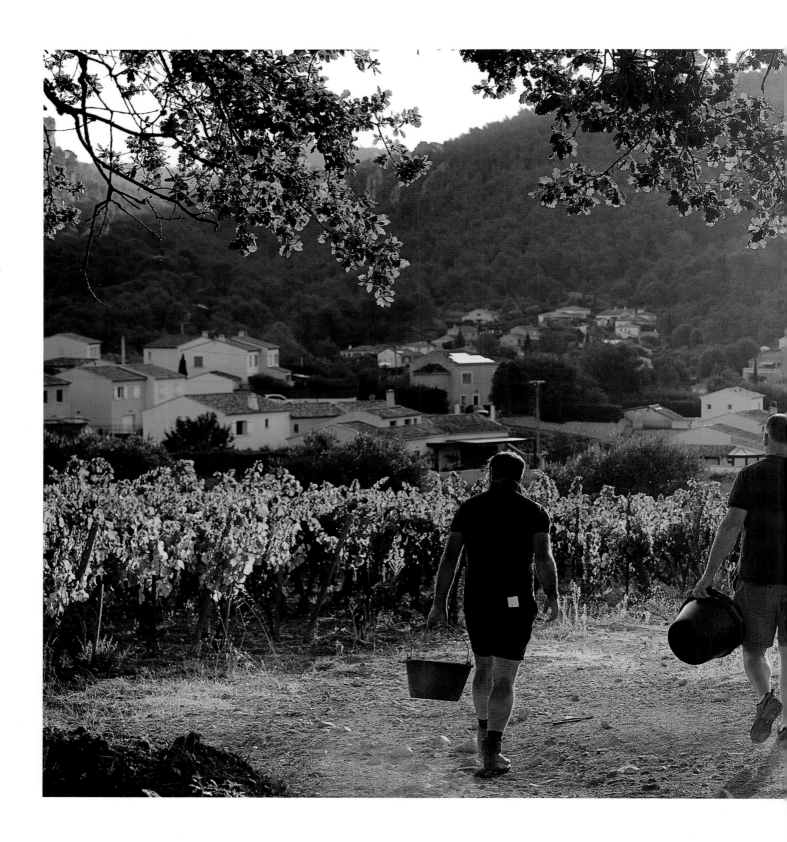

The spirit of Bandol: Joie de vivre

Up until the harvest, the ripeness of the grapes is tested regularly to determine when the harvest should be started and which grapes should be picked first.

To emphasize his point that Domaine Tempier's rosé evolves over time, he opens a bottle of rosé from 1999—as a tasteful encore. It's still crisp and fresh but slightly rounder and creamier than the younger vintages. This is when we think the tasting is over—grateful for the flavorful experiences we have already enjoyed. But as we're about to leave the cellar, Daniel Ravier raises an arm to indicate we have to wait.

Seized by a sudden urge, he disappears into a side room, is gone for five minutes, and then emerges with a new bottle that is absolutely filthy and has a slightly faded label. Gently, he cuts the lead off the top of the bottle, and with his fingers he rubs away dirt from around the cork, which he pulls up with a careful, controlled motion. Only now are we allowed to see the year on the bottle: 1979.

An inevitable solemn, almost devout, hush descends over us. We are about to taste a more than forty-years-old rosé wine—almost as old as the last bottle Lucien Peyraud drank with his family. Just then, the door opens, and Véronique Peyraud comes down a narrow metal staircase to us. She has a glass in her hand—she too wants to taste this wine.

This select company enjoys an absolutely extraordinary sensual experience of a wine that is completely dry but whose fruity notes have clearly developed. Among the little gathering, notes of dried apricot and quince are mentioned—as we all the while remember the couple in the picture above us. After all, they are the ones who are responsible for it all—including the great paradox that one of the world's rosé wines with the most promising storage potential is also a rosé that sells out the fastest.

Their portrait photograph will remain in pride of place on the wall in the cellar as new generations stand ready to carry on the family business. One of Daniel Ravier's closest associates is Véronique Peyraud's son, Nirvan. He's the most obvious successor when Ravier retires in about ten to fifteen years' time. And without hesitation his mother opines: "Everyone is watching him. That's good for him. But he needs his teacher, Daniel."

It's a widely held opinion that rosé should be drunk young—this applies to many wines. But there are good rosé wines that can last for years as they constantly evolve.

At Domaine Tempier, the symbiosis between food and wine is what drives their love of the South of France and the joy of life. "It's a culture that is about letting people know the good things in life. To value them and preserve them," says Véronique Peyraud, youngest child of the couple who received the vineyard as a wedding gift in 1936.

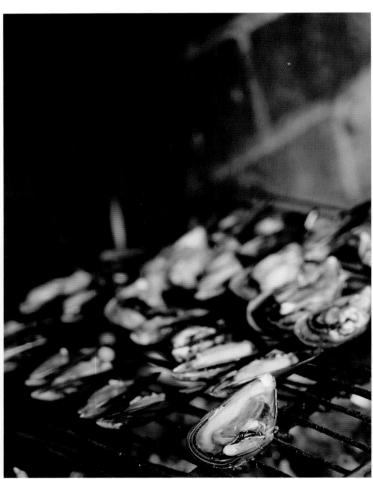

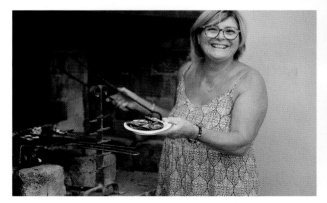

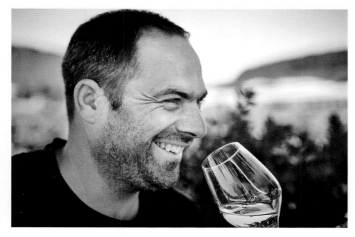

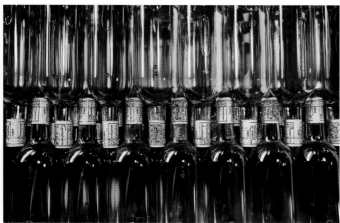

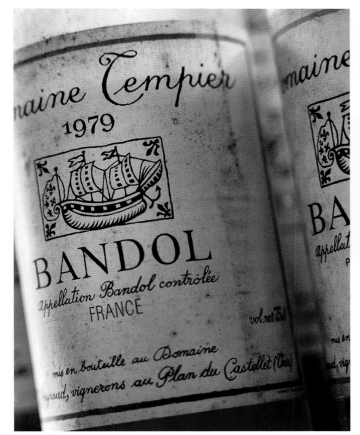

The spirit of Bandol: Joie de vivre

Both the amount of sugar and the pH value, which indicates the acidity of the grapes, are measured in the grapes put in the bucket and brought home to the winery.

Beautifully alluring wine

Wine is a sensual experience. And with rosé, it's our sense of sight that's activated first. The wonderfully irresistible color draws us in.

The popularity of rosé wine has increased concurrently with the color pink also becoming popular. It's a color that—like the wine—has had to fight to be taken seriously. Symbolic of a universe of Barbie dolls, Disney princesses, and bubble gum, as well as the most romantic day of the year, Valentine's Day. But nowadays it's a color universal to all genders, one that signals courage, a zest for life, and the ability to forge your own path.

Pink is popular among the millennial generation who, more than anyone else, have driven the success of rosé over the past ten to fifteen years. They have done away with many of the conventions of the established wine world, which definitely didn't work in rosé's favor. And they have helped promote the wine by posting pictures on social media of happy people enjoying the pink wine from see-through bottles.

Rosé wine spans a broad color palette—from pale, almost transparent pink to a darker, richer shade. At the bright end, a pink rose petal, salmon, or onion skin is used to describe the color of the wine. While in the dark nuances, there's talk of ruby red and rose red, or even the color of red currants.

The difference between a light and a darker rosé is also a matter of both style and quality for many consumers. These days, more consumers go for the lighter rosés, which we know particularly from Provence—which also happens to produce the most popular shades of pink.

Southern French producers, such as the Ott family and Régine Sumeire from Château Barbeyrolles near Saint-Tropez, were among the very first to develop the completely pale rosé. Back in 1985, the latter followed good advice from a colleague in Bordeaux, who recommended that she press her Grenache grapes—quite slowly and in whole bunches—in a hydraulic screw press traditionally used in Champagne. The result was the "Pétale de Rose" wine, which is considered by many to be the parent of the bright style that characterizes the most popular rosé wines of recent decades.

The opinion that pale rosé wines are the best wines is prevalent, but based on objective criteria, the color doesn't reveal the quality of a wine. Nevertheless, color has become a dilemma for producers in areas with a tradition of darker rosé wine. This applies, for instance, in Spain and in French Tavel, which historically has been known for making some of the best rosé wines. Here, many winemakers are considering whether they should continue as they have always done, or whether they should change their way of making wine, so the result is a paler wine.

A significant factor in the growth of sales of rosé in the United States is the increase in the number of men drinking rosé. Gender stereotypes related to color are, thankfully, being broken, which is expanding the market further. But the fact remains that more women buy and drink rosé than men.

CHATEAU D'ESCLANS → SACHA LICHINE

When whispering angels sing

The wine world hasn't been the same since Sacha Lichine from Bordeaux bought a vineyard in Provence and ignited the rosé revolution in earnest. Today, he makes the world's best-selling rosé wine.

The first time we meet him, we'd only just confirmed our visit half an hour beforehand.

We drive along the main road lined with lush vines on both sides. About half a mile from our final destination, we see large signs bearing the name of the man we are to meet hanging on some tall poles banged into the red-brown soil of the vineyards. Upon arrival, we're met by a long white wall built along the entire property to keep trespassers out.

We've been asked to park at a building to the left of the castle. The building functions as a tasting room and boutique for the many guests who come to visit. The façade is painted pink, and in front of it stand large pots with pink plants. The shade is the same as the one on the boxes of newly purchased wine some visitors are putting into the trunk of their car.

We are picked up by his communications director in a green golf cart with nougat-colored leather seats, and he takes us the last 200–300 yards to the château. We drive along a well-kept gravel path past a small park with sycamore trees and a round fountain as the electric vehicle's chauffeur tells us that his boss, who lives permanently in Switzerland, has come to Provence on short notice to meet with his new Spanish distributors. Eighty percent of the wine exported to Spain is sold on the island of Ibiza, we learn. The focus is now on the locals and the tourists in the rest of the country, and the new collaborative agreement is to be sealed with a good dinner enjoyed on the terrace.

It's late summer and early evening. So there's no longer any sun on the south-facing terrace where a handful of waiters put the finishing touches to the table setting. From here, there's a view over the vineyards in the

Provence

↓

43°31'40.8"N

6°54'02.7"E

↑

17⁴⁵ CET

When whispering angels sing

Esclans valley, which gave its name to the castle, and all the way down to the great rock wall, Le Rocher de Roque-brune, which shoots up as the crow flies toward the Mediterranean Sea approximately twenty miles from here. In contrast to the castle, the reddish-brown rock from which the vineyards' soil gets its color is still illuminated by the evening sun.

"Do you realize this is the place in France where the sun shines the most?"

Sacha Lichine, our host, appears once all the guests have arrived. He makes his entrance through the garden door and immediately takes the stage. With his full presence, dressed in a pink shirt, blue suit, and loafers with no visible socks—he has a dark, slightly hoarse voice that switches effortlessly between French and English. The latter with a distinct American accent.

Lichine points to the sunlit rockface as a waiter fills our glasses with a pale rose-colored wine from a transparent magnum bottle that has a label depicting two angels gently leaning their heads into each other.

He admits it was primarily the sun that drew him to Provence when he bought Château d'Esclans and the land we're all now looking out over in 2006. Today, the estate has more than 200 hectares planted with vines. At the top of the slope to our right, on the other side of the country road, we find those he is most fond of—almost 100-year-old Grenache vines whose roots penetrate deep into the calcareous and chalky soil, and which supply the grapes for the estate's most exclusive wines.

Sacha Lichine had spent several years seeking out the right place to live out his dream. When he finally found it, buying the castle was a huge risk. But tonight, with all the pieces coming together, it's clear it was a good move for Sacha Lichine.

The sun on the cliff. The soil in the fields. The man on the terrace. And in a glass, the wine that sends consumers into a frenzy—and that's forged a new path for rosé producers all over the world.

For the wine world has not been the same since Sacha Lichine took up the challenge in the new battle for a wine category that was widely disregarded. Today, his wine is the best-seller in the category, and his brand is the strongest wine brand to come out of France in the last twenty years.

All created for a simple mission.

"From the beginning, the idea was to make rosé into real wine," says Sacha Lichine. "Everyone looked at us like we were completely crazy. I guess, we were. But you know, no risk, no fun—and no reward."

"We don't follow trends—we start them"

The symbolism was clear when Sacha Lichine definitively turned his back on both the establishment and his own family heritage in 2006. Forty-six years earlier he'd been born in Bordeaux, one of France's most renowned wine regions—and throughout his life he'd worked with only the very best wines.

To the established wine world, leaving Bordeaux and buying a vineyard in overlooked Provence instead was a kamikaze move for a well-established winemaker. The astonishment, which also bore a hint of indignation,

03 → CHATEAU D'ESCLANS

wasn't lessened by the fact that Sacha Lichine financed the purchase by selling the Bordeaux wine estate, Château Prieuré-Lichine in Margaux, which he had inherited from his father, Alexis Lichine—one of the twentieth century's most influential people when it comes to French wine. The wine élite couldn't stop shaking their heads at the fact that the young Lichine now wanted to make rosé.

"I have always thought outside the box. It's easy to think inside the box, but I wanted to create something different," says Sacha Lichine.

Thinking big is something he learned from his father, whose core business philosophy runs through his son's veins. "We don't follow trends—we start them." And for Sacha Lichine, accomplishing something great like his father—and in that way both living up to his father's expectations and getting out of his shadow—has been a driving force throughout his life.

Alexis Lichine was a particular father. When his son came to him as a boy with a problem, he was expected to solve the issue himself. Alexis Lichine hated mediocrity, and his larger-than-life character was less concerned with the more mundane aspects of life, which had started dramatically for him as he was born in Russia just before the Russian Revolution and at the age of four fled from the Bolsheviks with his parents. Then again, he displayed great zeal when it came to what brought him the greatest pleasure in life—wine. And he taught his son everything about drinking, making, and selling wine.

"My father always said, 'You have to buy a corkscrew!' That's what I say when people ask me how I learned about wine too," says Sacha Lichine.

He was only five years old when he experienced being drunk for the first time. It was at his father's wedding to Hollywood actress Arlene Dahl. And he remembers as a boy being in Monaco with his father and drinking rosé for the first time around the pool of Prince Rainer's palace in Monaco with the prince and his wife, Grace Kelly.

Sacha Lichine's parents divorced when he was quite young, and at the age of four he moved to New York with his Belgian-German mother. But he spent the summers in Bordeaux with his father, a wine importer, wine writer, and wine estate owner—and who, through all three roles, made a significant contribution to introducing French wine to Americans.

Following in his father's footsteps, Sacha took advantage early on of his upbringing in both the USA and France that gave him a more cosmopolitan outlook on life. As a young man, he studied at a college in Boston but also became a sommelier in a fine restaurant in the city. And the combination of academic studies and practical training in the world of wine helped him on his way.

Sacha Lichine hadn't yet turned twenty when his career as an entrepreneurial vintner took off. He began arranging luxury tours around France for wealthy Americans who enjoyed culinary experiences. A few years later, he established himself as a *négociant*—a wine merchant. He bought wine from other producers, which he then resold under his own name. He also started selling wine for a major American wine distributor, and he established his own distribution company in the Caribbean.

When whispering angels sing

It caused quite a stir when Sacha Lichine sold the family's wine estate in Bordeaux and bought Château d'Esclans in Provence with the ambition of making rosé wine more widespread and recognized.

A defining moment came in 1987 when he received a call from his father's lawyer asking him to return home to Bordeaux and take charge of Château Prieurie-Lichine in Margaux—on his father's behalf. The dutiful twenty-seven-year-old son fulfilled Alexis Lichine's wish, and two years later he inherited the estate when his father passed.

However, running a vineyard in Bordeaux was no bed of roses. Along with inheriting the estate, Sacha also inherited a lot of debt, and a series of successive bad vintages in Bordeaux didn't lessen the fiscal challenges. And despite Sacha Lichine also having an eye for sweetening life with fun parties at the estate, he gradually began to realize Bordeaux was not the place for him if he was to make a difference. "I didn't do anything special there. It was more a management type of thing for me. In Bordeaux, everybody is vying for price and position. And Margaux was not one of Robert Parker's favorite appellations."

American Robert Parker is the most influential wine critic within recent decades, whose fondness for heavy, powerful red wines has influenced both producers and consumers worldwide. His rating of wines according to his own 100-point system has meant the difference between success and failure for many a winemaker.

But life is such that the pendulum swings both ways, and a long-standing trend that favored powerful wines also opened a door for the opposite. Sacha Lichine was one of the first to spot it. And rather than staying in Bordeaux and vying with the many other top winemakers for the connoisseurs' attention, he decided to open this door fully.

Two phenomena in the wine industry inspired Sacha Lichine. Firstly, he realized that white wine made from the Sauvignon Blanc grape was increasingly gaining popularity. These were easily accessible wines that were dry and had a crisp acidity and minerality—and which were drawing more and more consumers away from the heavier, buttery Chardonnay wines. He has been particularly impressed by the New Zealand producer Cloudy Bay who created a product and a brand that generated massive sales of their Sauvignon Blanc wines.

Secondly, Sacha Lichine noted the rising demand for rosé champagne. Rosé is the biggest success in the Champagne industry within recent times, and sales of rosé champagne had already begun to escalate much faster than white champagne around the turn of the millennium. Several Champagne houses had succeeded in branding the pink prestige cuvées as something particularly exclusive and sold them at a much higher price than the other Champagnes.

The Sauvignon Blanc white wines and the rosé champagne had one important thing in common—which they still have today—they catered especially to women.

"Women started drinking Sauvignon Blanc because they want something crisp, and light, and easy. And it was women pouring rosé champagne into their glasses too. It's easy to drink and it looks pretty," says Sacha Lichine.

If consumers are willing to pay a high price for a sparkling rosé wine, it must be possible to get them to pay a little more for a comparable still wine. And if at the same time you can make a wine that's not sweet and heavy but dry and acidic with minerality—and has a beautiful, light color—then you have a winner. That was Lichine's reasoning.

"Timing is everything. I think the world was looking for something new, something that reflected a special taste and lifestyle, and I saw the potential of a category because rosé in general was badly made. We wanted to give noblesse to the category."

Massive investments

Earlier in the day, actually nearer dawn, we were in the vineyards with a team of grape pickers. The harvest is under-way, and now it's the plot of the white Rolle grape's turn, which is called Vermentino in Italy. The grape grows on on a small part of Château d'Esclans' fields—and makes up a smaller proportion of the rosé wines. The white grape contributes some "roundness in the middle" of the taste as Sacha Lichine put it—and also helps to keep the color subtle. Otherwise, Grenache was the grape of choice Lichine trusted for realizing his dream.

Sacha Lichine bought Château d'Esclans from a Swedish pension fund that made only a limited wine production. The remaining grapes were sold to local wineries. Among them were producers whom Lichine respected, and it assured him that the grapes in the Esclans Valley were of high quality.

At the time, Domaines Ott was the only high-end rosé producer with a relatively exclusive customer base located in Cannes, Saint-Tropez, and along the Côte d'Azur. Sacha Lichine believed that the grapes in the estate's vineyards had a quality high enough for him to make a rosé that could compete with Domaines Ott and conquer new markets.

But he knew he couldn't achieve his dream on his own. In addition to teaming up with banks and investors to buy Château d'Esclans at a price of around thirteen million euro, he returned to Bordeaux and met with one of the area's most respected wine aficionados, Patrick Leon, who happened to be an old friend of the Lichine family. Leon had just retired after being head of wine production at Château Mouton-Rothschild, which made some of the most popular red wines in Bordeaux for years. Fortunately, retirement didn't suit him, and he had the courage to embark on a new adventure.

Patrick Leon and Sacha Lichine set about exploring the potential of Château d'Esclans. They quickly agreed to make rosé with as much care, attention, and precision as with the best wines of Bordeaux. They knew it would demand three things: First, they had to have the best grapes. Second, the grapes had to be picked only when they were fully ripe to get the best taste out of them. And third, massive investments had to be made in completely new technology.

A race against oxidation

We are standing at the entrance to the winery where the grapes have been brought in directly from the field. Here, they are tipped onto a conveyor belt, and four people do an initial sorting, removing leaves, stems, and bad grapes, which are thrown into large green plastic buckets. The grapes then roll immediately onto a new machine that does optical sorting. It's a vibrating table with an "electronic eye"—a system that uses light sensors to distribute the grapes according to their shape, size, color, and general condition based on guidelines set by Château d'Esclans' cellar master. This process allows him to use the juice from the different grapes for different wines.

The sorted grapes then pass to stainless-steel hoses with a built-in cooling system that brings the temperature of the grapes down to around forty-five degrees Fahrenheit (seven-eight degrees Celsius) before they

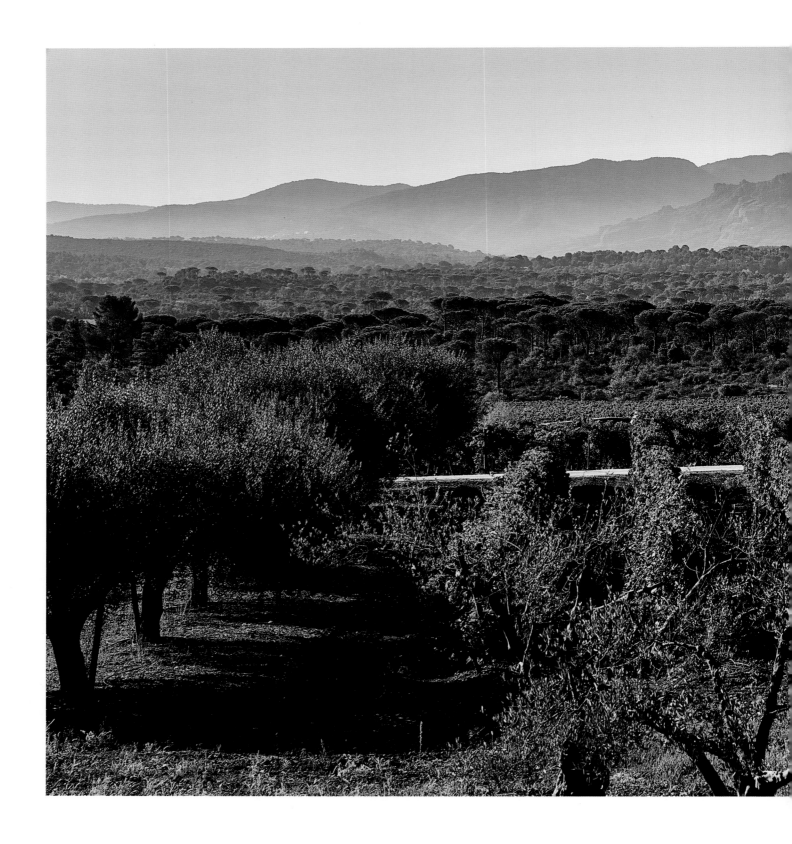

When whispering angels sing

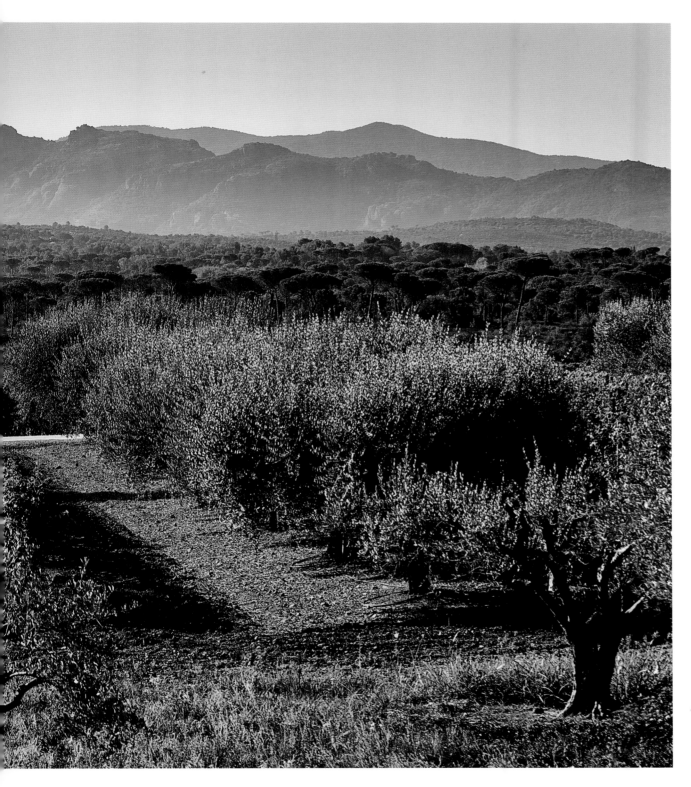

From Château d'Esclans' large south-facing terrace, there's a view over the vineyards in the Esclans valley and all the way down to the large rocky outcrop, Le Rocher de Roquebrune, which juts up toward the Mediterranean as the crow flies.

pass into the press. The first juice from this stage is called free-run because, essentially, the grapes press themselves. The pressure is then gradually increased, though still quite gently, which provides the best conditions for obtaining a clean and intense fruit flavor and a silky texture.

After pressing, the grape juice must be fermented and poured into either steel tanks or wooden barrels, depending on which wine the juice is to be used for. Both tanks and barrels have built-in cooling systems. The scale of the production is emphasized by the towering steel tanks standing outside the production hall—as well as the more than one hundred French wooden barrels holding 600 liters, called demi-muids, lined up in the castle's gigantic and newly excavated cellar.

And it all runs smoothly. A very short amount of time passes from when the grapes are picked in the vineyard to when the grape juice arrives in a barrel or tank in the cellar. All with the aim of getting the most flavor out of the grapes without the oxygenation process starting, which would give the wine too much color and too many tannins from the grape skins.

"Rosé is the easiest color to make average and the hardest color to make well. You want to make something with a lot of taste that has no color," says Sacha Lichine. "Technology has changed for the category. When I was a younger wine professional, I didn't like technological wines because I found them fabricated, but without technology we couldn't have done this. It's an accumulation of details and a race against oxidation."

Whispering angels

Château d'Esclans dates all the way back to the twelfth century, but only parts of the original cellar have been preserved. The estate itself, located between the two small towns of Callas and La Motte in the Provençal hinterland, was built in the nineteenth century after a Tuscan villa.

The yellow manor with blue shutters has its own chapel. As with everything else in the château—with the exception of the wine boutique in the pink building—entry is by invitation only. Sacha Lichine cherishes both his privacy and the exclusivity of his surroundings, which partly explains the long wall he had built out to the road. Similarly, the estate never have "visitors"—only "guests."

Space is tight in the chapel. There's room for only two chairs on either side of the aisle that leads up to a small altar where Sacha Lichine was married to his wife, Mathilde, in 2006. It was immediately after he bought the estate. Three children have since come out of the union. But the chapel has brought him more than love.

Above the altar hangs the plaster figures of two cherub angels with curly hair and surrounded by their wings. They smile gently and lean their heads toward each other. There's something at once intimate and affectionate about them. Perhaps they are sharing a secret? Perhaps they are whispering to each other?

Everyone has their own interpretation—as did Sacha Lichine on his first visits to the chapel where he received inspiration for the brand that, more than anything else, has defined his success and set new standards for rosé wine around the world.

"Whispering Angel" is the name of the world's best-selling rosé wine today, and as mentioned, the wine bears a label with a picture of the two angels from the chapel at Château d'Esclans. Two Methuselah bottles (six liters) of the wine also stand in a prominent place in the chapel as a kind of tribute to their namesakes above.

Today "Whispering Angel" is the flagship of a series of seven different rosé wines from Château d'Esclans. The wine accounts for the vast majority of the total production, which has passed 12 million bottles, half of them sold in the United States. "Whispering Angel" is the best-selling French wine in the United States, including white and red wines.

The truth is, however, that the grapes for Sacha Lichine's moneymaker don't come from his own vineyards at all. The grapes are actually bought from wine farmers in the area—and vinified at an old cooperative in the neighboring town of La Motte, which Lichine has leased since 2016 when demand for the wine was so great he had to find new ways to increase production.

That Château d'Esclans' biggest sales success is a so-called "negociant wine" has led to critical questions and comments from both the local wine authorities and competitors within the area. But Sacha Lichine insists he's both a winemaker and a businessman—and asserts that the two things are inevitably connected. It also means that Château d'Esclans' technical director, Bertrand Leon—who took over the job from his father, Patrick Leon, who passed in 2018—is quite careful in selecting the grapes and wine bought from local farmers. Then again, he pays a high price when he finds the right quality, which ripples out and gives a stronger fiscal foundation for making wine in Provence where over ninety percent of the total production is rosé.

"You have to remember that to make good wine, you need money. When we got here, a lot of the local producers made wine that was extremely cheap. Now growers are getting more money, and so they can invest in quality. And they know that if we're going to buy their grapes or their wine, we look only for quality," says Sacha Lichine.

Figures showing the average price of a hectoliter of rosé wine from Provence has tripled over the course of fifteen years supports him. Indeed, branding rosé as anything other than an inexpensive vacation wine has been an important part of his strategy. Château d'Esclans' relatively quick breakthrough is evidence of that. Sacha Lichine went boldly out into the market and proclaimed loud and clear from the get-go that he wanted to make the world's best—and most expensive—rosé.

Château d'Esclans' top wine, "Garrus," is made from the grapes of the nearly 100-year-old Grenache vines, which grow on top of the slopes opposite the estate. The wine is aged for ten months in French oak barrels, and during that time batonnage is carried out whereby the yeast residues in the tank are shaken twice a week to give the wine more flavor and depth.

With "Garrus", Sacha Lichine challenged the commonly held view that rosé is a light and fresh apéritif wine that's not very expensive. The wine has had a great influence on both producers and consumers, who have opened their eyes to rosé also being a gastronomic wine that can be made with the same attention to detail as, for example, a grand oak-aged white wine from Burgundy. The wine has been a role model for other rosé wines that

have followed and contributed to a changed perception among serious wine lovers who didn't pay rosé wine much attention before.

The first vintage of "Garrus" hit the market in 2008, and its price, set by Sacha Lichine, of €100 euro astounded much of the wine world. A bottle of rosé had never ever cost so much.

Measured in terms of turnover, "Garrus" accounts for a small percentage of Château d'Esclans' business. But the attention it receives has been worth its weight in gold. Initially, the wine was a hit in the exclusive environs of the Côte d'Azur, and Sacha Lichine knew he'd struck gold a few years after his start when he received a call from a luxury yacht on the Riviera asking for the dimensions of a three-liter Jeroboam bottle, so they could make fridges big enough. Today, "Garrus" remains one of the best-known options for a serious rosé.

The wine has helped consumers get accustomed to rosé wine not necessarily being a low-cost wine. And its success has had a major impact on the sale of the other wines from Château d'Esclans. Sacha Lichine found much inspiration for this marketing strategy from the large Champagne houses, which have a portfolio of products that support each other.

"We took the Champagne marketing approach. People like to surf up and down the price ladder within the same brand."

A marker of "the good life"

The second time we meet him, our invitation arrived several weeks in advance.

Sacha Lichine would like to invite us to an apéritif and dinner at the château, says the invitation. This time we park right outside the door and are led directly into two adjoining living rooms, one of which is furnished with a bar and lounge furniture.

It's January, five months after our last visit, which was during the harvest. The wines from last year have not yet hit the market. But the newest wine in the portfolio, "The Pale"—which has a lower price point than "Whispering Angel" and a screw cap in an attempt to get an even better share of younger audiences—is already bottled, and a few of them stand ready on the bar in a wine cooler with ice.

Once all our glasses are filled, Sacha Lichine makes his entrance from the castle's inner chambers. His attire is characteristic—pink shirt, blue suit, and loafers. As a host, he's as straightforward as the wines that have made him a superstar of the wine world. And for the next five hours, we experience a man who is aware of his own achievements but also of how far he still has to go—and who has the ability to grow excited about what's right in front of him—food, wine, and good company. And in that way, he's completely in sync with the wines he produces and sells.

His documented success allows him to downplay his accomplishments without downplaying his efforts. Efforts which, according to his own admission, have primarily been to develop a wine that consumers like—and ensure they actually taste it.

Today "Whispering Angel" is the flagship of rosé wines from Château d'Esclans. It's the world's most popular rosé wine and the wine is the best selling French wine in USA.

"The success of rosé is not about marketing, it's about education," he says. "To be honest, I don't think people were necessarily looking for a pink wine. There was no demand. I think the difference we made is that we created a taste profile and put it into people's mouths. They had never tasted anything like it. So I don't think it happened just like that."

Sacha Lichine epitomizes the increasing number of men who have followed women and now enjoy rosé. His own experience of a good rosé wine is that "it begins as a white wine and ends as a red wine," and he likes his own wine so much he drinks a bottle a day.

From the beginning, he's put himself out there in his mission to get more people to drink his rosé. And despite annual sales of millions of bottles, he's still one of very few people who represent Château d'Esclans externally. Over the years, this has—in addition to a hefty number of travel days—meant he and his family have moved around the world to where new markets needed to be opened. Thus, the family has lived in Singapore, Miami, Chicago, Hong Kong, Boston, and Switzerland.

"The first step was to get the product right, to make it taste good and look sexy—and then we have cruised around the world as much as we could, trying to get it into the right places and get it into the right mouths."

And when asked where in the world he's happiest to see his wine being enjoyed, he quickly answers, "Miami! Oh yes, Miami. It's fun, beaches and lifestyle."

That Sacha Lichine has branded his wines as Provence wines is a fascinating paradox—he has deliberately gone to great lengths to connect the wines with the culture and lifestyle for which the southern French region is known—but ninety-five percent of the wines from Château d'Esclans are sold outside of France, with the United States being the primary market.

But Lichine believes Provence is absolutely the best place on earth to produce rosé—and it's the strongest brand for the wine category.

"Provence is made for rosé. The region has a lot to do with it. And the lifestyle has a lot to do with it. Provence is to rosé what champagne is to sparkling wine," he says. "You can drink a lot of rosés in the world, and maybe one day producers from Italy, Chile, California, or somewhere else will get it right, but for the time being the best rosés come out of here."

Thus, it's the strongest new wine brand of recent decades. "Whispering Angel" has become a marker of "the good life," as it's lived in Provence and elsewhere. It's affordable luxury, and this more value-driven starting point is a large part of its success. But it didn't happen of its own accord. Over the years, time and money have been invested in sponsoring events and participating in wine festivals and other consumer-oriented arrangements where happy—and especially young—people drink rosé and take pictures of each other, which they then post on social media. In just one year, over four hundred consumer events were held in the USA alone to promote "Whispering Angel."

"From the beginning, the idea was to make rosé into real wine. Everyone looked at us like we were completely crazy. I guess, we were."

→ Sacha Lichine

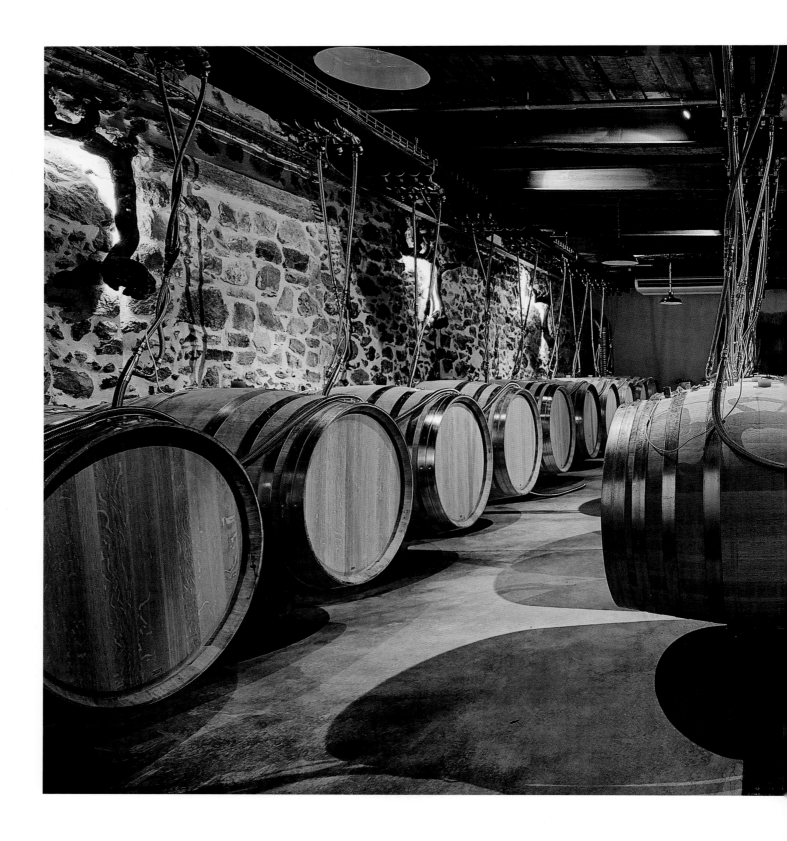

When whispering angels sing

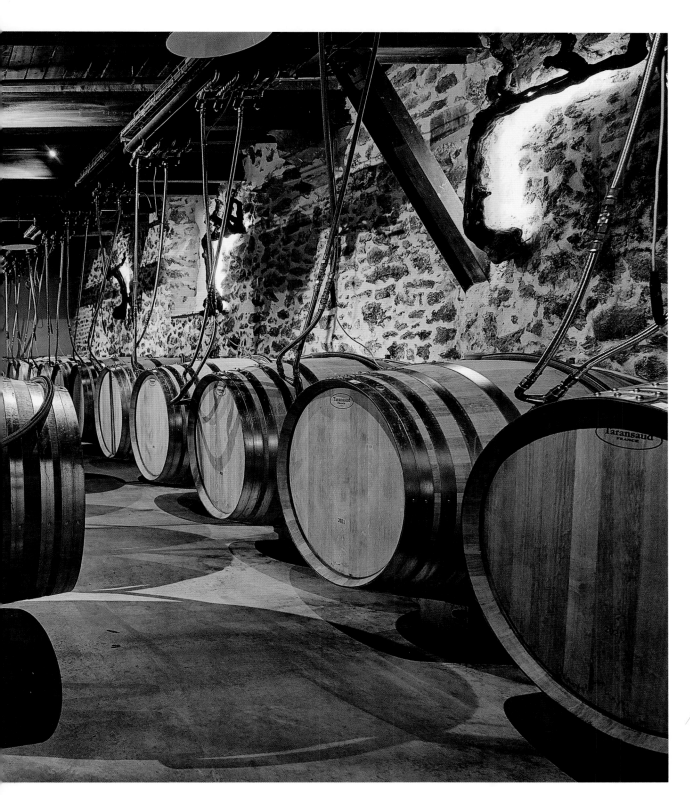

Château d'Esclans' top wine, "Garrus," is aged in French oak barrels in the castle's high-tech cellar. Stainless steel hoses with a built-in cooling system regulate the temperature in the barrels.

Lichine and his people also recognize the value in celebrities drinking the wine. He has happily sent bottles to exclusive addresses around the world, and a concrete example of that strategy came during the COVID-19 lockdown when British singer Adele announced everything would be all right as long as she had a stock of Heinz ketchup and "Whispering Angel" wine.

The ultimate recognition of the brand Sacha Lichine created came in 2019 when he got an offer he couldn't refuse. It came from the multinational luxury goods conglomerate LVMH, which controls around sixty brands within wine and spirits, fashion, watches, and cosmetics—with names such as Dior, Louis Vuitton, Möet & Chandon, and cognac producer Hennessy, being some of the best known. LVMH bought a majority stake in Château d'Esclans, which meant money in Sacha Lichine's pocket and gave him the opportunity to buy out his other investors. It was a clear cementing of both "Whispering Angel" as a luxury brand and rosé as a wine category with a bright future. With access to the new owner's distribution machine, Château d'Esclans could continue to sell as much wine as they could produce. And as the alliance with LVMH has unfolded, an increasing amount of top quality and award winning wines have been produced, marketed and sold throughout choice venues globally.

"I don't think we can do any better than that. That's why we did it. And bit by bit we will probably sell more to them as time goes on," says Sacha Lichine of the sale, which is also a personal milestone. It marks a turning point in Sacha Lichine's successful ambition to make rosé from Provence a worldwide phenomenon—an achievement that can justifiably be compared to the significant impact Alexis Lichine had on the spread of French wine in the United States for decades until his death in 1989.

A baron with two dog heads

Dinner at the castle is served in the dining room. Sacha Lichine sits at the end of the table under a painting that dates back to when Château d'Esclans had Swedish owners. It originally depicted a Swedish nobleman, but Lichine chose what can best be described as a work of provocative art. He hired an artist he knew from Bordeaux to paint over the face of the Swedish nobleman with the heads of his two golden retriever dogs.

The dinner at the château consists of turbot, cheese, and the classic French apple tart, tarte Tatin, with vanilla ice cream. Our glasses are filled with Château d'Esclans' three estate wines. It's both delicious and unpretentious—and is all served on large platters. That's how Sacha Lichine prefers it.

He's also the one who decides the music on the wireless system, which he controls from his cell phone lying next to his plate. On the other side is the ashtray where he taps off the cigarettes he smokes between courses without asking his guests. During the entire dinner we listen to the Spanish crooner Julio Iglesias. Another of his favorites is Rod Stewart, who by the way is also fond of rosé.

Sacha Lichine has his own style and taste. He would rather go to a French bistro and choose three or four dishes from the menu than have to struggle through twenty to thirty dishes on a set menu some Michelin chef has composed. He's also particularly critical of the many sommeliers who are tasked with helping guests choose wine in restaurants the world over.

"I was a sommelier for a long time myself, so I know. The problem is sommeliers just want to make you drink things that are obscure. They want you to drink a wine because they like it. They never listen to what you're looking for style-wise, and they don't understand that people want brands."

It's had an impact on both the spread and recognition of rosé wine, believes Sacha Lichine.

"Our success goes against the will of sommeliers. They didn't want to accept this wine because they never took it seriously. There was a tremendous push-back from the sommeliers. It's changing little by little, but there's still a lot of snobbery. That is why fine dining is not our market."

To reach the next level, Sacha Lichine wants to see "Garrus" and Château d'Esclans' other domain wines—that is, those made with grapes from their own vineyards—being sold side by side with the best red and white wines in the world. In the past years Sacha Lichine has expanded the vineyards of Chateu d'Esclans by purchasing neigboring domaines, Grands Esclans and Jas d'Esclans, with the ambition to put even more focus on the domain wines. That's what it will take to silence the sommeliers around the world. And it's what will further stimulate sales of "Whispering Angel" and the other negociant wines.

"Etoile" from Domaines Ott and Languedoc producer Gérard Bertrand's "Clos du Temple" are sold today for a higher price than "Garrus." But Sacha Lichine isn't worried about Château d'Esclans no longer being behind the world's most expensive rosé.

"I don't think the 'bling' factor is needed anymore. The work we have to do now is to break into the fine wine market. That is what is cool. We haven't gotten there yet. So if you're asking me whether I'm satisfied, I'm not yet because we're not quite there with the estate wines. And the estate wines are what is going to pull the rest."

So the battle for rosé's ultimate recognition as a serious wine category is still out with the jury. It's the battle Sacha Lichine continues to fight. And the increasing number of competitors around the world are first and foremost his comrades in arms, he stresses.

"Competition is great because it helps develop and expand the entire category. I think people just need to keep making quality, keep reinvesting, and the price of the wine has to keep going up because you need money to make good wine. It's a whole movement. We're not envious at all; we're very happy. And I think the future is very bright."

It caused a stir when Sacha Lichine sold the family's wine estate in Bordeaux to buy Château d'Esclans in Provence. The ambition was to make rosé wine more recognized and widespread. "I saw the potential of a category because rosé in general was badly made. We wanted to give noblesse to the category," explains Lichine.

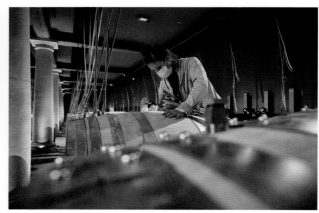

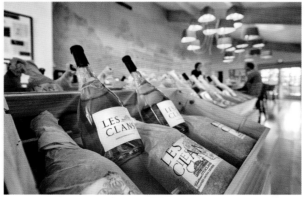

Lighter and more expensive wine

Most rosé wine is produced in France. The country accounts for a third of the world's production. Spain and the USA follow.

- The French also account for a third of the entire world's consumption of rosé wine. The Germans and Americans take second and third place.

- From 2010 to 2020 the total production of rosé wine in the world increased by 25 percent.

- Dark rosé wines are becoming less and less popular. In 2013, half of all rosé wines were dark—just five years later, it was less than a third.

- Every tenth wine drunk worldwide is a rosé wine.

- Rosé wine is growing more and more expensive. The price of a bottle of wine exported from Provence to somewhere else in the world costs twice as much in 2021 as it did in 2008.

- Nine out of ten bottles of wine produced in Provence are rosé wine.

- Grenache is the most popular rosé wine grape in Provence. Then comes Cinsault and Syrah.

Source: Conseil Interprofessionnel des Vins de Provence (CIVP)

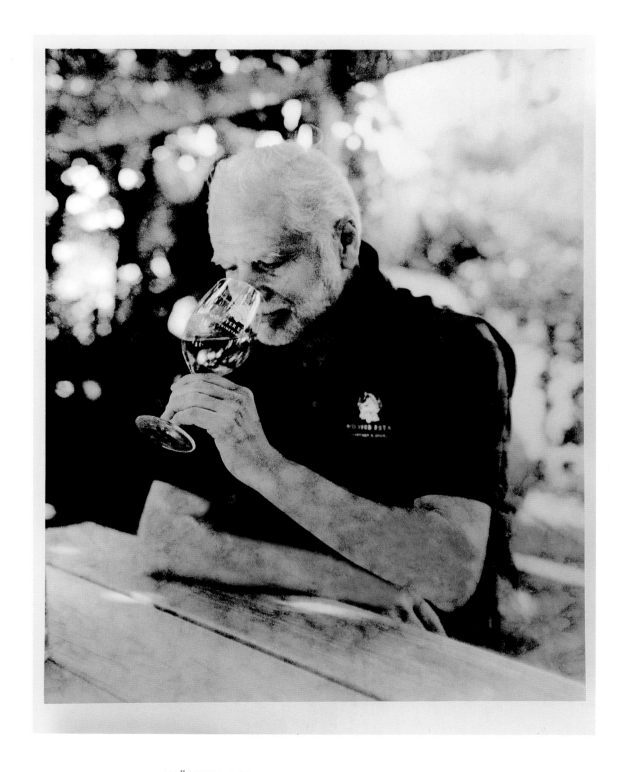

WÖLFFER ESTATE VINEYARD → ROMAN ROTH

Selling summer in a bottle: "Rosé is freedom"

Selling summer in a bottle: "Rosé is freedom"

More than thirty years ago, a German took the plunge and went all-in in making rosé wine on Long Island. Today, it's difficult to keep up with demand in America, but Wölffer is ready to conquer the wine's birthplace.

It's an ordinary Thursday afternoon in July, and the overflowing parking lot in front of the vineyard has given us the first hint of what awaits us. We've driven along small roads to the southern tip of Long Island where fresh Atlantic winds and the rural idyll with little, welcoming towns offer a break from the hectic city bustle of New York, a few hours' drive from here. It's hot and humid, and the walk up to the front door at the end of a long flight of terracotta-tiled stairs makes us sweat.

Opening the door, the quiet and somewhat lazy summer atmosphere is broken by the surprising volume of laughter and bright voices speaking over each other to be heard. We're immediately greeted by a man wearing a big smile, leather slippers, and chinos and a shirt all in the same pink color. He welcomes us inside to the throng of happy guests and busy staff waiting tables in a large room with a wooden floor and exposed beams in the ceiling.

We have visited many wine estates but have rarely witnessed anything like this. The obligatory tasting room has been converted into a drinks-after-work bar for 200–300 people. And we haven't been here for more than a few minutes when something else strikes us—virtually all the guests are women. Most are between twenty and forty years old and seem to be sitting grouped according to age—some at round café tables, others at long

The Hamptons

↓

40°56'43.4"N

72°16'58.5"W

↑

11⁰⁰ EST

Selling summer in a bottle: "Rosé is freedom"

tables with high bar stools, and some are seated on the sofa-like benches along the wall that are upholstered in nougat-colored, slightly patinated leather.

The tables bear platters with charcuterie, cheese, olives, and other classic canapés. And, naturally, there is rosé wine, which is undoubtedly contributing to the good atmosphere in the venue that offers an unspoiled direct view of the vineyards. Some of the wine is served in sets of delicate carafes to taste the different varieties, others in transparent bottles with floral designs in many colors. Both the pink wine and the variegated bottles match the summer-clad women, the sun's warm rays, and that feeling of carefree, untroubled leisure time spent in good company.

At one end of the room is a bar where wines are constantly being replenished on trays the waiters then bring out to the tables. At the other end is a wall with selected photos from the winery's history. In one of them, a tall, dark-haired man stands in the field with a bunch of grapes in his hand.

It's the same man we're to meet today. And when we meet him, we can see that his hair is now white—his gender and his age means he stands out in the day's gathering.

"I'm growing older, and the customers are getting younger," says Roman Roth with an accent that immediately reveals his German background.

He's the producer behind the wine on the tables—and that most guests also buy to bring home with them. But he's also the one who knows more than anyone else that the good atmosphere didn't happen of its own accord.

Today, Wölffer Estate Vineyard is one of the most sought-after producers of rosé wine on the American East Coast. The winery, located in Long Island's popular Hamptons area, in the village of Sagaponack between East Hampton and Southampton, is a very attractive day-trip destination for the locals. But it has been a struggle to make it so.

For years, Wölffer Estate had to pay the price of being ahead of its time. They were the first in the United States with a vision to make a pale and dry rosé wine based on the southern French model. But being a pioneer meant hard work and a red bottom line for years.

Then again, Wölffer was more ready than most when times changed after the turn of the millennium. And in recent years, the success of the rosé produced behind the door at the end of the long staircase with the terracotta tiles has been so great that Roman Roth and his partners have decided to take on the biggest rosé producers on their home turf in the birthplace of rosé wine, Provence.

As Roth himself puts it—three decades after he started making rosé wine on Long Island—"We've turned everything around."

Like a party on the Cote d'Azur

Christian Wölffer was born in Germany just before World War II. He grew up in Hamburg, trained as a banker, and discovered quite quickly that Germany after the war was not where he wanted to be. "Someone's calling my name," he told his mother as he hopped on a cargo ship bound for Mexico. He lived there for twelve years, after which he traveled around South America selling printing machines. The tour continued to Canada before he settled in New York where he became very wealthy by investing in commercial real estate. Over the years, he married twice and had two children with each of his wives.

Christian Wölffer used some of his wealth to buy an old potato farm on Long Island in 1988. His dream wasn't to grow potatoes but to make room for his passion for both horses and wine. Christian Wölffer was also driven by a desire to produce something that was more tangible than fleeting investments—something he could display, taste, and share with his friends.

At the time, Long Island had a very limited history as a wine region. The first wine producers arrived in 1970, and when Christian Wölffer bought his farm of seventy hectares, he was part of a second wave of entrepreneurs who wanted to grow wine on the narrow, sandy island. Wölffer's ambition was to make the best wine on Long Island, but he had a hard time finding the right person to help him make it. He thought those he had tried were either too expensive or too difficult.

In 1992, Roman Roth had just received his master's degree in oenology and was preparing to travel with his Australian wife back to her homeland when he got a tip from one of his teachers at the German Wine Academy that there was a vacant job at a winery on Long Island. Curious, he reached out to Christian Wölffer, who after two phone calls flew to Germany to meet him.

Roman Roth went to the meeting with his wife in one hand and a barrel-aged Pinot Blanc white wine, which he had made especially for their recent wedding, in the other. This meeting would prove life-changing for all three participants because two months later the Roth couple arrived on Long Island with three suitcases and a guitar—not knowing they would never leave again.

Roman Roth points down toward a building at the end of the vineyards. It was there—in Christian Wölffer's home—that he was invited to a party in August 1992, shortly after he had arrived on Long Island. Wölffer was a bit of a man of pleasure and was fond of big parties whose guests counted friends and business associates who shared their host's enthusiasm for the good life.

"I came to this party, and everyone was drinking French rosé. It looked like a party on the Côte d'Azur. Rosé flowed like there was no tomorrow," says Roman Roth about the celebratory evening that inspired the defining moment for both his own life and the future of Wölffer Estates.

"I looked at the vineyards and after walking around them for a couple of days, getting a feel for the sea breeze and the climate, I felt we needed to make rosé. Then I went to talk to Christian and tell him about my idea. He just lit up and said, 'Definitely.' I think he saw something he could get behind and that could compete with the rest of the world."

Semi-sweet wine for thirsty soldiers

In Wölffer Estate Vineyard's first year, red and white wine was produced from Merlot and Chardonnay—i.e. classic wines that originally had a broad target audience. So Christian Wölffer deciding to follow Roman Roth's suggestion and make a dry, light rosé in the Provençal style from France was a bold move. Sure, the rosé bottles were drained when Wölffer had enjoyed them with gusto with his celebrity friends and business associates. And sure, there was a widespread fascination with European culture and lifestyle among the generally well-educated and affluent population of New York. But getting the more mainstream American consumer to buy a bottle of rosé would be quite another feat.

At the time, most Americans associated rosé with a sweet, cheap wine with a relatively low percent of alcohol—a kind of soda for adults. And neither producers nor consumers had ambitions for these wines to be compared to the "real" wines, which were either white or red.

The USA is a relatively young wine country. After Prohibition (1920 to 1933), when all production and sale of alcohol was banned, it took time for American wine production to get going again. Therefore, more wines were imported. It was in those years that Provence legend Domaines Ott began exporting its rosé wines to the East Coast and to New York City in particular. And traditional rosé wines from Tavel in the Rhône valley also became popular among American wine drinkers.

An important factor in the spread of rosé wine in the USA was the large number of American soldiers stationed in Europe during World War II. They wanted to enjoy themselves when they had time off, and several local producers knew exactly how to take advantage of the soldiers' thirst for readily available wines. Semi-dry rosé wines, such as Lancers and Mateus from Portugal—the latter was even bottled in a shape inspired by army water canteens—were among the most popular. After the war, producers had access to a large market in the United States because it wasn't just the soldiers who liked these wines.

American wine producers, especially in California, planted predominantly Grenache grapes, which were mainly used for Rhône-inspired red wines. In the 1970s, the demand for white wines increased, and many producers tried to make light wines from the red grapes they had once cultivated—and which also happened to be the main grape behind many rosé wines from Provence.

On the whole, American rosé wine production was characterized by the fact that rosé wine wasn't the highest priority. As in other wine countries, it was mostly a residual product from red wine production where the ambition was to make as strong wines as possible—and where the producers therefore let the grapes "bleed" to obtain a more concentrated juice for the red wine. The saignée method made it difficult to make a high-quality rosé wine because all the handling of the grapes leading up to harvest was primarily designed to make it the best possible red wine.

This is also how they made rosé wine at Sutter Home Winery in California. Here, Zinfandel grapes, along with the Rhône grapes Grenache and Syrah, were the most used among producers on the American West Coast

state. They over-fermented the grape juice, and the result was a dry, light wine with no remarkable character. And so it remained until one day in 1975 when something went wrong at Sutter Home Winery.

The fermentation of the juice that had bled from a bunch of Zinfandel grapes stalled—that is, the yeast died before all the sugar in the grape juice had been converted to alcohol. The result was a sweet wine with an alcohol strength of around ten percent. And instead of trying to fix the wine—or even throw it away—Sutter's winemaker, Bob Trinchero, took the chance and launched the wine as a new, exciting product.

Long story short Americans loved the wine. As with Mateus and Lancers, the wine called "White Zinfandel"—or simply "White Zin"—suited the slightly sweet tastes of Americans, and Trinchero led the way for colleagues across the country, who had now found a way to capitalize on a residual product. The consequence was a decrease in demand for dry rosé wines, which, in turn, affected the Tavel wines from France.

The success of "White Zin" gave American producers the opportunity to find a name other than "rosé," which for many Americans was associated with wines such as Mateus, Lancers, and the French wines. Instead, the wines were called "blush" and gained a large part of the American wine market. In the late 1990s, more than every fifth bottle of wine drunk in the United States was a blush wine.

The great success also contributed to all rosé wines earning a bad reputation among those who were a little more au fait with wine. The big shift only came around the turn of the millennium when the so-called millennials, who came of age in those years, had different tastes and so a new approach to wine.

Success as a local wine

The vines in Wölffer's fields are covered in a thin net to prevent sugar-hungry migratory birds from devouring the ripe grapes. As they are ready to be harvested, the net has been rolled up on one side to allow the grape pickers access to the bunches, which are snipped from the vines with scissors. Some of the pickers have pulled up their hoods to protect themselves from the sun. Others wear sun hats with wide brims reaching all the way down to their shoulders.

Long Island shares its latitude with central Spain, and the sun's rays are intense. Yet the grapes have no protection. Throughout the season, the vines have been carefully pruned so no leaves shade the sun and no bunches of grapes come into contact with each other. It helps keep the grapes dry—and is thus an important protective strategy against Long Island's sometimes humid climate, which increases the risk of fungal infection. Thankfully, the cool sea breezes and the relatively low night temperatures help ensure the grapes are not "burned" by the sun and heat—as is often the case in both California and southern Europe where the leaves of the vines are used as umbrellas to provide shade for the grapes.

It's been a few months since our first visit. After the summer's concentrated activity among the guests at the vineyard, we return to an intense atmosphere in the field. The stress level has also increased notably for Roman Roth, whose is responsible for ensuring the grapes are picked at the optimum time.

"Rosé is freedom.
It reminds you of good
times. If you're in
a situation where
you're ordering
a glass of rosé,
you're in a good place."

Marc Wölffer

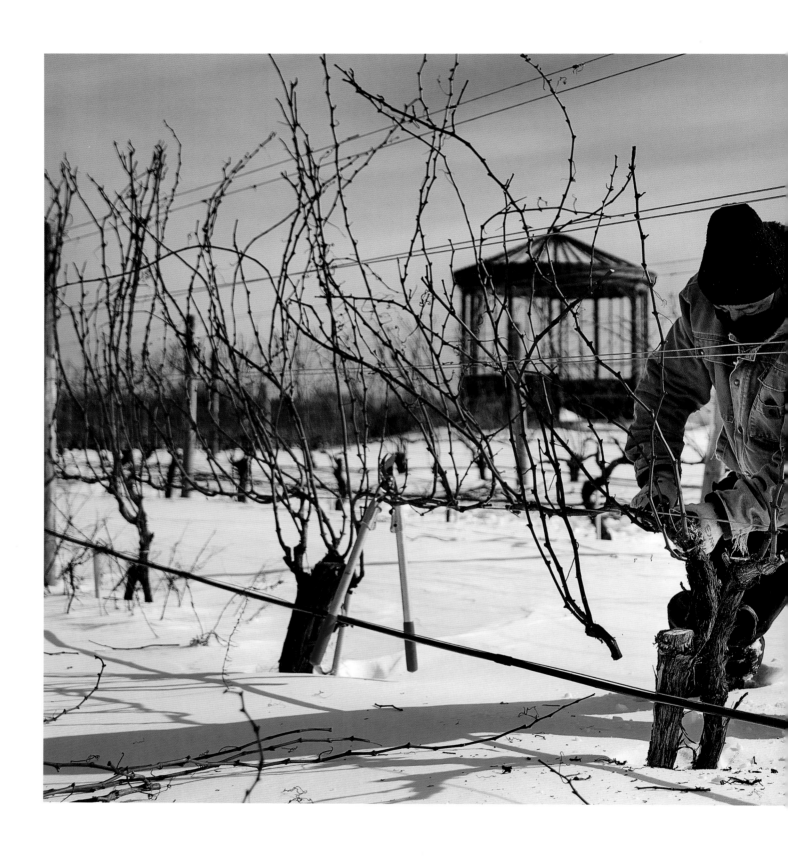

Selling summer in a bottle: "Rosé is freedom"

On Long Island in the state of New York, the seasons are clearly seen and marked. The winters are cold, but there's rarely frost during the spring. This allows the vines to be prepared for an early blossoming.

"Picking at the right moment is crucial for rosé. We want to pick the grapes when they're fresh, and vibrant, and very fruit-driven without being overripe," he says. "It's like a tomato—who wants to eat a tomato that's overripe?"

The Merlot grape is the workhorse of Wölffer's rosé wines, typically composing around half of the wine. Whereas the Grenache grape, which is dominant in the rosé wines from Provence, can give notes of, for example, peach and grapefruit, berries such as strawberries and raspberries become more prominent in a Merlot-based rosé. However, Roman Roth makes his own blend, in which he also uses Pinot Noir, Cabernet Franc, and Cabernet Sauvignon as well as white grapes, such as Chardonnay, Riesling, and Gewürztraminer, which contribute aroma, freshness, and acidity.

All the grapes benefit from the fact that Long Island almost never experiences frost during the spring. This makes it possible to prune the vines early in the year so they can, in turn, bloom early. During the summer, the buds turn into grapes, and as the wind from the sea keeps the summer temperature down around the clock, the grapes have a longer time to ripen. Overall, this means the "hanging time"—from the vines blossoming to the grapes being ripe for picking—is longer than in most other wine regions, which further develops the quality of the grapes even though global warming has meant the harvest typically starts a few weeks earlier now than it did ten to fifteen years ago.

"In Burgundy, they say if you have a hundred days of hanging time from mid-bloom to mid-maturity, you make a great wine. Our average today is 111 days. This shows that we have an excellent climate, and the result is elegant and balanced wines," says Roman Roth.

His work over the past thirty years hasn't only been about making good wine for Wölffer Estate. The goal has also been to change Long Island's reputation as a wine region—in collaboration with the other producers in the area. Until the 1970s, vines weren't planted in the peninsula's heavy clay soil and loam at all. In fact, the first wines made were not all equally good. So customers had some bad experiences, which gave Long Island wines a bad reputation from the get-go—to the detriment of all the region's producers.

"You have to grow as a region," says Roman Roth. "You can't make great wine if everyone else is making sour wine. So everyone helped each other. And things slowly started to change."

In the 1990s, Wölffer's bottles appeared on the wine lists of renowned restaurants in New York. Even the White House requested the wine several times. And at the same time, Roman Roth and Christian Wölffer began to spot the first signs of a rosé trend on the rise. But the numbers were low, and the optimism was based more on a feeling rather than on anything that could be seen on the company's bottom line.

As it turned out, Wölffer was ready to face the future. They gained recognition for their wines, Long Island's reputation as a wine region had improved—and among local residents drinking a local wine was becoming attractive.

"We were the local rosé. The rosé crept onto the lists of the big, expensive wines," says Roman Roth. "We saw our reputation grow. The actual growth wasn't yet happening, but we invested in the reputation—and that set the stage. And then at long last, when the rosé wave came, we had a good reputation as no one had ever tasted a bad Wölffer wine."

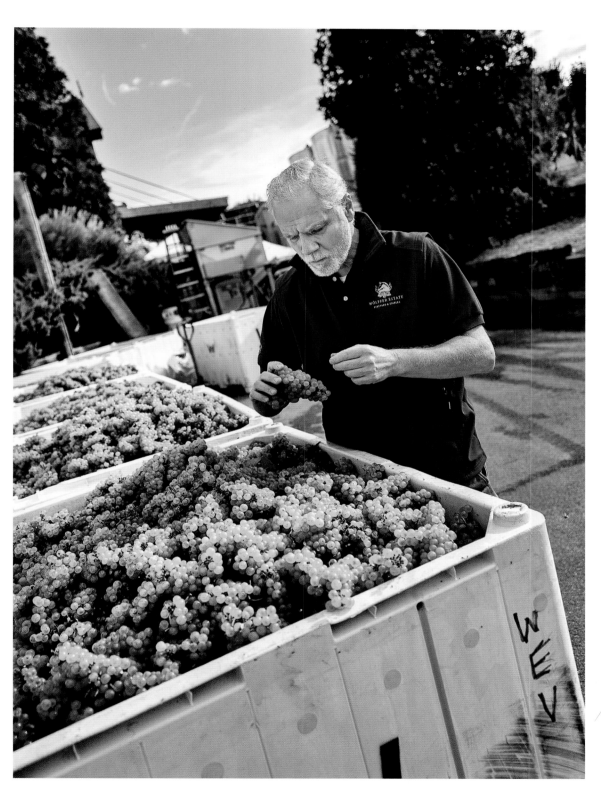

Wölffer's winemaker, Roman Roth, makes his own rosé blend and adds a smaller proportion of green grapes. Chardonnay, Riesling, and Gewürztraminer contribute aroma, freshness, and acidity.

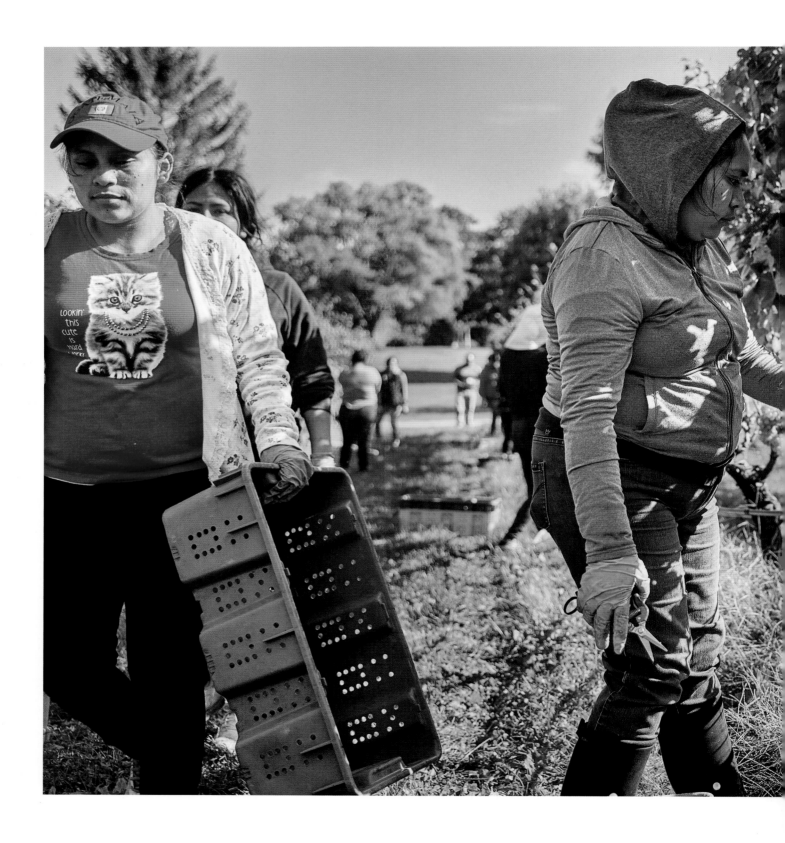

Selling summer in a bottle: "Rosé is freedom"

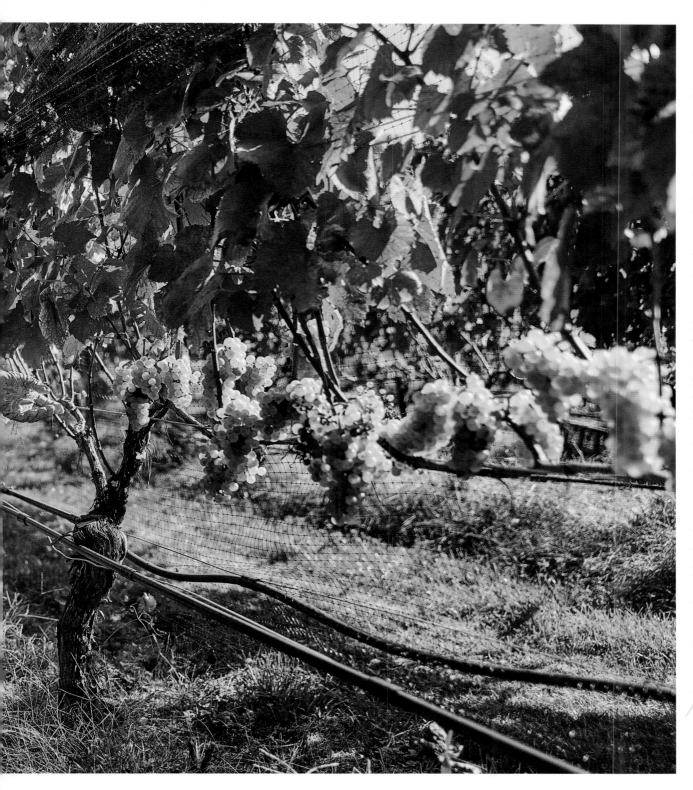

The grapes must be ripe but not overripe when picked. A legion of pickers stand ready to work when they get the word the grapes are to be harvested.

In the mid-2000s, there was a genuine upturn in sales figures. When Frenchman Sacha Lichine came to Long Island in 2006—the same year he bought Château d'Esclans in Provence—to discuss the possibilities of a collaboration with Christian Wölffer, it was the first sign that the global rosé revolution was fermenting. No collaboration materialized. But Lichine set about making "Whispering Angel," which within a few years became the world's most popular rosé wine—with the USA as its most important market. Wölffer, meanwhile, continued his stubborn work of putting rosé on the agenda in the USA, especially on the East Coast.

Statistics confirm that the efforts of Christian Wölffer and Roman Roth were truly pioneering. While the curve for sales of rosé wines from Provence on the American market increased in earnest in 2009, it had already happened for Wölffer's wines in 2007.

The Hamptons ran out of rosé

"We think of ourselves as trendsetters. We started rosé in the US," says Joey Wölffer.

She is one of Christian Wölffer's four children and gives credit to her father and Roman Roth for ignoring the laughter of the outside world when they embarked on making rosé in 1992—and for sticking to their vision, despite encountering a lot of resistance along the way.

We meet her in the vineyard. Although the harvest is underway, she doesn't participate in the work in the field. She is, however, the creative brain behind the lively tasting room that attracts thousands of guests every month—and where approximately twenty percent of all their wine is sold—and she is also responsible for Wölffer's digital marketing.

Joey Wölffer is part of a trio of partners that also includes her sixteen-years-older brother, Marc Wölffer, and Roman Roth. Her husband, Max, serves as CEO. Since the end of the 2000s, these four people together have been responsible for capitalizing on the momentum that arose when the demand for rosé wines ignited.

Regrettably, this quartet came about due to a tragic incident—Christian Wölffer died in a boating accident in 2008 and so didn't get to experience for himself how his years of persistent and determined work to spread rosé wine really bore fruit. Fortunately, the rise—and the fiscal fruit that came with it—made it easier for his four children to plan for the time ahead. And after a period of uncertainty about the future of Wölffer Estate Vineyard— where even selling the winery was considered—two of his four children chose to continue their father's adventurous legacy with Roman Roth as a partner.

They have no regrets. All over the world, the thirst for rosé has continued to grow, and in 2013 a new chapter in the adventure was opened for the Wölffer Estate when they launched the wine "Summer in a Bottle": A dry, fresh, and fruity rosé—made with nine different grapes, marketed as a tribute to the lovely summers of The Hamptons and bottled in a transparent bottle decorated with colorful flowers, aptly photogenic for Instagram.

Or as Joey Wölffer said of the wine: "We sell a lifestyle."

"Summer in a Bottle" was an instant success that reached even new heights the following summer when the wine and Wölffer were highlighted in an article in the New York Post, which reported that The Hamptons were running out of rosé wine.

"We should get that article framed and hang it up. It was a milestone for the integrity of the brand," says Roman Roth.

In 2023 Summer in a Bottle had become the second most sold rosé in the US over $20. It is now sold in 31 states and 9 countries. And following the vision of Marc Wölffer, a non-alcoholic sister wine—Spring in a Bottle—has been produced since 2022 and has become a sudden success in America with a production of almost 200.000 bottles in 2024. It is made from organic grapes from Rheinhessen in Germany, and the alcohol is removed by a top-modern vacuum distillation process, that is more gentle to the wine.

Like many other wine producers, Wölffer buys grapes and wine from other winegrowers to develop the business and keep up with demand. But access to grapes from Long Island is limited, which is why Roman Roth and the two Wölffer siblings look further afield. Since 2014, they've been collaborating with an Argentinian wine producer in Mendoza to make rosé wine from Malbec. And in 2021, they launched a Provence version of "Summer in a Bottle" for the first time.

The wine is primarily made from the same Grenache grapes that French rosé competitors, such as Domaines Ott, Château d'Esclans, and Gérard Bertrand from Languedoc, make their wines from. And with a production in Provence that totals over 450,000 bottles annually, Wölffer Estate Vineyard has taken a huge step up in both the rosé hierarchy and their own self-understanding.

"It's exciting, it's romantic, it's challenging," says Marc Wölffer, who lives most of the time in Europe and was behind the initiative for the new partnership with a wine farmer in Le Luc, a few miles from Saint-Tropez.

"I think we're ready to play with the big boys now. We're ready to produce a wine from the birthplace of rosé."

Young people are embracing a new lifestyle

Another five months have passed. The temperature on Long Island is now below freezing, and the vineyards of the Wölffer Estate are covered in about two feet of snow that fell two days ago. During our visit in the fall, Roman Roth served a tasting from one of the steel tanks that had just been filled with juice from grapes from the year's harvest. Now we're back in front of the tanks. Roth's polo shirt has been replaced with a thick fleece to shield him from the winter cold, which can also be felt inside the winery. The cloudy juice, with a sweet and somewhat simple grape taste, has transformed into a clear, salmon-colored wine with acidity, fruit, and a salty minerality.

A monotonous, rattling sound comes from the room next door where Wölffer's new bottling plant is busy bottling the wine. With the plant, 15,000 bottles can be bottled a day—twice as many as before. It's needed.

Wölffer has struck a little gold with the wine "Summer in a Bottle." It's marketed as a tribute to the lovely summers in The Hamptons and is bottled in a photogenic bottle with colorful flowers.

Selling summer in a bottle: "Rosé is freedom"

Wölffer's production of rosé is constantly increasing. It has reached close to one and a half million bottles a year. And still the wine sells out every year.

"We're sitting on something huge now. That is my feeling and my hope," says Roman Roth. "We're about to move into another league. But building on our own success is natural growth. It's not like putting a celebrity's name on the wine, making a fancy wine, or anything like that. What's happening is based on our history, and our reputation, and our consistent quality. That's what is giving us this momentum."

A lot of blush wine is still sold in the US. But it's the dry, fresh, and pale rosé that's made headway. Wines like the southern French wines from Château d'Esclans and Château Miraval, which was bought by Angelina Jolie and Brad Pitt in 2012. But the inspiration from Provence is also evident when it comes to rosé wine from American producers—and from producers in many other wine countries for that matter. It evokes fear in some that rosé wines from all over the world will lose their local identity and all taste the same.

Wölffer's wines are also inspired by Provence—they have been since 1992. But that doesn't mean Roman Roth wants to make the wines identical to those of his southern French colleagues.

"The dry, fresh wines have definitely won the battle. But for me, Provence is an idea, a style. We make our wines with different varieties. The idea is similar, but the taste is slightly different. The best ideas are always stolen, but you have to be true to your region and your terroir. You have to adapt to your climate and ideas, so they work for you, and it's not a constant uphill struggle."

The core idea for Roman Roth and Wölffer is to make wine that is at once of high quality and reaches younger generations who don't care whether their wine says Burgundy or Bordeaux—or actually, would prefer that it doesn't.

"The greatest growth is among the young people. They're embracing this whole new lifestyle. We ate big steaks, but they eat a lot of vegetables and maybe a small piece of meat. And these elegant wines pair well with that. If you present them with a heavy Bordeaux wine, they run away screaming. That kind of loyalty and somewhat old-fashioned Francophile focus isn't there anymore. On Instagram, they follow all kinds of wineries. And funnily enough, older Americans are also following this trend. Everyone wants to stay young."

Marc Wölffer takes it a step further and says that rosé is successful because it's a wine that sets you free to do the things you want—or makes you think about what you like.

"Rosé is freedom," he says. "It reminds you of good times. If you're ordering a glass of rosé, you're in a good place. Maybe you're with friends, maybe you're at the beach—or maybe you just want to feel like you were at the beach. If you close your eyes, you are where you want to be."

A new chapter in the adventure was opened for the Wölffer Estate when they launched the wine "Summer in a Bottle": A dry, fresh, and fruity rosé marketed as a tribute to the lovely summers of The Hamptons in a transparent bottle decorated with colorful flowers. "We sell a lifestyle," says Joey Wölffer.

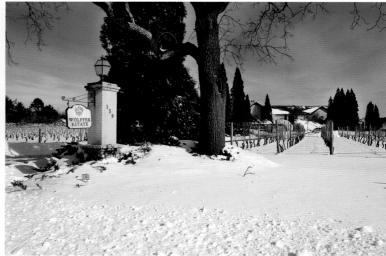

Selling summer in a bottle: "Rosé is freedom"

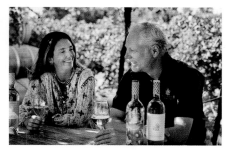

Selling summer in a bottle: "Rosé is freedom"

If the skin can easily be removed from the grapes and the grape juice sticks to your fingers, it's a clear sign the grapes are ripe and ready to be picked.

A rosé by any other name

Rosé means pink in French. Nowadays, it's the most widespread term worldwide for wines in this category. The use of the Francophile word reflects how the country has the strongest tradition of rosé wine and how French rosé wines are the most dominant in the world.

A rosé by any other name. Indeed, most wine countries have their own local terms for the pink wine.

In Spain, you enjoy a bottle of *rosado*, the Spanish word for pink. However, many of the pink wines in the country are also called "rosé." The same in Italy, where the local term is *rosato*, which means rose. To make things a little more confusing, the Italians also make a rosé wine, which they call *chiaretto*—and which, especially in the northern wine regions, is the term used for some of the pale and dry rosé wines similar to the Provence wines in neighboring France.

In Germany, it's more complicated again because here *Weissherbst* and *Rotling* are terms used for the country's traditional rosé wines, each made in their own way. Weissherbst is made from only one grape while Rotling is a mixture of blue and green grapes. And in the last category, you can find both *Schillerwein* from Württemberg and *Badisch Rotgold* from Baden. But in Germany too, which has the third largest consumption of rosé wine in the world, rosé has become a widespread term—not least because the country imports a large quantity of rosé wine from France and Italy in particular.

French rosé wines are also very popular in the US. Nevertheless, throughout the years, American producers have had success with their slightly sweeter wines such as "White Zinfandel," which is a pale wine made from blue Zinfandel grapes. And to distinguish themselves from European producers, they started calling their wines "blush" back in the 1970s. The word is still widely used today.

In fact, rosé is not the only name for the pink wine in its French birthplace either. In Bordeaux, they like to make a *clairet*, a slightly darker and stronger rosé wine. The wine has its own appellation. The name stems from the English *claret* and dates back to the Middle Ages when England imported many bright red wines from Bordeaux.

The blue grapes have a colorless juice. It's the skins that give color and tannins to the wine. If the skins remain in the tank for a long time, the wine becomes a red wine, but if they are only in the tank for a short time, it becomes a rosé wine.

LÓPEZ DE HEREDIA → MARIA JOSÉ LÓPEZ DE HEREDIA

Being trendy without being so

Turning their backs on fads and new technology, the López de Heredia family in Rioja continue to make wine like their great-grandfather did. With the result that their rosé wine has gained cult status in a booming market.

One of her first remarks after welcoming us is, "I actually don't really want to be in a book about rosé."

Maria José López de Heredia says it with a smile—and no, she's not about to throw us out. But the next fourteen hours of intense togetherness teaches us that behind the smile—not to mention the overwhelming hospitality and a desire to tell stories—lies a seriousness deriving from the weight of four generations of family history and an almost predestined obligation to continue the story with one overriding goal: To maintain the legacy of their predecessors and do as they have always done. Unchallenged by modern technology, new habits—and popular trends.

We are in Haro, the main town of Rioja Alta, the western part of the Spanish wine region Rioja. When we arrived, a thin layer of snow lay over the vineyards around the high-lying town where the winter is both cold and wet. This morning the snow has melted. It's raining, and puddles dot the muddy vineyards because the rainfall is so heavy the ground can't absorb it.

Most vineyards are located south of the Ebro River with its almost 600 miles cuts through north-eastern Spain. There is lime in the soil, which also contains sand, clay, and pebbles deposited by the river over the ages. Just outside Haro, the river bends and runs around a peninsula with plots of vines. It's Viña Tondonia, perhaps Rioja's most famous vineyard.

Rioja

↓

42°35'04.5"N

2°30'53.4"W

↑

11^{30} *CET*

Being trendy without being so

On the way back toward the town, we see a lookout tower rising above the city's roofs. The tower is featured on the bottle labels of Tondonia wines too. It was built in the late nineteenth century and originally served two purposes: An observatory from which both the vineyards and the weather could be studied and an icon to promote the name of the company, which is on the tower and can be seen from afar—R. López de Heredia. A name that no longer needs a tower to draw attention.

The *bodega*—the Spanish term for a vineyard—is located on the outskirts of town, right next to the train station. At the center of the winery is a fascinating building with whimsical architecture of composite building elements on different levels and ornate rooflines, which, along with the central location, have earned it the name "the cathedral of wine." The building's iconic status isn't diminished by the fact that even now—almost 150 years after the first stone was laid—it has yet to be completed. It probably never will be.

The latest addition is a pavilion designed by award-winning Iraqi architect Zaha Hadid that doubles as a tasting room and wine boutique. An example of modern architecture that stands out from the rest of the vineyard—well, except that the pavilion, which is shaped like an asymmetrical bottle encloses an original recreation of the stand López de Heredia had at the World Expo in Brussels, Belgium, in 1910.

The ambition was to build a bridge linking the past, the present, and the future. It's a statement from a family who have been active citizens for generations and who have left their mark on a development that reaches far beyond the bodega in Haro. And for whom traditions don't mean resistance to change but are rather a matter of adhering to eternal principles and values.

This applies equally to Maria José López de Heredia, who is running slightly late to meet us in the pavilion. Only when she pulls down the hood of her green oilskin jacket do we see it's her. She stuffs a pair of knitted mittens in her pocket but keeps a large scarf around her neck. On her feet she wears rubber rain boots.

She's a small, slender woman who immediately fills the room with her fast, verbose speech. As the face of López de Heredia, she manages the story of one of the world's most iconic and original wineries. When she speaks, she does so on behalf of her siblings, her father, her grandfather, and her great-grandfather. And she does so with an awareness that this unique history must be at once communicated and protected.

The latter in particular demands full focus in a world in constant flux—not least at a time when the outside world has begun to view López de Heredia differently. Not because the family and their wines have changed, but because the increasing popularity of the rosé category throughout most of the world has led to a new demand for the very distinct rosé wine from the old bodega.

The wine has achieved an almost cult-like status as an exclusive rosé wine in a booming market where it occasionally sells for astronomical prices at private auctions. It's a wine that emphasizes the versatility of a category that some fear is becoming uniform. And it accentuates rosé's potential as a grand wine—and the fact that more wine enthusiasts have started exploring the pink wines.

But for a winemaker who wants to keep things simple and do exactly like their predecessors—and who for all intents and purposes doesn't want to contribute to the hype—that type of attention is a challenge.

"For me, rosé is a problem," says Maria José López de Heredia. "It's a nice problem, but it's a difficult problem. It's the problem of success."

Wine not to be drunk by just anyone

Maria José López de Heredia's great-grandfather, Don Rafael, was a young Chilean who came to Spain to study wine. He fell in love with Rioja Alta—especially the area around Haro where he established his vineyard in 1877. At that time, the terrible wine pest, phylloxera, was ravaging France, so Don Rafael initially built his business by selling grapes and wine to French wine merchants from Bordeaux who were looking to Rioja to keep their businesses afloat.

Essentially, the desperate French hunt for wine kick-started Rioja as a wine region. Don Rafael was one of the first to spot the potential in the area and built up a good business within a few years that also benefitted from him having established himself right next to a newly built railway station from where the wine could be easily transported to France.

It was the Bordeaux merchants who taught the local winegrowers to use the Garnacha grape—the Spanish version of Grenache—to produce a more alcoholic wine than the flimsy local Tempranillo wine that was so low in alcohol it all too often turned to vinegar during transport to France. And it was also thanks to inspiration from the French that Don Rafael built his bodega using a wine estate from Bordeaux as a model.

The Spanish vines didn't escape being affected by phylloxera. But when it happened around 1900, the cure for the aphid had been found—grafting the vines to resistant roots from the USA, from where the aphid originated. By that time López de Heredia's business had become sufficiently resilient to survive.

As the years passed and the French wine merchants returned to France, Don Rafael's ambitions grew. He realized he couldn't make top wines if he didn't have the best grapes, so he replanted the now famous Viña Tondonia vineyard. He also planted three more fields, reaching a total area of 190 hectares.

Don Rafael was a visionary, an educated man who always wore white shoes and a top hat, a man who used formalities with his own children. He built his brand by selling a wine that was to be drunk neither every day nor by just anyone. The target group was largely the upper class—those who drove a car, wore a tie, could speak English, and had good connections to both the royal family and the embassies. Don Rafael succeeded in getting his wines associated with the well-to-do life during the European golden age up until World War I when art, beauty, and new technological inventions flourished.

Initially, López de Heredia produced primarily red wine. But if the grapes were suitable, white wine and rosé wine were also made. No two production years were the same as Don Rafael only decided which wines he would make once he knew what the year's grape harvest would be.

And so it remains to this day. Indeed, several years can pass between López de Heredia launching new rosé wines—and having to wait perhaps years for a new rosé from the producer in Haro has only contributed to the wines' iconic status.

The predominant part of the production is red wines made from a classic blend of Tempranillo, Garnacha, Graciano, and Mazuelo—always with Tempranillo as the dominant grape. But regardless of color, all the wines from López de Heredia have a common feature that has characterized the bodega since the first day it opened its doors almost 150 years ago.

Sunday school in the vineyard

Large oak barrels line one side of a long hallway. The largest of them are 640 hectoliters—almost 17,000 gallons. We are about fifty feet below ground in a basement over 650 feet long that stretches toward the Ebro River. The barrels have the matte gray color of aged oak. In several places the wood is so saturated with wine contained in the large barrels that red patches are visible on the outside.

Along the opposite wall run shelves with thousands of filled wine bottles stacked on top of each other. The bottles lie with their bottom facing outward. Here a small white sticker tells the visitor what year the wine is from. Most wines are up to ten years old while other wines are over a hundred years old and are covered in a thick layer of dust and mold that contributes to a constant level of humidity.

At the end of the hallway, thick layers of mold have settled on both the wall and the ceiling, and moisture runs down the wall. Maria José López de Heredia notes the mold is grayish.

"We can always tell what the weather will be like from the mold. When it's not raining, the mold is completely white. But if it's not white, then we know there is a probability of rain."

In the next hallway, oak barrels stand close together in two rows along each wall, leaving only a small path in the middle for access. First, we meet a man sweeping with a broom. It's Friday, the weekly cleaning day at the winery. A little farther on, we come across Maria José López de Heredia's younger sister, Mercedes, who has removed the plug from one of the barrels and is sucking up wine with a long wine thief. The wine is from 2012 and is to be used in a blend before being bottled.

"I actually don't remember the harvest from that year," says Maria José López de Heredia. "It was the year I got married and we went on our honeymoon, so my thoughts were elsewhere."

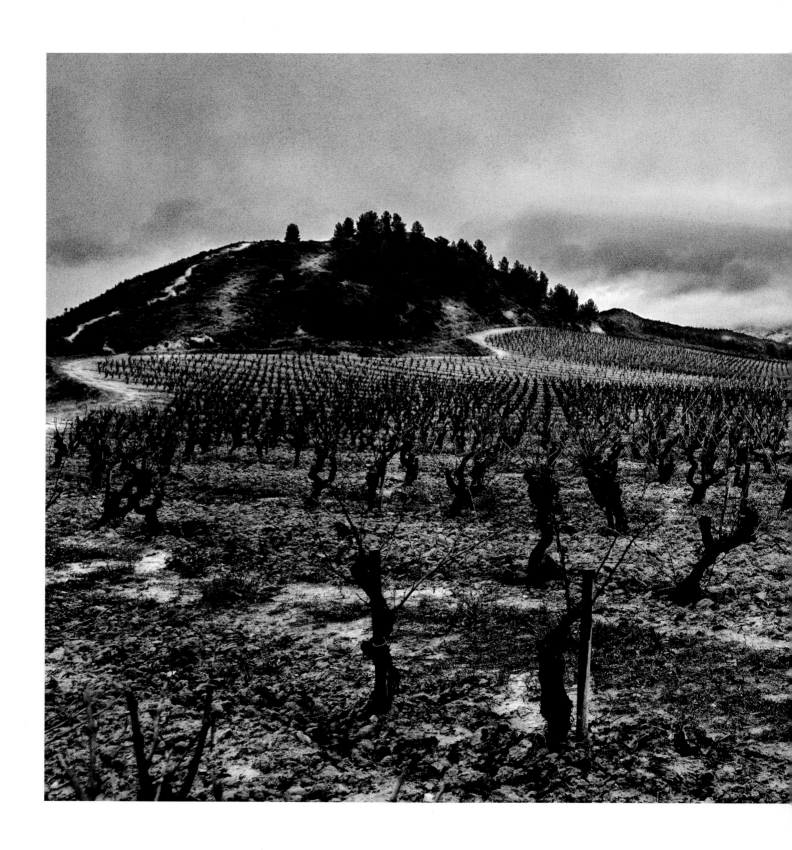

Being trendy without being so

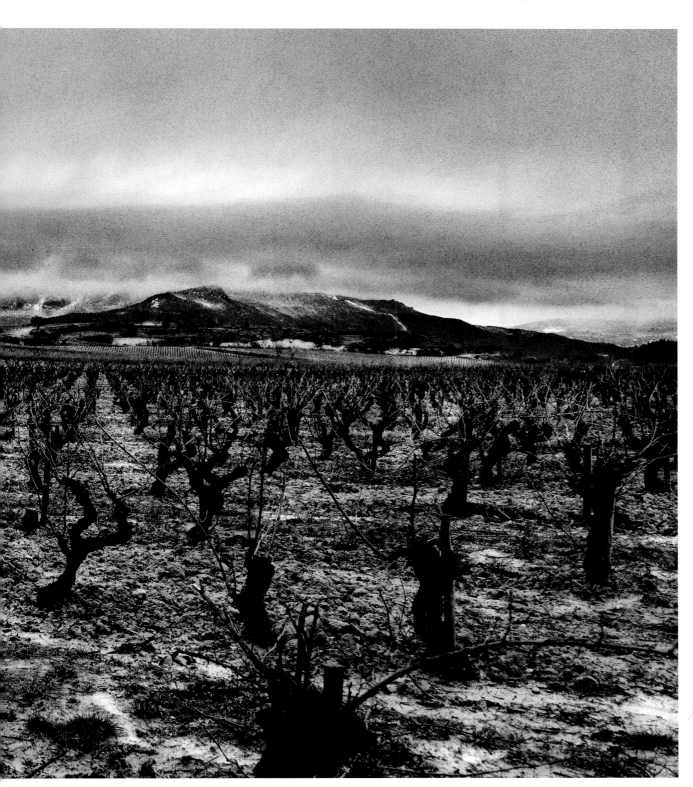

The vinyeards around Haro in Rioja Alta have lime in the soil, which also contains sand, clay, and silt deposited by the water of the Ebro river over time.

Her sister smiles as she shakes her head. She pours the wine into a glass and tastes it thoughtfully to see how it has developed over the years—and to make sure it's flawless. The tone between the two sisters is both loving and mischievous, and the little sister reveals one of the many tiffs they have regularly.

"My sister likes the wine too hot. I prefer it cooler."

Mercedes López de Heredia is a qualified engineer. So is their brother, with whom they run the family business together. Maria José López de Heredia herself studied law and theology. Both sisters have also been schooled in wine—unlike their father, grandfather, and great-grandfather.

When the children were young, their father taught them in his own Sunday school, which consisted of a walk in the vineyards to learn about the soil, the weather, the vines, and the grapes. No matter the weather. And back then the children hated it. It was also their father who later made it clear that their university studies were more important than working in the vineyard. They didn't always particularly like that either.

But their father's upbringing was in line with the core values that have permeated the López de Heredia family for a century and a half—that the family has obligations as citizens of society that go beyond making good wine. And that wine is a way of expressing yourself and your values.

It's with this starting point that the family came through two world wars, the Spanish civil war, and technological development to which it itself contributed. In the interwar years, in particular, López de Heredia made as much money from repairing race cars as from wine production. Don Rafael's two sons had a flair for mechanics and were specialists in Bugatti race cars.

Don Rafael was a visionary who used contemporary cutting-edge techniques when he began excavating the massive cellar beneath his vineyard. And in the cellar we come across machines, implements, and tools that the founder's descendants have created themselves, including a tool for digging up vines and another with some iron chains to transport the many wooden barrels around the cellar.

The three siblings played hide and seek with each other in the cellar when they were children. It can still take twenty minutes to find your way out if someone turns off the light. With its roughly 86,000 square feet, the cellar is gigantic—especially when you consider the winery "only" produces around 300,000–400,000 bottles a year. But every foot is needed because the fourth generation of the López de Heredia family is one hundred percent faithful to their predecessors' way of making wine.

A method at once remarkably simple and quite extraordinary.

A wine that develops true character

The cellar at López de Heredia is notable for its absence of steel tanks. Whereas most producers ferment their wine in such shiny tanks, here the freshly pressed grapes are stored in large oak vats where they ferment naturally with the help of microorganisms from the soil that both the wind and many insects have sprinkled over the grapes out in the vineyard.

After fermentation, the wine is poured into aged oak barrels where it matures for between three and ten years. Hence, the total of 12,900 barrels—each with a volume of 225 liters—in the cellar. And this is also the reason why López de Heredia has its own coopery where trained coopers make and repair the winery's own barrels from American oak.

During barrel aging, a very slow oxygenation process happens through the pores of the wood, which plays a vital role in the development of the wine. And this process continues when the wine is subsequently bottled, after which it goes through further multi-year aging where the complexity of the wine is further developed, and it acquires a smoother and softer structure.

All in all, this means that no wines from López de Heredia are released earlier than ten years after the grapes were harvested.

The philosophy of López de Heredia is that aging the wines is kind of pedagogical—whereby the wine is given peace and quiet and plenty of time to develop its character. The result shouldn't be a wine that tastes of oak, but rather a wine where all its components are in balance—and that process takes time and mustn't be rushed.

This approach to wine production is unusual, not least when it comes to the production of rosé wine. Fortunately, Grenache is the main grape in the rosé wines from López de Heredia—in the same way as, for example, it is in most popular rosé wines from Provence. But in almost every other area, this Rioja winemaker differs significantly from most other rosé producers—she merely shrugs at the new production techniques that have become more and more widespread during the past few decades as the demand for rosé increased considerably.

The differences are immediately visible in the vinification process where the grape juice is allowed to lie with the skin for a period of thirty-six to forty-eight hours—sometimes even longer. Through the maceration, some of the color from the skin is absorbed, and the wine gets more tannins. However, the skin is removed from the juice before actual fermentation begins.

At no time are the grapes to be used for rosé cooled—neither before the grapes are pressed nor during fermentation. The temperature in the tanks can be rather high, which means the grapes are more easily exposed to oxygen, which other producers fight so hard to avoid.

"We don't have temperature control, and people think we're crazy. But we make rosé the way we've always made it," says Maria José López de Heredia, who instead puts her trust in the quality of both the grapes and the natural yeast the grapes bring with them from the vineyard.

Being trendy without being so

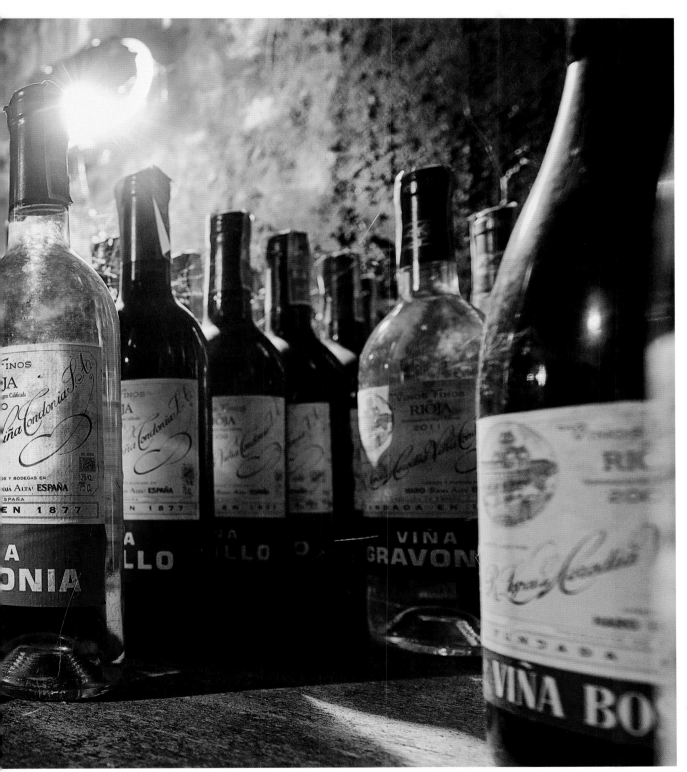

The inner room of the wine cellar is a treasure trove of the bodega's best wines. It's called the "cemetery"—a term used indiscriminately in Rioja today with "wine cellar."

Oxidation is enhanced by the fermentation taking place in large wooden barrels that are less airtight than steel tanks. This makes the wine less fruity, but in contrast, controlled contact with oxygen during wine production can produce more complex taste notes that contribute to making it a wine suitable to be paired with food.

Maria José López de Heredia wasn't brought up to articulate how a wine tastes.

"When we were younger and our father taught us how to make wine, we weren't allowed to describe the wine. The best wine was the one where you said, 'this is good.' So, the wine should be flawless. And there should be finesse and roundness. This is also what I look for in a wine today."

The rosé wine from López de Heredia is undoubtedly rounder in flavor than most other rosé wines, which is also a result of letting nature take its course here and not blocking the malolactic fermentation where the sharp malic acid in the wine is converted into a milder lactic acid. This "malo," as it's simply called in wine jargon, has gradually become almost a dirty word among rosé producers because some acidity, freshness, and fruit aroma are lost in the process. Then again, malolactic fermentation can help to stabilize the wine during aging and give it a creamier fullness when tasting. This is emphasized here in Haro where ten percent of the local white Viura wine grape is added to the rosé wine to keep the acidity level up.

"Maybe we have a little less freshness. But what you get is more important than what you lose," says Maria José López de Heredia.

However, the greatest difference between López de Heredia and other rosé producers is that rosé wine is not made every year.

"Let me die drunk and full"

Maria José López de Heredia draws us further into the cellar. She doesn't speak loudly because she was brought up with the belief there should be quiet in a wine cellar—having said that, she talks constantly and is always ready with a new story about the winery, the family, and herself. Now she says she's sure she had a past life. She knows a lot about the family business that no one has ever told her.

"For several years I told my brother there was a painting of our great-grandfather hidden somewhere. He shook his head, but one day we found it under some floorboards in the cooperage. I don't know how I knew."

For the same reason, she—a person brimming with life—is not afraid of dying.

"I know I'll come back. All I ask of God is to let me die drunk and full."

The mold on the walls is getting thicker. It can now be measured in inches. Porridge-like clumps of cobwebs and dust hang from the ceiling. We end in the cellar's innermost sanctuary—a treasure trove of the bodega's oldest vintages—and where usually only the family is allowed access. In the center of the room is a round dining table with a four-armed candelabra, all of which are covered in webs. Just above hangs a lamp with an electric bulb.

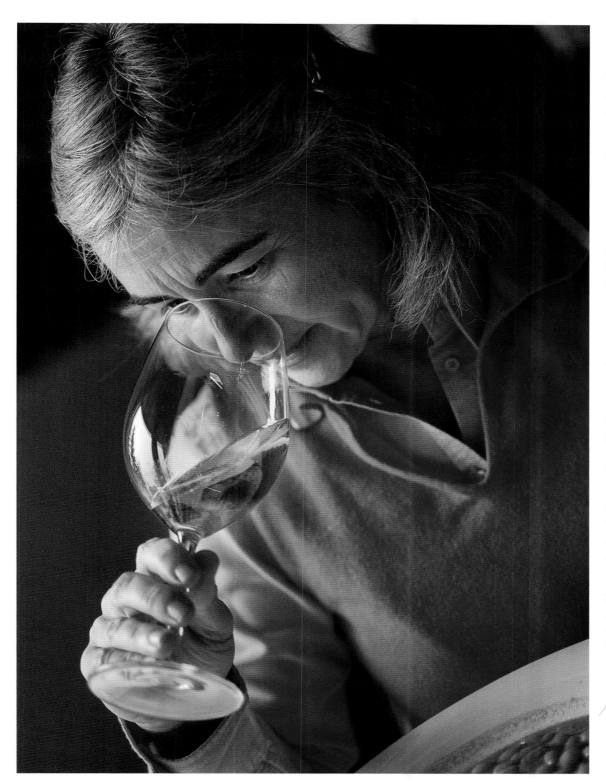

Maria José López de Heredia is a member of the international wine academy, Académie International du Vin, one of only eighty specially appointed people within the international wine industry.

"It's a problem when we have to change the bulb in the lamp," explains Maria José López de Heredia. "We have to be careful with the cobwebs because they're the best way to protect the corks in the bottles from being attacked by moths."

The room is a kind of family wine museum created by her grandfather. It was dubbed the "cemetery"—a term later used by other producers, and which today is so integrated into Rioja's vocabulary that it's often used as another word for "wine cellar."

The family meets here occasionally to have lunch. To taste their wines and share what's going on in their lives. The oldest wine in the cemetery dates to 1885. On another table stand several younger wines. It's almost lunchtime, and Maria José López de Heredia takes one of two bottles of 2010 rosé on the table.

Bottle in hand, we show up half an hour later at a local restaurant. And one of the first things we notice is a bottle of Spanish rosé wine on the neighboring table. Even though it's December and cold outside.

The Spanish rosé boom is sprouting

The Spanish share a long history with rosé wine. After its neighbor France, Spain is the country that produces the most wine in this category. It's predominantly wine at the cheap end, which hasn't garnered much recognition, but it delights many consumers. Among the larger Spanish wine regions, Rioja and Navarra account for the greatest quantity.

The focus has long been on volume, but more and more producers are starting to make wines that have more of their own style and reflect the area they come from—whether they are made from local or international grapes. This has contributed to a sprouting Spanish rosé boom.

At the restaurant, we meet another Spanish rosé wine producer. He's Maria José López de Heredia's husband, José Luis Ripa, who, in addition to being the commercial director of his wife's family company, also makes his own wine. A rosé made from grapes from a small vineyard in Rioja Alta—Garnacha and Tempranillo—and aged in oak barrels for eighteen months.

He's a little more concerned about the new trends emerging around the rosé category than his wife. José Luis Ripa would like López de Heredia to produce more rosé wines. But with a production time of ten years, it won't happen any time soon.

The 2010 vintage is soft and round, yet still a fresh wine with many flavor nuances and a hint of a sherry note that pairs well with the strong bean soup we're served as our first course.

The 2012 vintage is the latest. But then there will be a long pause because during the six vintages from 2013 to 2018, not a drop was made. Not enough of the Garnacha grapes harvested from each of those years was assessed as having the required quality. Only in 2019 did the rosé return, which means the next Viña Tondonia rosé from López de Heredia to hit the market will be in 2029—with a production of just 14,000–15,000 bottles.

"I don't want our wines to be among the most expensive. Those who know how to enjoy a wine should be able to, not just those who have money."

→ Maria José López de Heredia

The wines from López de Heredia are stored in barrels first and later in bottles. They need to have time to develop their character. No wines are released earlier than ten years after the grapes have been picked.

This is just one of the reasons why the rosé wine from Haro has become one of the world's most hyped in its category. American wine critic Robert Parker gave the 2010 vintage 96 out of 100 points, calling it "the finest rosé in recent times." In the retail sector, some wine vendors will only sell a single bottle of this cult wine if customers buy a minimum of six other wines at the same time. And at private wine auctions, the skewed balance between supply and demand has pushed the price sky-high.

This doesn't sit well with Maria José López de Heredia, who refuses to raise her prices—the result being the wine is significantly cheaper than many of the wines with which it shares a place on lists of the world's best rosés.

"I don't want our wines to be among the most expensive. Those who know how to enjoy a wine should be able to, not just those who have money."

Neither is she tempted to increase production. Doing so would break with the philosophy that has been the foundation of the family company for a century and a half.

"We've had our own style, our own personality, because we haven't been affected by trends or under commercial pressure to make such decisions. Somehow, we've always forced people to adapt to what we like, to what is our style—not the other way around."

Recognition means more than success

Back at the vineyard, we head to the office. Like everything else, it is as it always has been, we are told. Old heavy desks overflow with stacks of papers and books. In the middle of the room stands a distinctive heater designed by her grandfather. The same is the case with the ceiling fan. It's like a living museum, and the current generation of the López de Heredia family recognizes their duty to continue telling the story. It's almost as great a task as continuing to make the wine.

On a desk is a clipping from a newspaper stating that López de Heredia has recently won an award at an international gastro festival in San Sebastian for their collaboration with the restaurant world. In one of the drawers sits proof that Maria José López de Heredia is a member of Académie International du Vin, the international wine academy—one of only eighty specially appointed key figures within the international wine industry.

That recognition means more to her than the success of a rosé wine, which surprises her a little. It also worries her a little. She doesn't want the success to shift too much focus from the red wines that underpin López de Heredia. She admits this when, for the first time during the day, we sit down opposite each other and talk—without being distracted by something else at the same time.

"Honestly, we knew we were making a good rosé wine, but we didn't realize our rosé wine was 'something to die for,'" she says, laughing at the description of the wine.

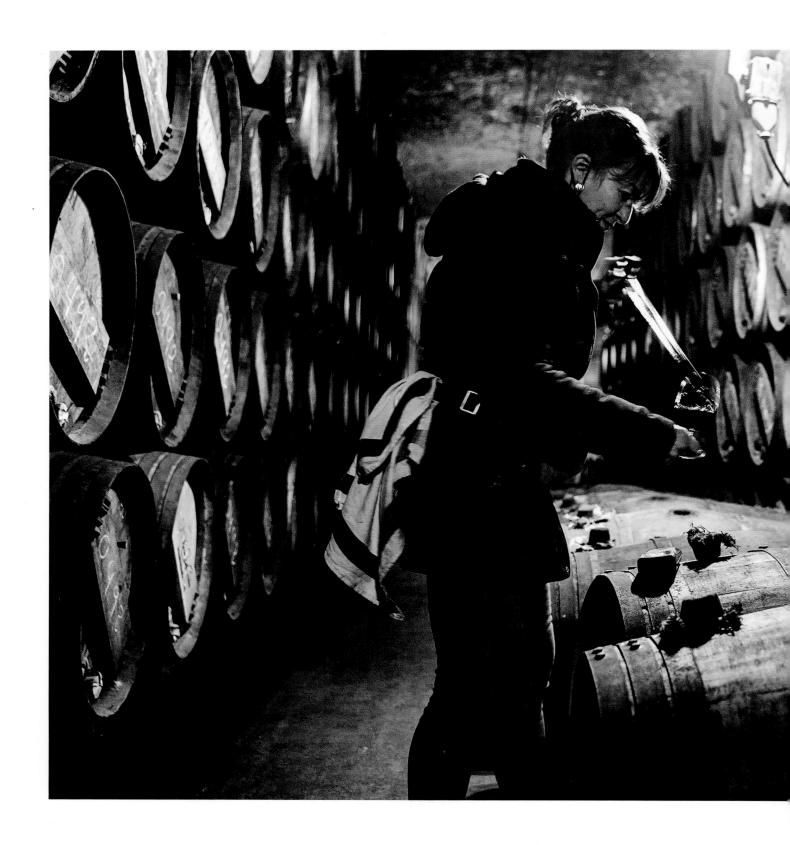

Being trendy without being so

The wine from 2012, which has aged in barrels for several years, has to be used in a blend. Mercedes López de Heredia tastes the wine to see how it has developed.

"I fear times of success because I don't feel in control. Having too much success isn't something we're used to. I don't actually like being successful."

Once again, she laughs out loud—acknowledging that if she has no greater worries than being behind one of the world's most sought-after rosé wines, then everything will all work out in the end. And she herself suspects—with good reason—that the increasing attention is also connected to how López de Heredia represents more fundamental, current values.

"We represent everything people are looking for—our wines are natural, organic, crafted. And we are authentic. In all the years we've never had a winemaker from outside the family, and I think that history is something people appreciate."

The day is drawing to a close, but Maria José López de Heredia suggests one last thing before we say goodbye. First, however, she divulges a little secret—she loves beer! And we're sitting in a beer bar in Haro's old town at the very end of the evening—fourteen hours after we first met in shelter from the rain—when she reveals her intention was actually to convince us to author a book that wasn't just about rosé.

"I have to admit that this morning—before I met you—my idea was to convince you that we should be the only red wine in your book on rosé," says Maria López de Heredia, lighting up once again with her infectious smile, behind which lurks both amusement and seriousness.

"It's interesting because our rosé will probably be the only rosé in your book that doesn't fit with the reason you wrote the book. Our rosé doesn't pretend to be trendy. But our rosé is certainly one of the most original rosés in the world."

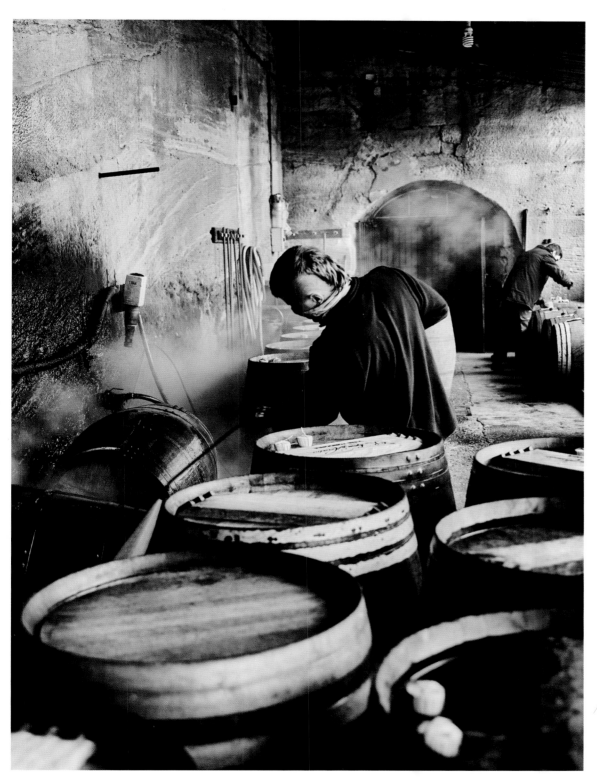

López de Heredia makes their own barrels from American oak. The large cellar holds 12,900 barrels—each with a volume of 225 liters.

The wines from López de Heredia are released after aging for a minimum of ten years first in oak barrels made by their own coopers and then in bottles. Aging gives the wines peace, quiet, and plenty of time to develop their character. They're stored in a cellar where mold contributes to a constant level of humidity.

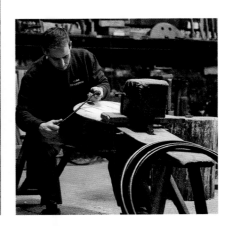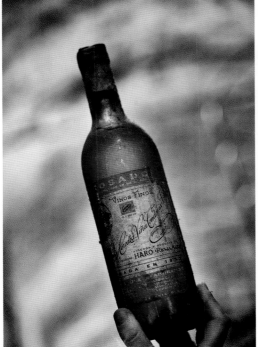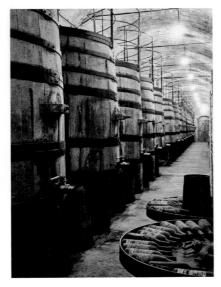

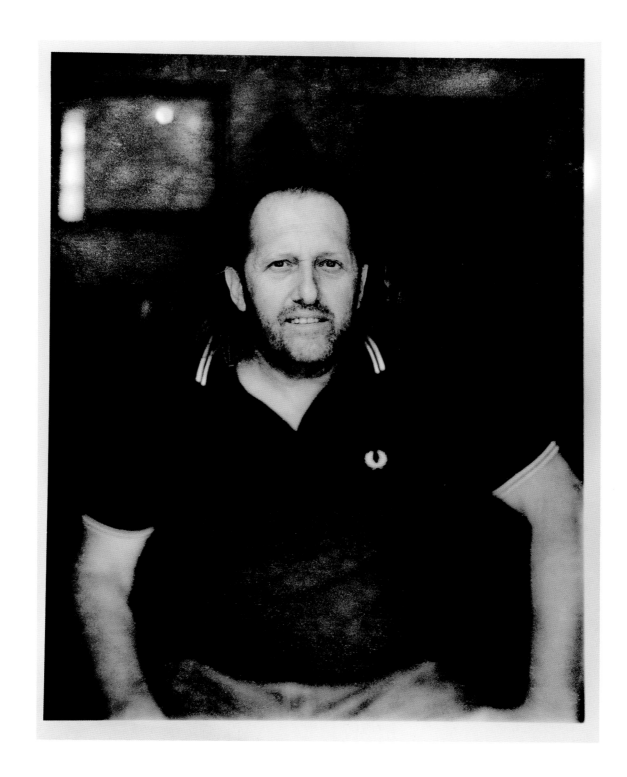

CA' DEI FRATI → IGINO DAL CIERO

The truth is in the wine—and it's pink

The truth is in the wine—and it's pink

A family-run vineyard in an Italian vacation paradise wants to make a rosé so good tourists won't forget it when they return to their everyday lives. The biggest problem is disappointing guests when the wine is sold out.

It's a Saturday in September, and the summer still has a little more to offer. A few women are sunbathing on a lawn between the restaurant's terrace and the lake. Out on the lake, some motorboats have dropped anchor and are bobbing dreamily on the calm water.

We've been shown to the middle table on the terrace—with a direct view of the lake. Large square parasols provide shade from the sun for the many patrons who would like to dine outside. Nine tables are occupied on the terrace. We start counting. One, two, three, four, five, six. Bottles of rosé stand on six of the nine tables.

We are at Lake Garda in northern Italy. Specifically, we are at Lugana di Sirmione on the southern coast, right on the border between Lombardy and Veneto. The Dal Cero family has invited us to lunch. The table was reserved without much difficulty as the family owns both the restaurant and the hotel of which it's a part. They are also the owners of Ca' dei Frati, one of the area's dominant wineries—and the largest producer of rosé wine. It's obviously a winning combination.

"The city is a romantic place, and rosé is a romantic wine. Many tourists come again," says Michele Maffizzoni, the son of one of the three siblings who now run the family business.

He even held his wedding reception at the restaurant with 130 guests when he married his Danish wife a few years ago. As did his sister, Sonia, who manages the restaurant and hotel. She tells us that one of the courses for their wedding dinner was fish paired with a rosé spumante.

Ca' dei Frati makes its income by creating good experiences, and their rosé wines perfectly complement the lifestyle around the lake. Anna Maria Dal Cero, mother of Michele and Sonia, reveals they have built up their position without spending a single euro on marketing. Instead, they take advantage of the area's ability to attract both Italian and foreign tourists—and do their best to ensure the tourists have a good experience with their wine while on vacation.

Imagine you return from holidaying in Provence with a desire to make rosé more than a wine you enjoy on vacation. Or perhaps you would like to relive the vacation with a glass. For that same reason, there's a direct correlation between the large number of German tourists at Lake Garda and Germany's position as Ca' dei Frati's most important export market.

A wine called Rosa

Visiting Ca' dei Frati is like playing an accordion constantly being pulled out and then pushed back in again. One moment, we're blown away by the grandeur and pomp characterizing the Dal Cero family's estate with production facilities of almost factory dimensions and a capacity for hundreds of visitors every day. The next moment, we're gripped by the closeness and intimacy embodied by the family, who, on a foundation of hard work, close relationships, and being down-to-earth, have created something much greater than themselves. And where family photos hang on the walls.

As we approached the large gate into the vineyard on the outskirts of Lugana di Sirmione earlier in the day, we saw the first sign. The tarmacked street in the city changes to a mussel shell-shaped pattern of stones that leads us through the gate and into a gigantic parking lot with twelve tall palm trees in the middle. To either side lie fields of vines with a delicate rosebush planted at the end of every other row. And in front of us rises a building that gives the impression of being a modern version of an old Italian monastery. The porch has arched vaults and columns. The style is rustic, but the construction is new, so it hasn't yet acquired a patina.

On the way in, we pass a sculpture of a large hand holding a globe with a ribbon wrapped around it. The ribbon bears the text "Il Mondo di Ca' dei Frati"—"the world of Ca' dei Frati." We enter a structure that looks like a nave—with ornate stone walls and a very high vaulted ceiling. In the center are showcases with internal lighting that reflect in the wine bottles on display. On both sides of the showcases, guests sit on wooden benches along narrow wooden tables on which are wine glasses and leaflets describing the wines being tasted. And on a white end wall, a film about the history of the winery and the family is playing.

It's a busy late summer day with many guests and a high level of activity. An older woman takes her time, leaning on a cane as she walks around. Her name adorns one of Ca' dei Frati's most popular wines—a rosé wine called " Rosa". A picture of her husband sits in pride of place on the wall.

His name was Pietro Dal Cero, and it was he who made the family's first wine. He took over the vineyard from his father who, just before the outbreak of World War II, moved from Verona to the area south of Lake Garda

Lombardy

↓

45°27'17.3"N

10°57'00.5"E

↑

16³⁰ CET

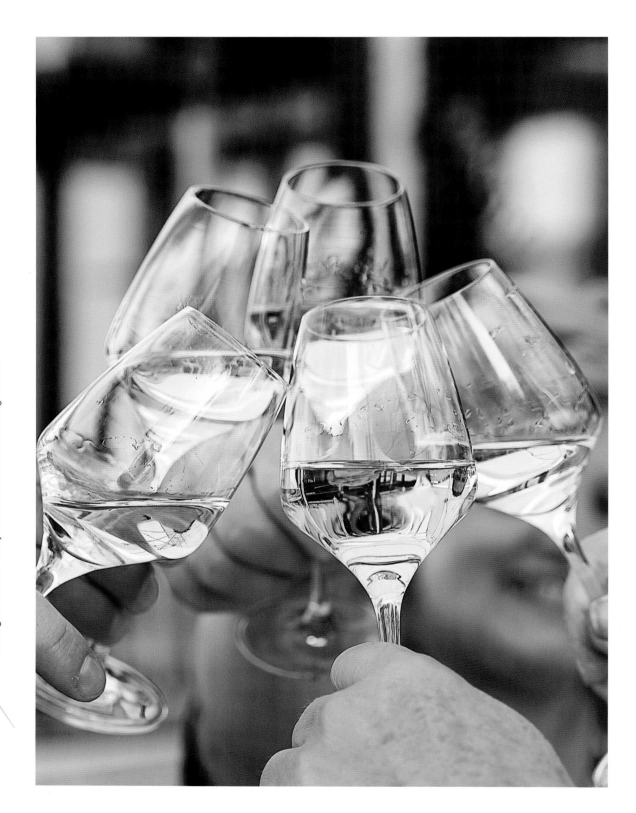

Ca' dei Frati earns its income by creating good experiences, and their rosé wines perfectly complement the lifestyle around Lake Garda. They take advantage of the area's ability to attract both Italian and foreign tourists.

The truth is in the wine—and it's pink

to make wine. He bought a small property of a few hectares, which in the fifteenth century had been a monastery whose monks also produced wine. Those monks and their monastery are the inspiration for the winery's newly restored buildings—they are also responsible for the slightly special name, which means "monks' house."

The family didn't sell its wine under its own name for the first three decades, but when Pietro Dal Cero took over, he implemented strategic changes followed by a thorough modernization of both the vineyards and the cellar. He was one of the first producers in the area to focus on quality over quantity, and it was largely to his credit that in 1967 the Lugana wine region received its own DOC classification.

The Italian system for classifying wines is strongly inspired by the French AOC system. Therefore, when DOC is printed on a label, it means it's a wine from a carefully defined area and with very specific requirements for grape varieties and composition, harvest yield, and alcohol strength, for instance.

Initially, Lugana was given a classification for its white wines. And in 1980, recognition followed for the local rosé wines, which also receive the wine authorities' seal of approval if they fulfill certain criteria.

Personality in the bottle

We have been invited into the innermost sanctuary of the winery—the original buildings from when the family moved here. In the corner is a small bar with a tap—it's the house's old kitchen. A door next to it is the one the monks used 500–600 years ago for going down into the cellar. On a shelf are old copper jugs, one of which has some huge dents. And up an internal staircase are the family's original bedrooms, which today house the office of Igino Dal Cero.

He is the middle of the three siblings who now run Ca' dei Frati, and it's he who is responsible for the family's wine production—trained by his father, who let him make his own first wine at the age of seventeen.

"My father was a good teacher because he gave me the opportunity to make mistakes. He gave me the keys and said, 'go out and try,'" says Igino Dal Cero.

Since then, production has increased immensely. His elder sister, Anna Maria Dal Cero, still remembers the time in 1969 when she was only ten years old and her father took her to the city of Brescia to register the first wine under their own name. From then on, she continued to help her father with the administrative work, and today she's head of administration. Similarly, the youngest of the three siblings, Gian Franco Dal Cero, had barely learned to walk before he was running around the vineyards—he is responsible for the vines and ensuring the best grapes.

In the late 1960s, the family owned ten hectares. Currently, Ca' dei Frati has a total of 240 hectares—and has a production of almost four million bottles of wine a year. The latest acquisition is some high-lying fields with red grapes, which will be used for the expanding production of rosé wine. Ca' dei Frati primarily makes white wine, but about twenty-five percent of the wines are rosé—which means they make about the same number of bottles as Domaines Ott in Provence.

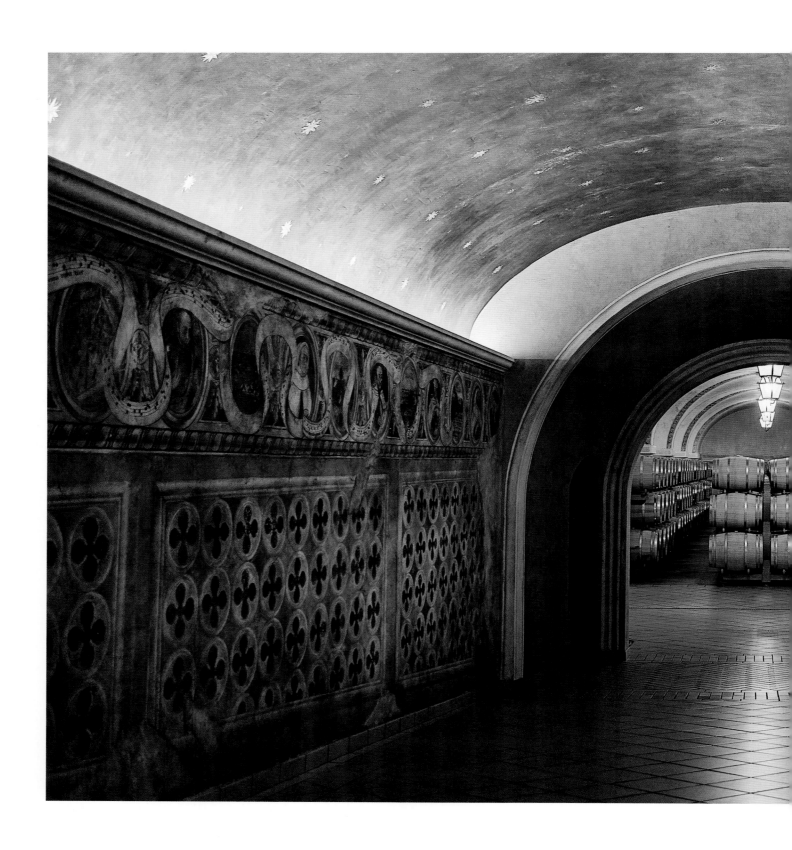

The truth is in the wine—and it's pink

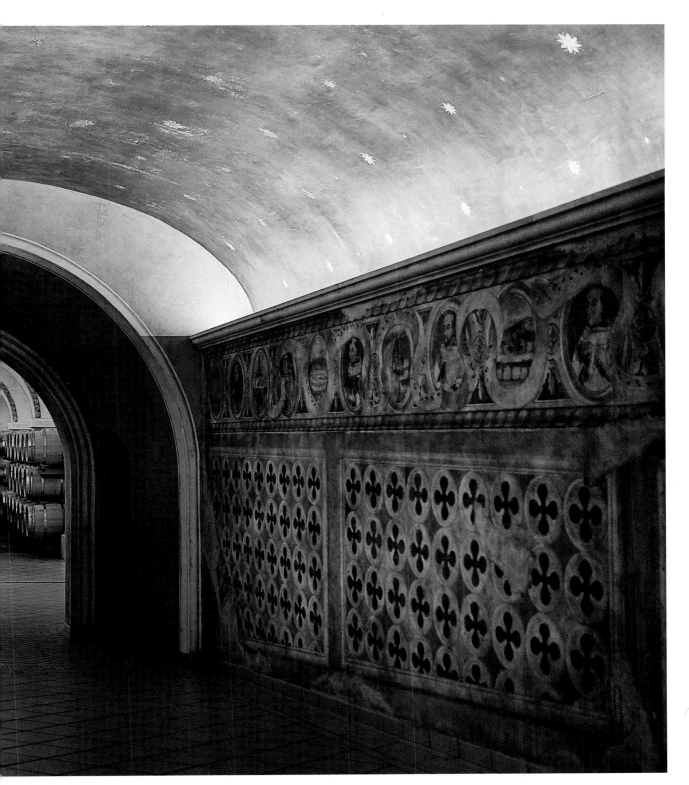

Back in the fifteen century Ca' dei Frati was a monastery whose monks produced wine. Those monks and their monastery are the inspiration for the vineyard's buildings.

"We're growing. We would like to make more rosé because the demand has grown enormously in recent years. We buy more land and grow more red grapes for rosé. But we have to do it slowly and in the right way," says Igino Dal Cero.

He emphasizes that being able to offer this wine in their wine catalog has always been an important part of Ca' dei Frati.

"My ambition is to give the wine personality—it's the most exciting part of my work and also the most challenging. As a winemaker, you always have to give something of yourself," he says. "I never follow trends when I make wine. I make wine the way I like it, and the consumers can choose whether they want our wine or wine from other producers. If you just follow the market, you will lose your identity."

Understood by many

Italy is the biggest wine producer in the world. Throughout the country, rosé wine—or *rosato*, as the wine is called in Italian—is also produced, with Abruzzo, Puglia, Veneto, and parts of Lombardy the primary centers of power. The boot-shaped country experiences different climates, which makes it difficult to talk about a specific type of rosé wine encapsulating the entire country. But the conditions for making the wine are good as most Italian vineyards are either by water—by the coast or close to a lake—or at an altitude that helps with the intense summer heat.

On the southern shore of Lake Garda a cool northerly wind helps give the grapes acidity and freshness. The lake softens the climate and makes the land fertile. It provides good conditions for making *chiaretto*, which in the regions of Lombardy, Veneto, and Piedmont is a term for pale, dry rosé wines that have many similarities to the Provence wines of neighboring France.

Igino Dal Cero believes there is a direct correlation between the increasing demand for rosé and the fact that more and more producers are taking the category seriously and making an effort to constantly improve the quality.

"Rosé has been around for years, but it wasn't so good before. Now many producers are working hard to improve the rosé wines," he says. "People are increasingly looking for good quality, and many are switching to rosé because they're beginning to understand the wine better. They understand that the wine is special."

The general trend among many rosé wine producers worldwide is shorter or no maceration and an increased effort to avoid oxidation, which affects both color and freshness. Moreover, some choose to harvest their grapes early to ensure a high level of acidity. But for Ca' dei Frati's winemaker, it's crucial to pick the grapes only when they are ripe—otherwise the wines won't have the fruit flavor he wants. It would be like drinking the juice of a sour, unripe apple.

"The secret is to pick the grapes at the right time. The flavors and aromas will be right if you pick the grapes when they are ripe."

"People are increasingly looking for good quality, and many are switching to rosé because they're beginning to understand the wine better. They understand that the wine is special."

→ Igino Dal Cero

In vino veritas

Michele Maffizzoni and his brother-in-law have taken us out to Monte Mario—Ca' dei Frati's new, forty-three-hectare field, perched on a hilltop. The grape variety is Groppello, Lake Garda's answer to Pinot Noir—and which will make up at least fifty percent of the rosé wine. The other grape varieties in the wine are Marzemino, Sangiovese, and Barbera. He tastes the grapes and nods.

"They're ready. They have the right sweetness, but still a good acidity too."

The harvest is ready to begin on Monday, just two days from now. It must be done by hand-picking to prevent the grapes from being destroyed and starting to oxidize—which is why a team of forty people is ready to get started on Monday morning.

Back at the winery, we go down into the cellar, which actually consists of two sections. The first was established in 1990, the second twenty years later to accommodate the increased production—and as with the entire newly renovated winery, it too is built on the foundation of the growing success of recent decades.

In the doorframe of the old entrance to the cellar, we pass a mural. It's all that remains of the original building. It depicts a monk sitting and writing in a book—with a pen in one hand, a wine glass in the other, and a bottle in front of him, which bears exactly the same design and label as Ca' dei Frati's wine bottles do today.

In vino veritas—the truth is in the wine—is written at the bottom of the painting. And if it is true, then there is a great deal of truth to be found here in the extensive and fully automated cellar where up to 40,000 bottles are bottled every day from March to October and packed in boxes of six without human intervention. Almost half of the boxes are exported abroad—to sixty to seventy countries with as much as seventy percent exported to Germany.

The size of production becomes evident in a completely new way as we emerge from the cellar and into a large storehouse where forty gigantic, shiny steel tanks stand next to each other in five rows. The characteristic smell of yeast from the fermentation hangs in the air.

"That's how we smell." Michele Maffizzoni laughs as fortunately he has gotten used to the smell. As his uncle's right-hand man in wine production, the family has appointed him responsible for taking over the wines one day.

Most of the large steel tanks are empty, waiting to be filled when the harvest starts next week. As for the grapes for rosé wine, things are going to move fast. The grapes must go from the field into the vineyard as quickly as possible and then immediately into the press, possibly after a brief cooling, depending on the temperature in the field.

"As the grapes are ripe, they already have all the characteristics we need. This means that we can simply press them to get all the grapes can give us," says Michele Maffizzoni.

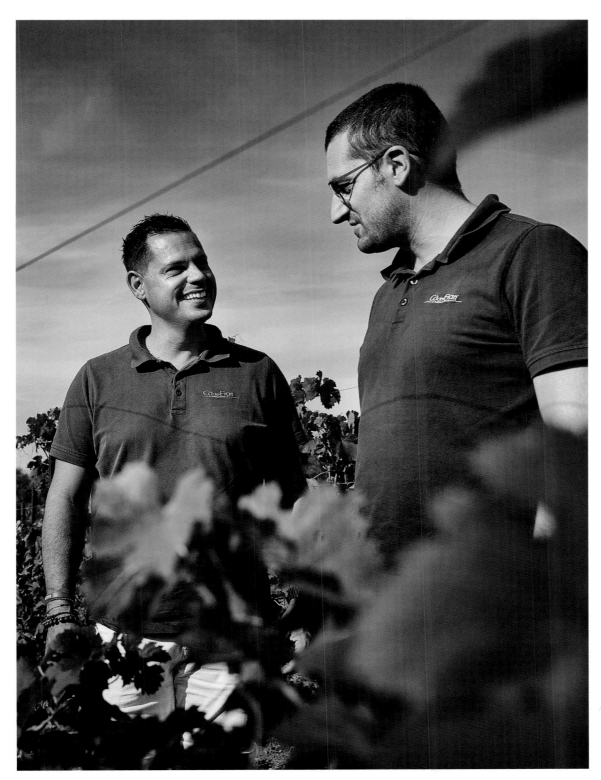

The latest acquisition is some high-lying vineyards with blue grapes for the production of rosé wine. The grape variety is Groppello,

Lake Garda's answer to Pinot Noir.

Ca' dei Frati produces a spumante rosé too. The yeast settles at the top of the bottle, which is later frozen, so the lees can be pushed out with the help of the pressure from the carbonic acid.

At Ca' dei Frati, they press the grapes three times. The first press gives elegance with a juice with little color and high acidity. The second press brings structure and more aroma. The skins come into play more in the third press—the quantity of tannins increases while the quality decreases, but the wine from the juice can be used as a more neutral wine after being cleaned and filtered. And about twenty percent of the grapes aren't harvested until October—which means the grapes from the late harvest are riper and give more sugar and a darker color.

The juice from each pressing, including that from the late harvest, ferments separately—without the use of industrial yeast but with the blocking of the malolactic fermentation. This is done so they can blend the different wines and hit the profile Igino Dal Cero wants—with fruit, freshness, and a perfect balance between sweetness and acidity.

"It's more important to make the best possible wine every single year than to make exactly the same wine year after year. But I worked on finding this flavor profile, with a bit of tannin and good acidity, for a long time," says Igino Dal Cero, who also makes a sparkling version of his rosé wine—a spumante that stays on the lees for twenty-four months.

Despite the increasing production, he makes less rosé each year than he can sell. He could probably sell twice as much as Ca' dei Frati typically sells out of the year's rosé in August, just four months after it goes on sale. This was also the case this year. Much to the frustration of the many guests who come to visit—we can even feel it here in September. A "sold out" sign has been placed on the rosé bottles in the winery's boutique.

"We're proud of the wines we have, and we believe we have the right balance between price and quality. We could easily raise the price and still sell it all. But then some customers would think we're just doing it to get rich," says Anna Maria Dal Cero.

"The secret is grapes at the right flavors and aromas if you pick the are ripe."

The truth is in the wine—and it's pink

to pick the time. The will be right grapes when they

→ Igino Dal Cero

The truth is in the wine—and it's pink

On a foundation of hard work and close family relationships, the Dal Cero family has created something greater than themselves. The family also owns two hotels with restaurants.

Quirky transparent bottles

Experiencing rosé wine begins even before the wine is opened.

Many of the wines stand out due to their bottles, which have distinct designs and quite often very creative wine labels. The bottles are transparent too, allowing us to be attracted to the alluring color of the wine even before it's poured.

Along with dessert wines, such as Sauternes, rosé is the only type of wine generally bottled into colorless bottles. Almost all producers follow this rule. And they do so even though it's not at all good for the wine.

It's a paradox that rosé—considered by many to be a summer wine, often drunk when the sun is shining—can't tolerate being exposed to light. UV rays break down the color of the wine, turning it brown, and giving it a flat taste. Therefore, in theory, there is a greater risk of rosé wine being damaged en route from the cellar where it was bottled, to the drinker. And it's also because of the sun's rays that the rosé in a glass, which has been on a table outside for a while, changes color and looks far less appetizing than when it was first poured.

Originally, the popular Mateus rosé from Portugal, which got its breakthrough with American soldiers in Europe during World War II, was bottled in its characteristic flat, rotund bottle shaped like a canteen—that was green. You can see it in an iconic picture from the 1970s where music legend Jimi Hendrix is drinking the wine straight from the bottle. At the time, Mateus' rosé was one of the most popular wines in the world but demand fell as rosé developed a bad reputation. In an attempt to make a comeback, the wine was reintroduced in a transparent bottle in 2015, thereby meeting the wish of many consumers to be able to see the wine in the bottle.

But there is no rule without at least one exception. The Provence producer Clos Cibonne, which in some circles has achieved cult status for its gastronomic rosé wines made from the old Tibouren grape variety, has deliberately chosen to market itself by going against the grain. Clos Cibonne is one of very few wineries to bottle the wine in a dark bottle—and has also opted for a label with an archaic look, going against the trend of brightly colored, quirky labels on rosé wines.

Many of the labels are pure works of art, which help to brand rosé as a modern wine that spreads fun and joy. And it's certainly fair to assume that many consumers have taken a bottle of rosé off the shelf of their wine shop or supermarket because they liked the label.

But not only that. Many producers choose to bottle their rosé in bottles with distinct designs. One of the first to do so was René Ott—son of Domaines Ott's founder, Marcel Ott. In 1932—inspired by an amphora found at one of Domaines Ott's estates in Provence—he designed the special bowling-pin-shaped bottle that to this day is so very characteristic of all the wines from the legendary rosé producer.

PERRIER-JOUËT → SÉVERINE FRERSON

Rosé corks popping in Champagne

Rosé corks popping in Champagne

Champagne is a drink of celebration— the bright pink bubbles add to any festive occasion. Today, rosé cuvées are among the world's most expensive and sought-after, which has helped the rosé category on its way to the top.

The street is said to be the world's most expensive. A statue of the Benedictine monk Dom Perignon, eponymous with a most famous Champagne, adorns the square in front of Moët Chandon. Just one of the many Champagne houses that are neighbors on both sides of the Avenue de Champagne in Epernay. The large, beautiful buildings send a clear signal of exclusivity and wealth. But the true valuables are below ground where Champagne worth billions of dollars is stored in mile-long subterranean passages.

Perrier-Jouët owns six miles of galleries, running on three levels, twenty-two-, forty-five-, and sixty-nine-feet underground respectively, connecting the Champagne house's three addresses on the famous street in one of the main cities of the Champagne region. Thick walls of lime ensure the right temperature and humidity in the cellar. The walls are damper than usual because it's been a particularly wet summer this year. From the ceiling hang lamps with sodium bulbs, emitting a warm and soft light that protects the wines.

The oldest wine in the cellar is also the world's oldest Champagne. Dating from 1825, it's locked behind an iron gate at the end of a passage. Only two bottles of it remain. A bottle from 1874 was recently sold at a Christie's auction for £42,875 British pounds sterling—roughly $53,000 US dollars. Not for the money, but to create awareness around the brand.

Champagne

↓

49°O2'33.8"N

3°57'39.5"E

↑

8³⁰ CET

Rosé corks popping in Champagne

The 2012 vintage still have the capsules on. The dead yeast cells—or lees as they are called—have collected on one side of the still horizontally-lying bottles. The vintage cuvées of the great houses typically spend around ten years on the lees before being sent to market, and soon it will be this wine's turn to go through the usual process where the sediment is collected in the neck of the bottle, frozen, and shot out using the pressure of the carbonic acid in the bottle.

We've climbed the fifty-six steps from the basement and are now at the library in the main building a few minutes before our meeting. In front of us is a heavy door with an enamel handle. We're about to go in but are asked to wait. It contributes to the solemn, almost meditative, atmosphere that already characterizes the house where everyone speaks in subdued tones and their movements are gentle and measured. It only stimulates our anticipation of what is awaiting on the other side.

At the agreed time, the door opens. It's opened from the inside by a woman who signals with a nod and a discreet smile. Slender in physique, but with an expression that has power and intensity, she welcomes us in, opens our meeting with the ritual of small talk—and then asks us to take a seat at two tables set with six glasses, a bottle of water, and an hourglass-shaped spitting tray of freshly polished steel on each.

It's late morning on a November day. Outside, the sun is low, and through the floor-to-ceiling windows, it casts its rays on the tables with the still-empty wine glasses and onto the back wall where faded reference books line the shelves of built-in cabinets with glass doors. The uppermost rows of books can only be reached with a wooden stepladder made of the same light wood as the cabinets.

It's the records of the entire history. The oldest books have dates from the nineteenth century on their spines. Over the years, various cellar masters have kept detailed notes on their wines by hand of what characterized the vintages, which grapes were blended in the wines—and on who bought the wines too.

Since 2020, our host, Séverine Frerson, has kept the record books of Perrier-Jouët. She is only the eighth cellar master of the house, which was founded in 1811. And the first woman ever to manage the Champagne house's exceptional style that depending on taste can be described as both conservative and timeless—and which is characterized by light, feminine wines with florality and elegance.

In the journal from 1841, we find proof that this was the year Perrier-Jouët made its first rosé champagne. And in the most recent books, Séverine Frerson's notes document that today the rosé cuvées belong to the Champagne house's most popular and expensive wines—and that increasing demand is leading to more bottles of rosé champagne being produced year after year.

It's a challenge the cellar master is happy to accept. For here she has greater opportunities to make the best wine. She has to focus as much on the wine's color as on its aroma and taste so as to succeed with a product that attracts consumers and contributes to the commitment that Perrier-Jouët has made to itself over the years—to put aesthetics first. This is where the rosé champagne is playing an increasingly important role for the Champagne house.

For Séverine Frerson, tradition and renewal are complementary aspects, and she herself calls Perrier-Jouët's vintage rosé "the most surprising interpretation" of the Champagne house's traditional style.

"Making rosé champagne is more complex than making regular champagne," she says. "If it was a piano, there would be more keys to play on. For me, it's a complicated and challenging process that also offers more opportunities to make different wines. I like that."

Those words are a remarkable tribute to rosé from the cellar master of one of the oldest and most iconic Champagne houses. And they are also a tribute that comes not just from her. For whereas still rosé wines continue to struggle to fully achieve status and recognition, the rosés of the Champagne houses have been in possession of them for some years now.

In fact, rosé is the greatest success in Champagne in recent times. Even after years of rapid growth in rosé champagne, sales of rosé are still growing far faster than sales of white champagne. Indeed, the pink prestige cuvées can be up to twice as expensive as the whites.

Champagne is a drink of celebration—the bright pink color and the red fruit notes from rosé add *je ne sais quoi* to any festive occasion for many people. But the rosé wines have also helped the Champagne houses expand their horizons, for example when it comes to pairing food with wine. And the success of rosé champagne has been a great source of inspiration for several contemporary producers who made still rosé wine an immensely popular drink.

"The Yellow Widow" blended red wine with champagne

In the old days, rosé champagne was viewed as something impure—something best avoided. In the time of the wine-loving Sun King, Louis XIV, in the 1600s and 1700s, the majority of vineyards in Champagne were planted with blue grapes, and the grapes were often shaken so much during transport from the vineyard to the cellar, where they were to be pressed, that oxidation started. The result was a pink and not a white champagne, which was in demand by the royal court, and where anything other than a white champagne was considered poor craftsmanship.

Even when oxidation was better controlled later, all Champagnes had a touch of pink to them. The color came from the skin contact during the pressing of the grapes. But with improvements in technology, it was possible to make the color paler. As the blue grapes have a colorless juice, it's possible to make wine from the grapes that's completely white or very light pink—especially if the grapes are only exposed to light pressure. Today, for example, when you talk about a Champagne that is *blanc de noirs*—i.e. "white of black"—it's a sparkling white wine made from the dark grapes, Pinot Noir and Meunier. Other Champagnes are wholly or partly made from the white Chardonnay grape.

A white grape, however, also contains tannins, which can give a yellowish-brown color—this is what you see, for instance, in orange wines where there's contact between skin and juice during the initial hours of fermentation. Therefore, in Champagne, there is an extremely high focus on pressing all the grapes without any skin contact or oxidation occurring. For the same reason, Champagne is one of the few wine regions where harvesting by machine is prohibited. Here grapes are collected in relatively small containers, so they don't get crushed, and then it's about getting them to the press as quickly as possible.

Ruinart was the first Champagne house to deliberately enter the market with a rosé wine that hadn't been colored by mistake or due to poor craftsmanship. That was back in 1764, which is documented in the house's own records from that time. And Veuve Clicquot—"The Yellow Widow"—was the first Champagne house to export a rosé champagne a few years later.

Madame Clicquot was an innovative young woman who married into a French Champagne family in the late 1700s. But just a few years later, her husband died of typhus and as a widow of only twenty-seven, she assumed running the entire production—despite not having much understanding of it at the time. But the young widow was sharp, and she is considered to be behind the world's first vintage Champagne—a Champagne made exclusively from grapes harvested in the same year. That was 1810. Only eight years later she made an improvement that revolutionized wine making. And which has been absolutely crucial for the type of rosé champagne most popular today.

Back then, rosé champagne was created by adding a fruit juice, for example from elderberries to the wine. However, Madame Clicquot wasn't particularly enthusiastic about that. Therefore, she found herself blending some of her own favorite red wine into the house's traditional blend. The result was a rosé with a fruity and full-bodied expression, which also means that to this day it's taste, aroma, and color that determine the quality of a rosé champagne.

The method of mixing red wine into the white wine is called *rosé d'assemblage*, and it's only permitted in the Champagne region. When it comes to still or sparkling rosé wines from other regions, it's forbidden to make the wines by blending a little red wine with the white wine—whether the white wine is made from green or blue grapes. Therefore, pertinent to all places other than Champagne is that rosé is essentially made from blue grapes, possibly with a small proportion of green grapes added, and the wine gets its color from contact between the juice and the skins of the grapes during pressing—and possibly a little more by maceration.

But in Champagne they have other options—thanks to "The Yellow Widow." And when red wine is added to the white Champagne, the wine typically gains some intensity and notes from fresh red fruits. It also gets more structure, more tannins, and a greater aging potential, which are just some of the qualities that make rosé champagne very suitable for pairing with food.

Rosé champagne is playing an increasingly important role for Perrier-Jouët, which focuses on the aroma, taste, and color of the wine so as to succeed with a product that also puts aesthetics in pride of place.

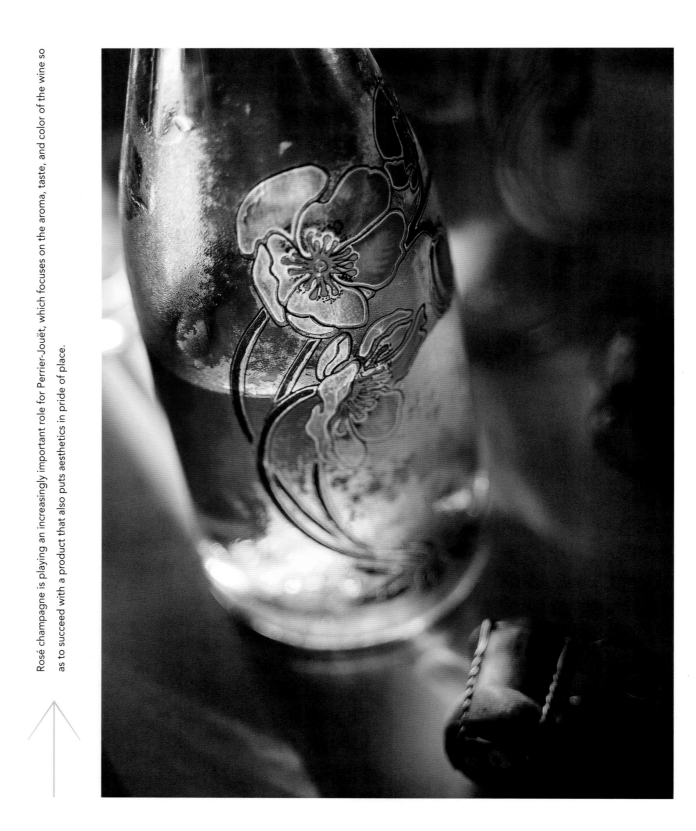

Rosé corks popping in Champagne

White anemones on the bottles

Maison Belle Époque, the main building of Perrier-Jouët, is a three-winged mansion with a driveway paved with small cobblestones in neat patterns around a large flowering bush. Inside, the building is like a living museum—a symbol of the passion for art, nature, and Champagne that the house's founders, the couple Pierre-Nicolas Perrier and Rose-Adélaïde Jouët and their descendants, were driven by. And now, more than two hundred years later—when Perrier-Jouët is owned by the beverage group Pernod Ricard—that passion is still what gives the house and its wines its distinct profile in a category shared with some of the world's most exclusive brands and wines.

Particularly in the years around the turn of the last century—in the European Golden Age, which gave its name to both the Champagne house's main building and its vintage wines—Perrier-Jouët's relationship with art gained momentum. At that time, the third generation of the family established strong relations with the contemporary artistic movement in Paris, Art Nouveau. Maison Belle Époque is a testament of this relationship—with over two hundred pieces, it houses the largest private collection of Art Nouveau in Europe.

On one of the walls hangs a cabaret woman painted by Henri de Toulouse-Lautrec. The entrance to a reading room with its upholstered chairs was designed by Hector Guimard, who also designed the original entrances to the metro stations in Paris—and the similarity is clear. The furniture was designed by Émile Gallé, one of the most prominent Art Nouveau artists. He worked with glass in particular and was closely associated with Perrier-Jouët. In 1902, he designed the white Japanese anemones that adorn all the bottles of the house's vintage Champagnes.

In the salon stands one of the few works not from the Art Nouveau movement—a bronze statue by the French sculptor Auguste Rodin. The words "Au Patron"—"to the boss"—are written on the statue, which was a gift from the employees on the occasion of Perrier-Jouët celebrating the house's first one hundred years in 1911.

In a dining room, waiters are preparing for lunch. Seven places are set around the oval dining table with a white tablecloth and vases of roses and anemones. Soon, a seven-course meal will be served, put together by the three-star Michelin chef Pierre Gagnaire, who collaborates with Perrier-Jouët. And one of the three wines served is the house's vintage rosé, Belle Époque Rosé, from 2010. It is to accompany the dessert—macarons with grapefruit, Champagne granite, and poached pear.

In the library, a few rooms away, an assistant is about to pour wine into our glasses but is stopped by Séverine Frerson. She insists on tasting the wine herself first—to ensure the wine isn't corked or been damaged in some other way, due to being exposed to light, for example.

We also taste Belle Époque Rosé 2010, the last of the six wines. Before that, we tasted the 2012 and 2013 vintages—some of the most recently released vintage rosés—as well as the house's standard rosé, "Blason Rosé," a blend of wines from different years.

But first, two wines made especially for the Japanese market are poured into our glasses. A spring and autumn edition based on the house's white vintage Champagne from 2015 and 2012 respectively, both with added red wine. The spring edition has a fresh scent of a blossoming cherry tree while the autumn edition has more red fruit and a note of ginger in the aftertaste.

The two wines are sold exclusively in Japan and offer something of a nod to Japan as Perrier-Jouët's most important export market and the general Japanese enthusiasm for rosé. The slightly pale, floral wines as well as the house's focus on sensuality and aesthetics have proven to be a good match with Japanese mentality, culture, and gastronomy.

"In Japan, we work very hard to combine food with our wines. The Japanese love our style, which goes well with their cuisine. Especially, their fish dishes, for example white fish or fresh fish as in sushi," says Séverine Frerson.

She herself believes the increasing demand for rosé champagne is explained by the fact that more consumers have opened their eyes to such wines not just being a festive apéritif wine that looks good. It's an epiphany that didn't happen of its own accord.

"It's our job to demonstrate that Champagne is more than a mere welcome drink or accompaniment to dessert. We believe that Champagne can be drunk with an entire menu, and therefore we have different wines that pair well with different dishes. For example, our rosé champagnes pairs perfectly with veal, or BBQ dishes with some sweetness, and even cheese too," says Séverine Frerson.

Rosé is romance and glamour

In the happy decades at the beginning of the twentieth century—just before the Great Depression—there was huge demand for sparkling wine, and many Champagne houses began to prioritize rosé champagne more. However, its popularity declined sharply in the 1940s when Madame Bollinger, head of the leading Champagne house of the same name, stated that "champagne is white."

Then again, when the producer Pommery made a pink champagne for the coronation of the British Queen Elizabeth in 1953, it had the opposite effect. It contributed to the phenomenon that continues to this day—that rosé is associated with romance and glamour, for example Valentine's Day. It's also a symbol of excess luxury—The Eagles even sang about its decadence with the lyric "pink champagne on ice" in their classic hit "Hotel California" from 1976.

From the 1960s, most Champagne houses have offered rosé as part of their repertoire. Where the share of total production was previously down to around two or three percent, for some producers today, it's up to ten to fifteen percent. And for several Champagne houses, rosé wine has been decisive for their current status.

Rosé corks popping in Champagne

"I use my passion, my memory, and my intuition. I have confidence in myself and feel no pressure. Making wine is a feeling for me. And it comes easy to me."

→ Séverine Frerson

Rosé corks popping in Champagne

This applies, for instance, to Billecart-Salmon in Mareuil-sur-Ay, about four miles from Épernay. A family-owned Champagne house founded in 1818, it's now run by Mathieu Roland-Billecart, who is seventh generation. They have almost always made rosé wine here, but it wasn't until around 1970 that they came up with the slightly lighter and fresh Chardonnay-based version, now their signature wine—and focal point of the house's success, especially over the last twenty to thirty years.

For despite the Billecart-Salmon Champagne house being more than two hundred years old, in the past it didn't enjoy the status and recognition it does today. But when the house rolled out a new strategy in the 1990s to become a more exclusive brand, it was the rosé wine that opened the doors of the best hotels and restaurants. Typically, restaurants offered a single Champagne that patrons could buy by the glass. The breakthrough came when Billecart-Salmon succeeded in getting several hotels, restaurants, and bars to do the same with their rosé champagne. The strategy was to send bottles to some of the most recognized establishments, and when the Hôtel de Paris in Monaco then asked for more bottles, they knew they were on the right track.

"That was how more people got to know Billecart-Salmon," says Mathieu Roland-Billecart. "We weren't the only ones, but we contributed to the growth of rosé in Champagne. And it grew much bigger after this."

The rosé champagne thereby helped Billecart-Salmon move up a rank in the hierarchy of Champagne houses. Ever since then, the rosé wine, which is also made as a vintage champagne, has been their crowning jewel, and to this day many still know them best for their pink cuvées—despite the success also rubbing off on the house's white champagnes.

Even so, Mathieu Roland-Billecart feels there's an overall change in the understanding of rosé—wine experts recognize rosé, and many consider rosé champagne to be a good gastronomic accompaniment. And what's more—all year round.

In the USA, "Pink Bill," as the champagne is called, has achieved a high status. As it has in Japan. Moreover, several prominent chefs have used the rosé champagne to explore and develop new dishes to pair with the wine. For instance, Alain Passard from the three-star restaurant L'Arpège in Paris was first to pair the wine with red meat and has since used it with a number of vegetarian dishes.

"It has taken time, but something has genuinely changed. Actually, a lot has changed because consumers are realizing that rosé champagne can be good quality and is a special type of wine. This is what has happened in recent years with still rosé too," says Mathieu Roland-Billecart.

In the mile-long passages, the artist duo, Glithero, have created a work of art that can be viewed as an interpretation of both the moisture drops in the cellar and the bubbles in the wine.

Émile Gallé was a prominent Art Nouveau artist and has been associated with Perrier-Jouët since he designed the white Japanese anemones that adorn the house's vintage Champagnes in 1902.

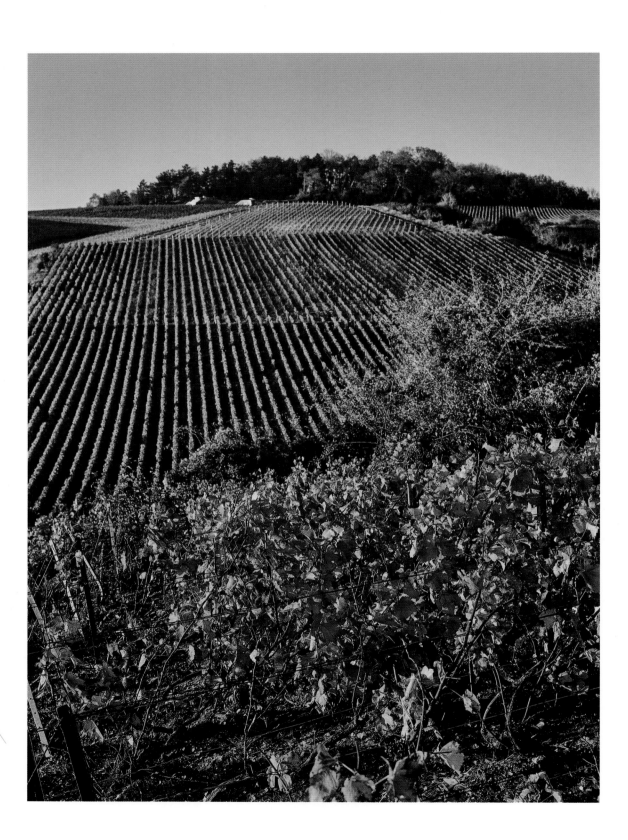

Paradoxically, global warming is helping in Champagne. The rising temperatures mean it's easier to get fully ripe grapes for rosé.

Rosé corks popping in Champagne

Passion, memory, and intuition

In the library at Perrier-Jouët, our acquaintance with the three vintage rosés from 2013, 2012, and 2010, under the expert guidance of the cellar master, has taken us through a select taste journey from pomegranate and tangerine leaves—to cumin, white pepper, nuts, and ginger—to strawberries and chocolate, which emerge as the wine ages. Tasting is an individual experience, but the vertical tasting—tasting the same wine from different vintages—emphasizes once again the difference in rosé wines and how they develop with age.

Cellar Master Séverine Frerson expects rosé production to continue to increase in the coming years, so it will constitute an even larger share of Perrier-Jouët's total production. However, making more rosé is not without its challenges for the Champagne houses. It requires more red wine, which according to the appellation's strict rules also has to come from Champagne—not an easy criterion to fulfil. To make a good red wine, the vines must be pruned more heavily, so there are fewer branches with buds. In turn, this means fewer grapes on each vine, so the yield is much smaller. This makes it expensive to make good red wine in Champagne, which partly explains why rosé champagne is typically quite a bit more expensive than white champagne.

Paradoxically, global warming offers a little help. Despite presenting rosé producers in, for example, southern France, with great challenges, the rising temperatures in the cooler Champagne region mean it's getting easier to get fully ripe red grapes and make good red wine.

At Perrier-Jouët, most vineyards are planted with the white Chardonnay, and here they face more or less the same challenges as most other Champagne houses. However, it has the advantage that their pale rosé champagnes contain a smaller amount of red wine than many others. It gives them flexibility to keep making more bottles.

"We will definitely increase our rosé production due to the increasing demand," says Séverine Frerson. "We have different options, so we don't need more hectares to make more rosé."

Her seven predecessors spent an average of around thirty years in the position as Perrier-Jouët's cellar master. Everything therefore points to her being the one who, over the coming years, will be responsible for meeting the future with respect for the past. Over two hundred years of history rests on her slender shoulders, but it's not a burden, she emphasizes. On the contrary, being able to lean on the achievements of her predecessors' neat records in thick journals lining the back wall of the library is a great help.

"I use my passion, my memory, and my intuition," says Séverine Frerson. "I have confidence in myself and feel no pressure. Making wine is a feeling for me. And it comes easy to me."

Perrier-Jouët wants to put aesthetics in pride of place. This is where rosé champagne plays an increasingly important role. Master Winemaker Séverine Frerson must have as much focus on the color of the wine as on its aroma and taste to succeed. "Making rosé champagne is more complex than making regular champagne," she says.

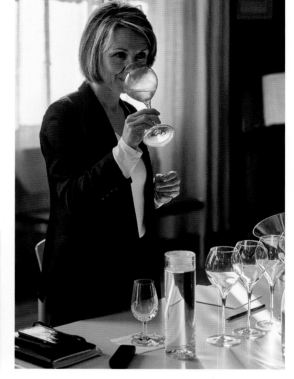

Rosé corks popping in Champagne

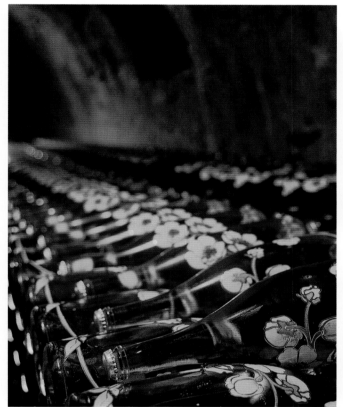

The road markings in Sant Sadurní d'Anoia clearly convey what the small town outside Barcelona is known for. The town is the center of Spanish cava production.

Salvador Dalí was mad about rosa cava

Salvador Dalí was mad about rosa cava

A trip through the town of Sant Sadurní d'Anoia outside Barcelona leaves no doubt as to what goes on here. Road markings are shaped like either chubby bottles used for sparkling wine or like the round-headed corks that hold the bubbles in until you pop them.

Sant Sadurní d'Anoia is the center of a massive cava production, the Spanish counterpart to Champagne. If you arrive by train, you are immediately greeted at the station by factory-sized buildings housing part of the production for the cava giants, Coderníu and Freixenet.

At the heart of the town lies one of the top producers, Juvé & Camps. They make their wine from the grapes from 450 hectares of vineyards in the area, thirteen million bottles are in stock in the cellar—and they can hardly keep up with the demand for their rosé wines in particular, which has been steadily increasing since the 1980s.

At the time, the Spanish painter Salvador Dalí was an ardent fan of rosé cava, which helped its popularity. Dalí died in 1989, but demand has continued to rise. The same applies to Juvé & Camps' prioritization of their rosé wines—and currently, the house's most exclusive and expensive wine is a rosé.

The salmon colored "La Siberia" is made from one hundred percent Pinot Noir and ages for an average of seven years before being released to the market. And as to emphasize both the quality of the wine and the evolution of the rosé category, "La Siberia" is entering a list of only very select wines classified as the best wines the cava category has to offer. The first rosé wine to do so.

Celebrity wines

What do you do when you're going to the Cannes Film Festival and need a good place to stay? For Angelina Jolie and Brad Pitt, the solution was to buy their own southern French wine estate.

In 2008, the movie stars initially entered into an agreement to rent Château Miraval in Provence, but four years later, they bought the estate, which also boasts a sound studio where Pink Floyd recorded their legendary *The Wall* album back in 1979.

At the same time, Jolie and Pitt entered into a spectacular collaboration with the well-known Perrin wine family from Château de Beaucastel in southern Rhône, which is known for their notable Châteauneuf-du-Pape wines. The ambition was to produce a new rosé wine under Miraval's name. The first vintage, 2013, sold out within hours of its release, and the rosé wine from the southern French château has since become a smash hit in the booming rosé market.

In the USA, there is great demand for rosé wines from Château Miraval, which has a total of 500 hectares of vineyards. The large production, which has survived the couple's divorce, now includes negociant wines whereby the grapes are bought from other vineyards.

Angelina Jolie and Brad Pitt have helped to sprinkle stardust over Provence as the leading region for rosé wines. And several prominent names in both film and music have followed in their footsteps by launching their own rosé brands—making rosé a pop culture phenomenon.

George Lucas, renowned film producer of sci-fi and fantasy masterpieces such as *Star Wars* and *Willow*, bought Château Margüi in 2017, which is actually located directly opposite Château Miraval in Provence. Actors with their own rosé wines include Drew Barrymore, Cameron Diaz, Sarah Jessica Parker, and John Malkovich.

Within the world of music, Sting was one of the first to dive into the rosé category when he bought the Il Palagio winery in Tuscany in 2007. Several of his wines are named after some of his greatest musical hits. Colleagues such as Jon Bon Jovi, Kylie Minogue, John Legend, and the rapper Post Malone have since followed suit. In the case of Jon Bon Jovi, it's a collaboration with wine producer Gérard Bertrand from Languedoc.

DAOU FAMILY ESTATES → GEORGES AND DANIEL DAOU

With Lebanon in heart and Provence in mind

With Lebanon in heart and Provence in mind

The rosé boom in the United States was underway when the Daou brothers decided to join the party. Carried by a childhood on the run, a French upbringing, and strong family values, they have turned California's Central Coast into a powerhouse of rosé wine.

In 1973, a missile landed on the sidewalk in front of the Daou family's home in Beirut. Shrapnel flew through their house and injured every member of the family—mother, father, two girls, and two boys. The youngest son, eight-year-old Daniel, was hit in the face and had his chest ripped open. His four-years-older brother, Georges, was hit all over his body and fell into a coma for forty-eight hours, hovering between life and death.

At the time, Lebanon's capital was a vibrant, cosmopolitan city known as the Paris of the Middle East. The head of the Daou family, Joseph, ran a successful furniture business, supplying furniture to ninety major hotels in the region. The four children enjoyed the free and cheerful life in the city but got a taste for life in the country too when they visited their grandparents who had olive groves and vineyards.

The civil war in Lebanon changed everything. For years, they lived in fear. When they went to bed at night, they didn't know if they would be alive the next morning. And when the war escalated in earnest in 1975, the family chose to leave everything but each other and flee to France where they had to start all over again.

The Daou family came to Provence where the warm climate reminded them of where they had come from, and they decided to settle around the city of Cannes on the French Mediterranean coast. Here they had to live a more modest life than what they had been used to in Lebanon—but the everyday-normalcy of school for the children and work for the parents returned.

It was here that Joseph Daou developed his passion for wine. He was particularly fond of Cabernet Sauvignon wines from Bordeaux, which he drank with his dinner. At lunch, he liked to drink a glass of rosé—like many others in Provence. Indeed, there was generally more rosé on the table than water.

Georges and Daniel were still just boys when their father started pouring wine into their glasses as well—as is customary in many French families. They only got a dribble, but unlike other children, Daniel didn't want the wine diluted with water—he could both smell and taste that something was happening in the glass, an experience that shouldn't be diluted. And surrounded by vineyards and a centuries-old wine culture, over the years both he and his brother developed the same interest in wine as their father.

By the early 1980s, the two brothers had become young men. Their passion for wine had grown, especially for Daniel, who realized however that becoming a winemaker in France wasn't a realistic career choice for him—that path was primarily reserved for those who had a lot of money or were born into a wine family.

Instead, with an ambition to improve their skills in mathematics and engineering respectively, the brothers headed to California to study at a university in San Diego. The Daou family had developed a strong tradition of entrepreneurship over the generations, and Georges and Daniel wanted to follow in their father's footsteps by pursuing their own dream of creating something successful.

The family back home in France helped finance their studies, but one day their father called with a fateful message—the money was about to run out and the sons had to return. But the brothers, who as boys had already looked death straight in the eyes, were no longer afraid of anything. They were prepared to take responsibility for the family, and after careful consideration, the brothers called back and asked for two things.

First, that the whole family move to California to live with them in their small townhouse in San Diego. And second, that the father give them what he had left of his savings.

The family's faith in the young men was strong. So, with an initial capital of $50,000 US dollars, Daniel and Georges founded Daou Systems in 1987, supplying IT solutions for the healthcare sector. Georges had identified the hospitals' desperate need for new IT solutions, and from their modest living room, Daniel developed software his older brother sold in strong competition with IBM and other IT giants.

It was all-their-eggs-in-one-basket for the entire Daou family who lived off spaghetti and olive oil while they waited for the breakthrough that would give them back the ultimate feeling of freedom. And which later gave the brothers the opportunity to both follow their passion and honor their family—and at the same time, show the whole world how they had been shaped by a dramatic life spanning three countries.

Paso Robles

↓

35°38'29.2"N

120°47'03.5"W

↑

13³⁰ PST

With Lebanon in heart and Provence in mind

The hospitality at the top of Daou Mountain is overwhelming, and there's something poignant about it when it's shown by two people who were forced to flee.

Bet everything on wine

Georges Daou drives right up to the main entrance and parks his Rolls-Royce convertible in the space closest to the door. He has driven two hours straight from his home farther up the coast and stretches his back for a moment before coming over and introducing himself.

Another car stops a little farther down in the parking lot—a Jeep Wrangler with extra fitted halogen spot-lights, Kevlar paint, large all-terrain tires with visible red shock absorbers, and a mighty engine rumble. Daniel Daou discreetly jumps out of the car and disappears through a back door.

We're standing on a mountain the two brothers have named after their family. Here, from the top of Daou Mountain, over 2000 feet above sea level, we have a panoramic view of rolling hills and valleys with winding rows of vines that belong to the brothers' estate. Between the vines run trimmed rows of plants that supply the soil with nutrients—and whose green color reveals spring is on the way. The sky is blue, but a low fog on the horizon has settled between the mountain and the Pacific Ocean about twelve miles away.

We can see down to the walnut trees lining the winding road we drove along. Olive trees are a feature of the last stretch, and at the entrance gate of Daou Family Estates, guests are welcomed by lavender bushes flanking an iron gate with an arched lintel and a bell hanging in the middle.

The bell rings three times a year. When the harvest commences, when the harvest is over, and on their parents' wedding day, February 11, which also happens to be the day the Daou brothers release their absolute top wine. The wine is called "Soul of a Lion" and is a tribute to Joseph Daou, who as the family's lion saved his loved ones from the atrocities of war. And who, according to his two sons, taught them the values that have helped them all the way from Lebanon, across the South of France, to where they are now, Paso Robles, in the middle of the American West Coast—passion, courage, and persistence.

"I think the combination of our background really enabled us to do what we do today. Lebanon gave us heart, France gave us discipline, America gave us opportunity," says Daniel Daou.

He has come out to welcome us properly and invites us into the winery's tasting room where a table with glasses of rosé wine attracts the first patrons of the day. They have all booked in advance because it's the only way to gain access to the full experience of wine, food, and spectacular surroundings that Daou offers its 60,000 guests a year.

French lounge music plays from the speakers. Large, colorful jars stand on the floor, whose tiles feature a Middle Eastern design. We seat ourselves at a table in a corner where Lebanese delicacies such as hummus, tahini, and pita bread are served on patterned ceramic dishes. The hospitality is overwhelming, almost insistent, and it contains a touch of poignance when it's shown by two people who have experienced the opposite—being forced to flee.

Georges Daou articulates the experience the brothers want to give their guests:

"People come here because they're interested in wine. But they want more than that. The problem with many wineries is that they make good wine and leave it at that. You're on your own with the rest. For us, it's not just that we make great wine—we also want to serve a good lifestyle to our guests."

There's no denying it—you feel comfortable on top of Daou Mountain. It's laid back and professional, and the Daou lifestyle is personified by the brothers themselves. Their casual attire is the same—sneakers, jeans, hoodie, and a cap. They are in control of every situation that arises around them, creating a safe environment for both employees and patrons alike. Their confidence is balanced by humble gratitude for the privileged position to which life has brought them.

The sale of their IT company in 1998—eleven years after they founded it with the remains of their father's savings as start-up capital—made the Daou brothers very wealthy. It also gave them the opportunity to take a new direction in life. And for Daniel Daou, there was no doubt. He wanted to pursue the dream whose very first seeds had been sown during a childhood visit to his grandparents in Lebanon—and which had continued to grow through his youth in France and adulthood in California.

He wanted to make wine.

For years, Daniel Daou had spent every free moment he had studying wine. The very same day he and his brother sold their company, he cleared out his garage to make room for vinification equipment. It was also the day he began his hunt for the perfect place to make his wine.

However, his brother's initial reaction was skepticism. But once Georges Daou realized his younger brother believed he could make some of the best wine in the world, he gave him his unconditional support, which meant the brothers risking their fortune.

"We decided to bet everything on this," says Daniel Daou.

The brothers had no doubts about which wines they wanted to primarily make. They wanted to make wines like the ones they had drunk with their father growing up in France. But it took them eight years—and a lot of traveling around the world, including to Argentina, Spain, and Italy—before they found a place with the right soil and the right climate. They had actually given up on finding it in California when Daniel Daou finally arrived at "his" mountain in Paso Robles.

A pile of dirt with a nice view

"Jump in!" Daniel Daou opens the door to a special all-terrain four-wheel drive vehicle as he hops into the driver's seat. With his left hand on the steering wheel and his right hand on the stick, which sits almost all the way up in the windscreen, he sets off. On one wrist hangs a bracelet that measures his physical activity, and on the other is a gold watch far too large and thick to hide under the sleeve of his hooded sweatshirt. We're on our way out to inspect the land, which to Daniel Daou is worth much more than gold.

When he arrived here for the first time in 2006, he drove through hay that reached up to the vehicle's windows. The area had no water, no electricity, no vineyards—only mountain lions roaming the wild terrain, which, according to Daniel Daou, could best be described as "a pile of dirt with a nice view." Yet it was right here that he found what he'd been looking for, for years.

The eighty-five hectares have slopes of up to sixty-five percent, which the 4x4 climbs in first gear. Daniel Daou knows exactly where he wants to go. He stops at a slope, jumps out of the vehicle, and sticks his bare fists into the ground—after which he proudly displays two lumps of limestone in each palm.

The calcareous clay soil is reminiscent of the soil found in the appellations that make the best wines in the Bordeaux style. And with a climate that provides sun, stable heat, and fresh winds from the Pacific—far better conditions for ripening grapes than in, for example, Bordeaux—Daniel Daou had no doubt this was where he was going to live out his life's dream.

Back then Paso Robles on California's Central Coast was best known for producing relatively inexpensive red wines from Zinfandel and classic Rhône grapes such as Syrah and Grenache. The more prestigious wines in the Bordeaux style were found in Napa Valley a little farther north. But Daniel Daou had ambitions of taking on both Napa and Bordeaux and so set about planting new vines, primarily Cabernet Sauvignon.

The former engineer supplemented his intuition with a scientific approach to wine production, optimizing all processing and creating some of the most color-intensive, aromatic, and age-worthy Bordeaux-based wines in the world. After only three years, his signature wine "Soul of a Lion" scored top marks from wine critic Robert Parker.

A success dedicated to the Daou brothers' father, who was able to visit Daou Mountain to bless his sons' wine adventure before he passed away in 2010. And it was a success that left its mark on the entire Californian wine world in the years that followed—with the result that well over half of the vineyards in Paso Robles are now planted with Cabernet Sauvignon and other Bordeaux varieties.

Daniel and Georges were making their dream come true. And they were doing it by following the same recipe for success as when they set up their IT company. One brother made the wines while the other one raised awareness about them by establishing sales channels, organizing creative events, and making Daou Mountain one of the area's most popular day-trip destinations with an impressive annual turnover.

"Dani found his gift in making wine, and I found mine in sharing it. That's how it became a success story," says Georges Daou.

It was also Georges who approached his little brother in 2017 with a good idea. And once again, it was an idea inspired by their upbringing in Provence. They had come full circle again. Or as he puts it: "It was another piece to the puzzle."

The calcareous clay soil of Paso Robles is reminiscent of the soil in the appellations that make the best Bordeaux-style wines.

"Peach! It's the first thing I smell when I drink rosé. If I can't smell peaches, it's not right."

Daniel Daou

Idols from Provence

Around the time the Daou brothers were embarking on their adventure on top of a mountain in Paso Robles, Americans were beginning to develop a taste for dry, crisp rosé wines from France in earnest—especially those from Provence. Before then, most Americans associated rosé with a cheap, semi-sweet wine made according to the saignée method—from grape juice left to bleed from grapes that then produced extra powerful red wines. Or the wine was made from grapes that had been damaged—or maybe were even rotten—and whose skins therefore weren't of the quality to give red wines their color and tannins.

Select southern French rosé wines—for instance, those from Domaine Tempier in Bandol—had found their way into more progressive circles in California. But otherwise it was only at the end of the 2000s that there was an actual boom in the sale of French rosé wines. A boom that had partly been set in motion by Frenchman Sacha Lichine, who sold his wine estate in Bordeaux, bought a new one in Provence, and with "Whispering Angel," created what was to become the world's most popular rosé.

On one of his frequent visits to the South of France in 2015, Daniel Daou visited Sacha Lichine at his Château d'Esclans estate. And the two wine colleagues remain in contact.

"He told me his story and I'm very impressed. He's a visionary, he's the person who has to be credited for starting the rosé revolution all over the world," says Daniel Daou.

If he were to hang posters of his rosé idols on the wall, there would be a picture of another Provence rosé giant too.

"I love Domaines Ott. It's actually my favorite rosé in France. It's smooth, elegant, perfumy, just balanced—it has all the characteristics of a beautiful rosé. And when I'm in Provence, that's the wine I order the most."

That's why Daniel Daou was not in any doubt when his brother came to him in 2017 and said now was the time to make the second of their childhood wines. Making the wine their father had drunk at dinner had been a home run. Now it was time to make the rosé he drank at lunch.

"We grew up with it. When I think about rosé, I think about the family meals we used to have," says Georges Daou. "It was the Mediterranean; it was summer days. It's a happy memory. So I don't see it as a beverage. I see it as storytelling. As a nostalgic moment."

And it goes without saying that Daou's rosé had to be made the way the wine was made in Provence. Georges Daou had been reading the market and noticed how an increasing number of American wineries were beginning to make a rosé that wasn't a sweet blush wine but rather was inspired by the southern French style. And the higher price of the wines, which consumers were apparently prepared to pay, also piqued his interest.

"The American palate was starting to appreciate rosé. We'd always wanted to make a rosé. We came late to the rosé game, but we wanted to do it at the right time—and that time was now," he says. "It's like Apple. They didn't invent the computer, but they came up with a better version of it and took over the market. That's exactly what we did with Cabernet, and it's what we're going to do with rosé."

The scent and taste of peach comes from the Grenache grapes, which are also dominant in most rosé wines from Provence. The grape variety produces pale wines because it has a thin skin.

A scent of peach

Daniel Daou pours some wine—and immediately after we've stuck our noses into our glasses, he asks impatiently, "Can you smell it?" He answers the question himself before we have given him an answer.

"Peach! It's the first thing I smell when I drink rosé. If I can't smell peaches, it's not right."

The fragrance and taste of peach comes from the Grenache grapes that Daniel Daou uses for his rosé wine. It's the dominant grape variety in most rosé wines from Provence. It produces pale wines due to its thin skin. But it's a large grape with a lot of juice. And it has a sweet and fruity taste with a hint of herbs reminiscent of the southern French hinterland.

With the help of the calcareous soil, which gives the wines minerality, Daniel Daou can make an even better version of the rosé wines he and his brother drank with their father when they were young. But it's vital the Grenache grapes are only picked when they're ripe. According to Daniel Daou, far too many rosé wines—including some from Provence—lack a fruity flavor because the grapes are picked too early for fear the wine will have too much color and too little acidity.

At Daou Family Estates, the vines are planted close together. They are only artificially watered if they are about to die in the summer heat—and so are almost tormented into giving their very best. Only the best grapes are used for wine production. And the selective approach is repeated during pressing—only the free run juice, the juice that comes out of the press from the grapes' own weight—is used. This means not much more than twenty percent of the juice of the grapes is used for wine production, says Daniel Daou. An astonishingly low percentage compared to most other producers—but it's part of the secret behind the delicate, silky texture captured in the wines from Daou.

The philosophy is that the wine is created first and foremost out in the vineyard, and that nature should take its course in as far as possible during the production of the wine. However, the malolactic fermentation is blocked with a shot of sulfur during vinification to prevent the wine from becoming too flat and buttery. Daniel Daou wants minerality and fresh acidity. But the wine still has to have a fragrant aroma—this happens through a very long fermentation phase at very low temperatures. Some producers ferment their wines within a few weeks—so the fermentation tanks can be used relatively quickly for a new batch of wine. But Daniel Daou's rosé wines take a month and a half to ferment—that is, until all the sugar has turned into alcohol—because it happens at a temperature of only fifty degrees Fahrenheit (ten degrees Celsius).

"Rosé has to have an aromatic component. It can't just be wine, it has to have a bouquet, like white wine. It plays a big role."

Daniel Daou blends his Grenache-based rosé wines with a little white wine made from Sauvignon Blanc. In the four-wheel drive vehicle, on the way back from the sloping vineyards, we ask who helps him taste his way to the perfect blend. It's a topic we have spoken to other winemakers about too—for many it's almost a ritualistic process

With Lebanon in heart and Provence in mind

Daou has joined the list of recognized wine producers who have thrown themselves into rosé wine—and who have contributed to the category becoming more widespread and respected.

where they meet in a group to go through many tastings and long discussions before the wines of the year reach the right blend. This is not the case with Daniel Daou.

"I just finished the blend. I did it myself."

Daniel believes he has a "super palate"—and that he inherited it from his father. He relies one hundred percent on his taste buds—and also on his understanding and sense of what consumers like.

"I feel it and I express it. That's what wine is all about for me. It's a gift that I was fortunate to receive and that I apply to all the wines I make, and it doesn't matter if they sell for $15.00 or $1,000.00—we make both. It's driven by passion, it comes from the heart, and that's why I know I want to make wine until the day I die."

And judging by the popularity of his rosé wines, he can safely continue to do so. Only three months after Daou launched its first rosé wine in 2020, the news broke that the wine was among the best-selling rosé wines in the United States. It is still the case today, though Daou now makes two rosé wines—their classic Provençale wine called "Discovery" and a "Reserve Rosé" where fifty percent of the wine has been aged in oak barrels, which they themselves made from wood from French forests. Between 400,000–500,000 bottles of rosé are produced, accounting for fifteen percent of production. The brothers expect production to continue to increase as they gain access to more grapes and the share of rosé to grow to a quarter of their total production. The popularity of the rosé wines supports the success of the Cabernet-based red wines and helps make Daou one of America's fastest growing wine brands, which is also sold in sixty countries around the world.

Daou has joined the ranks of renowned wine producers who have devoted themselves to rosé wine—and contributed to the category becoming more widespread and respected. And here on California's Central Coast, the endless sunshine, long growing season, and windswept hillsides close to the Pacific Ocean, have become a powerful set of conditions that has elevated rosé to a level unmatched by any other region in the United States.

Another prominent winemaker is Manfred Krankl of Oakview, just a few miles from Paso Robles. With his wine brand Sine Qua Non, he has achieved cult status among wine enthusiasts who line up to acquire a few bottles from a production that is much smaller than Daou's, but which includes rosé wines. Occasionally, when demand exceeds supply, things can get a little extreme—headlines were made around the world when a single Sine Qua Non rosé wine from 1995 sold at an auction for $42,000.00 US dollars in 2014.

Sun, summer, and happy people

Daou's success stems not only from making good wine, but also from creating good experiences around the wine from the 320 hectares of vineyards the brothers have at their disposal. Georges Daou is delighted the rosé wines have opened the door to experiences different to those from red wines.

"When you think of red wine, you generally think of something complex with nuances that are difficult to understand. You often need a sommelier because if you're going to spend more than $20 or $30 dollars, you need someone to tell you, you're going to like it. But when you think of rosé, you think of summer, sun, being outdoors,

perhaps enjoying a fresh salad with it. It's easier, it's more accessible and less intimidating."

At the same time, Daniel Daou notes a clear connection between the increasing popularity of rosé wine and a global trend of shifting eating patterns due to climate change.

"There's a tendency to eat less red meat, more vegan, more vegetarian. I was vegan for a year and actually drank less red wine because I was drinking more white wine or rosé with food. So yes, I think you're going to see rosé's popularity grow because the world is realizing that too much meat isn't good. And that's a door opener for rosé," he says.

Daniel Daou's lip hangs on the right side because his face is partially paralyzed. And Georges' body is still riddled with shrapnel—constant reminders of when a missile exploded in front of their childhood home almost fifty years ago. About the time they had to flee the life they knew to start another.

And they continue to use this life to create experiences that, in different ways, are about the same thing—holding on to the joy of life while helping others to do the same. That's the mission here at the top of Daou Mountain. And the rosé wines are an exceptional part of that on a day like today under the Californian spring sun where transparent bottles of salmon-colored liquid are placed on the tables—and where pictures of the wine and the happy people drinking it are posted on social media a few seconds later.

The two brothers who put their name to the wine are happy to pose for photos. It's their party and they celebrate it with joy. But they know life is not just easy and carefree—and that it can all change in a split second.

Nowadays, they don't have to run anywhere. But they appreciate learning that it can be necessary.

"I have no regrets. I think it has made me a better person," comments Daniel Daou on the experience that, more than anything else, has defined life for him and his brother. "We almost all died in a terrorist attack in Lebanon. It allowed us to form a bond that's unbreakable. If I have to choose between having all this and having my brother, I would quit in a second and I would keep my brother. And he would do the same."

The next generation of the Daou family consists of Daniel's four daughters and his son. Georges has no children—his brother's five children are enough for both of them, he says with a smile. The eldest daughter manages Daou's digital marketing. Number two is currently working at Château Latour in Bordeaux after completing her training as a winemaker in California. And his son is about to embark on his wine education.

Daniel Daou is convinced at least two or three of them will join forces to take over what their father and uncle have created. In 2023, the wine business was extended with the purchase of some land in Tuscany, Italy. And later the same year, the two brothers did what they had done once before in life—they sold their company! For a price of almost one billion dollars, Australian Treasury Wine Estates acquired Daou Vineyards with the ambition to make "the next global luxury icon".

However, this time the sale will not lead to a new direction in life for Daniel and Georges Daou. They will remain highly involved in the wine business. Together with the next generation they will carry on the legacy.

"For us, this is a family affair," says Daniel Daou.

With Lebanon in heart and Provence in mind

Daniel Daou believes he has a "super palate." He relies one hundred percent on his taste buds and on his understanding and sense of what consumers like.

"When you think of summer, sun, perhaps enjoying salad with it. It's accessible and

→ Georges Daou

of rosé, you think being outdoors, a fresh easier, it's more less intimidating."



All over the world, more people are developing a taste for rosé, and they are prepared to pay a higher price for the wine. This gives producers better opportunities to invest in the quality of the wine.

A range of taste notes

Tasting wine can be a complex affair. For some, it's a discipline that can trigger heated discussions and creative descriptions of a wine's character.

Compared to both the red wine and white wine categories, rosé wines fall within a narrower range of taste notes. For many, it makes the category a little easier to deal with, and this easy accessibility undoubtedly explains in part rosé wine's popularity. But there is still a world of sensory taste experiences to delve into.

It opens with the aroma of the wine. Here you can get a really good sense of whether it's an exciting wine where the aromas ascend from the glass. Or whether it's a more anonymous aromatically poor wine where the most important thing for the winemaker may have been getting the color right. How much of a price more and more producers are paying in terms of taste in their attempt to meet the demand for the completely pale rosé wines is something frequently debated among both producers and consumers.

The wine can be straightforward and immediate, a characteristic of many rosé wines that fall under the heading "terrace wines." But the wine can also be more complex and ambitious, which is the case with the more gastronomic wines that challenge both red and white wines when it comes to pairing the right wine with food.

A rosé typically has some of the freshness and minerality known from a white wine. But it also likes to have some body, power, and depth more characteristic of a red wine. As with most wines, the quality lies in finding the right balance. For one of the best-known rosé wine producers, Sacha Lichine from Château d'Esclans in Provence, a good rosé wine "begins as a white wine and ends as a red wine."

Rosé wines can have much minerality with notes of, for example, chalk, flint, or slate. Typically, these aromas come from the soil in which the vines are planted. Somewhat similar, the wine can have something salty about it, which usually comes from sea winds blowing over coastal vineyards.

Most rosé wines are very fruit-driven—they may even smell and taste of freshly sliced fruit. It could be yellow fruits, such as peaches, apricots, and melons, or red fruits, such as strawberries, raspberries, and red currants. The fruit can help give the wine a touch of sweetness, even if it has no residual sugar. Notes of citrus fruits, such as grapefruit, mandarin, and orange can also be sensed in both the nose and mouth.

The most fragrant rosé wines enjoy a floral bouquet—for example roses, lilies, lavender. And some wines may take on the character of local plants such as herbs or pine trees.

Keeping the acidity level up is an uphill struggle for many winemakers, especially if their grapes are grown in a climate where the sun and heat make them very sugary. Acidity is necessary to make the wine fresh and juicy, and in a rosé wine that can be supplemented by the bitterness from the tannin in the skins of blue grapes.

DOMAINE DE LA MORDORÉE → AMBRE DELORME

A favorite of kings: "The only good wine in the world"

A favorite of kings: "The only good wine in the world"

Tavel is called "France's first rosé." Throughout the ages, the wine has been hailed by thirsty kings, popes, and barons, but today it has to fight harder for its status. At the center stands one of France's youngest producers.

Her father told her to go out and experience the world before she started making any big life decisions. Which is why she was in Santa Barbara, California, when the phone rang. It was the middle of the night, and it was her mother on the line. She had news that was going to change both of their lives.

We're sitting in Ambre Delorme's little Nissan. She is clearly not used to having passengers with her. At least not in the back seat where she has had to remove some papers and dog toys. Before we get in, she bangs the upholstery a few times to remove the worst of the dust. She laughs in her characteristic hoarse voice—her laugh is liberatingly without any embarrassment. This is our chariot. We can take it or leave it. We'll take it.

That's why we're now on our way from the winery on the outskirts of the small town of Tavel to the vineyards. The car has a light suspension, and at low speed, and with rocking movements, we drive on gravel roads with large stones and deep tractor-made tracks. Ambre Delorme has one hand on the steering wheel, the other holds tightly to the little miniature pinscher sitting on her lap and looking out of the windshield, quite at home. The dog's

Tavel

↓

44°00'43.0"N

4°42'20.9"E

↑

10^{30} *CET*

A favorite of kings: "The only good wine in the world"

owner alternates her gaze between the road we are driving on and the car's rearview mirror where we have fleeting moments of eye contact as we chat.

Ambre Delorme isn't the type to look away. Even though she is simultaneously driving the car and taking care of the dog, she is completely present. She gets straight to the point. Direct. Even when it comes to the difficult story of her father she's sharing with us.

The most reputable rosé wine

The story of Christophe Delorme is in many ways a good one. He was twenty-four years old when he established Domaine de la Mordorée with his own father in 1986. He had actually studied business. But driven by a love of nature—and a completely uncompromising ambition to work in harmony with it—he threw all his energy into producing wine in one of France's most traditional areas.

The vineyard is located on the periphery of Tavel in the southern part of the Rhône valley, which cleaves its way through France between the Alps and the Massif Central. The town lies to the left of the river in an undulating valley right where the main road leads to Provence in the south or to Languedoc in the west. The estate's total of forty-two hectares is spread over eight villages within the area's various appellations—Côtes du Rhône, Lirac, Châteauneuf-du-Pape, and Tavel, which takes its name from the little village.

Tavel is one of the only appellations in the world where only rosé wine is produced—and is by far the most significant of them. For hundreds of years, Tavel represented the most reputable rosé wine in the world, hailed by thirsty popes, counts, barons, and kings. More recently, the area was one of the very first to be recognized by the French wine authorities when the appellation system was invented in 1936 and Tavel was awarded AOC status. Today, Tavel is one of eighteen wines in the Rhône valley that can be called "cru." Yet another hallmark of quality underlining the wine's authenticity—that it has been made to highlight the local terroir.

The appellation's approximately 1,000 hectares are distributed among thirty to forty producers who make between five and six million bottles of wine per annum. That's less than what Château d'Esclans in Provence sells of a single rosé, "Whispering Angel." And in competition with this blockbuster and the other trendier rosés from Provence, contemporary Tavel producers have to fight hard to maintain the status of the past. For with their darker and more powerful wines, they aren't exactly the vanguard of the rosé revolution.

Over the years, Christophe Delorme fought for his historic wines, to which he gave his own character. He built up a reputation as one of the area's leading producers of both red wine and rosé. When lists of the best rosé wines were issued, Domaine de la Mordorée was mentioned regularly. And it still is.

His focus wasn't on expensive investments in new technology for the wine cellar. It was on the vineyards that initially he converted to organic farming—one of the first in the area to do so—and later to biodynamic production. He was dedicated in his belief that respecting the planet is not only an obligation for all of us who live on it but also a path that can lead to sublime wines. His values were his compass. He had visions, he was passionate, and

he was a perfectionist to the last. He was constantly concerned with how he could change things for the better—to the benefit of both nature and his wines.

But such dedication had its price. And Christophe Delorme came to pay the ultimate price. That was clear to Ambre Delorme when the phone rang in Santa Barbara in 2015. At the age of just fifty-two, her father had died from cardiac arrest.

Christophe Delorme's daughter looks directly into the narrow mirror on the car's windshield. "My father worked with great passion. He pushed himself to the limit, and his body couldn't keep up with his dreams. But every day, he did what he wanted, and I think that's the best way to live, even if you end up dying young."

Ambre Delorme talks about her father's death with a small smile on her face. There's no anger or resentment, only gratitude. For all he has passed on to her. She has a conviction and strength that is clearly evident here in the car—and leaves an extra impression because it comes from her slender body, which doesn't occupy much of the driver's seat.

As mentioned, Christophe Delorme had warned his daughter against making big decisions too early on in life. But his sudden death forced her to. She found herself facing a very difficult decision.

She felt her father hadn't taught her enough about winemaking, and she was unsure whether she and her mother could continue to run Domaine de la Mordorée. But the alternative was to sell his life's work, and so, at only twenty-two years of age, Ambre Delorme decided to continue her father's legacy, knowing she hadn't only chosen a job, but a lifestyle.

As one of France's youngest wine producers, she has taken on the task of further developing some of the country's most historic wines. Of course, it's her generation, born in the years leading up to the turn of the millennium who have been the driving force behind the worldwide rosé boom of recent years—with a particular love for the dry, fresh, and very bright type of rosés produced by the Provence region a few miles to the south. But Ambre Delorme plays by her own rules. Like her father, she has a mission to show the world that the rosé category can do so much more.

"We don't have the same perception of rosé here," she says. "Today, that wine category is so broad that the word rosé actually makes no sense. There are so many types of rosés and so many different approaches to rosé wine."

The wine of love

Le 1er rosé de France—France's first rosé—was written on a large sign as we drove into Tavel earlier in the day. It's also the slogan of the local cooperative, which accounts for half of the appellation's production. And with good

reason. There has been wine in the area since 400 B.C.E. The vines were planted by the Greeks, and later the Romans took over and expanded the fields.

In the past, the wine was much more reminiscent of the generally produced wine. Because with the absence of modern technological aids, winegrowers were forced to pick, press, and ferment the grapes as quickly as possible to avoid the wine being attacked by disease—with the result that their red wine managed to turn only pink.

But the wines from Tavel stood out. Historically, they are among the most famous and one of the first true brands in the world of wine. Around the year 1300, the French King Philip IV—called "the Fair"—was said to have ridden through Tavel whilst on a tour of his kingdom. He was offered a glass of wine, which he drained without dismounting from his horse, after which he declared Tavel to be the only good wine in the world. Similarly, the Sun King, Louis XIV, who reigned a few centuries later, enthusiastically praised the wine and contributed to its distinguished status.

Incidentally, Louis XIV also delighted in another historic rosé wine, Rosé des Riceys. An appellation in the southern part of the Champagne region that, like Tavel, only produces rosé wine. Here, the wines are made exclusively from Pinot Noir grapes from vines that are at least twelve years old. Today, the appellation only has twenty-five producers who produce 40,000–50,000 bottles a year. Therefore, the area is significantly less well-known than Tavel and historically has been of less importance for the history of rosé wine.

A more recent enthusiastic fan of Tavel was Ernest Hemingway. He once stated in an interview that he couldn't eat lunch without drinking a bottle of Tavel. And in his book Garden of Eden, he describes Tavel as "the wine of love."

However, a major trauma for Tavel, which is still talked about in the town, was the devastating vine plague, phylloxera, that ravaged the vines around 1870. Originating only three miles from the village, the area was one of the first to be hit. When the plague was over, large parts of Tavel had been planted with forest, and it wasn't until the 1960s that wine production expanded again by clearing trees and planting vines in the lush soil.

At that time, Tavel wine was again in high demand. Not least in the USA where exports had gained momentum and the wine sold at high prices. That changed in the 1980s after American Sutter Home invented a sweet and light wine made from the Zinfandel grape. The so-called "White Zinfandel" quickly became popular and drew demand at the expense of Tavel and others.

Unlike "White Zinfandel," however, Tavel is a dry wine. And it's primarily made from the Grenache grape, also dominant in the rosé wines from Provence. But compared to the Provence wines, Tavel has more color, weight, structure, and some of the tannins known from red wine. For good reason, many consider it a light red wine.

This is because winemakers let the must from the grapes ferment with the skins for up to three days before the juice is allowed to run off. Moreover, the fermentation takes place at a higher temperature than usual with rosé. At the same time, Tavel rosés are characterized by a generally higher alcohol percentage—another feature that goes

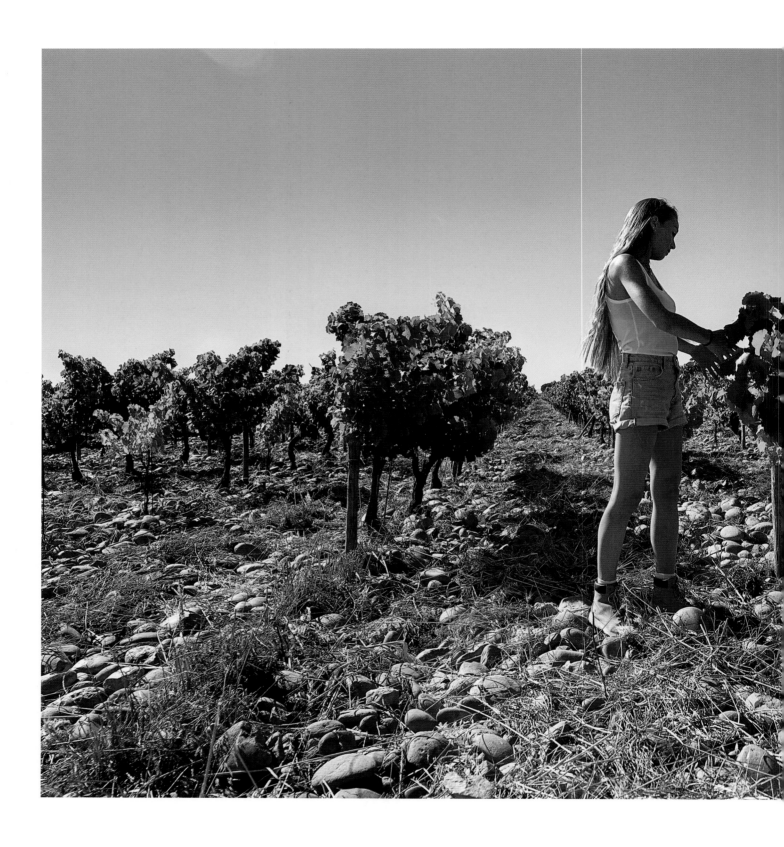

A favorite of kings: "The only good wine in the world"

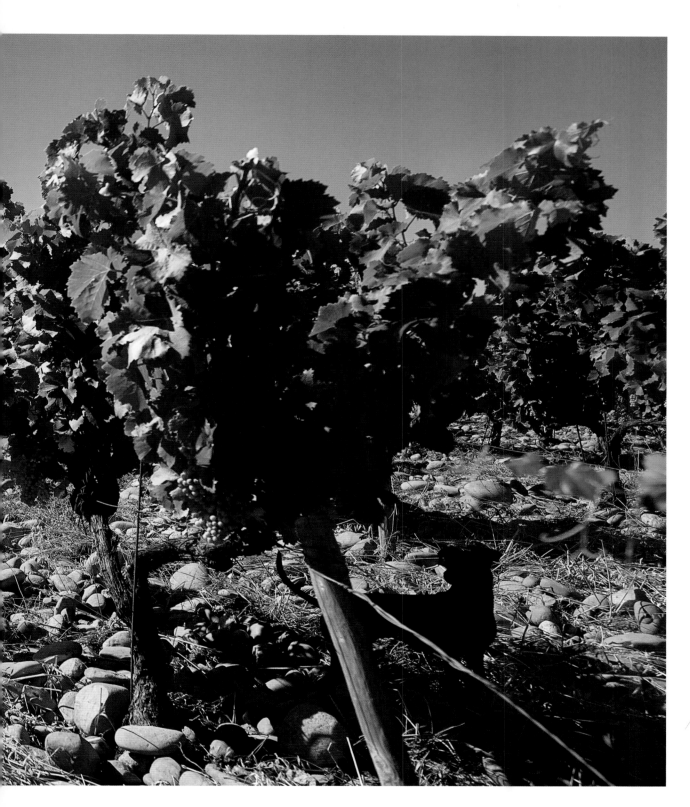

The large pebbles insulate the vines' roots and help the grapes to ripen because they retain the heat in the evening and at night. During the day, the leaves protect against the strong sun.

against the prevailing trend of wines with less alcohol. This is because the grapes are riper when they are picked, which also gives the wines their typical notes of red fruit.

In other words, Tavel wines are not for those looking for an apéritif or a fresh thirst quencher on a terrace under the summer sun. It's a wine highly valued by many wine connoisseurs and for many is a suitable companion to a good meal, preferably with meat and all year round.

Thus, the previously very famous and exclusive wine breaks with today's common perception of what characterizes a rosé. And in the small town in the southern Rhône region, they can feel both the lower demand from the USA and the dominant rosé trend from Provence.

A geological jumble

Ambre Delorme stops the car at a vineyard where three men are trimming the leaves of some Grenache grape vines, the main grape in this windy and sunny corner of the world. The grape is practically tailor-made for the climate as it ripens relatively late and therefore needs warm, dry surroundings to deliver its best.

Getting out of the Nissan, we almost trip over some large round stones on the ground around the vines. The smooth pebbles—*the galets roulés*—measure up to sixteen inches in length and give the field a raw look—yet another reminder that nature is in charge here.

Despite its limited size, Tavel is a geological jumble of sand, clay, granite, limestone, and quartz. It gives the area's wines a diversity in both aroma and taste, which is distinctive of the entire Rhône region where the mountains, the river, and the valley have been formed through volcanic eruptions, floods, and other natural phenomena spanning millions of years.

The large stones, which are also known, for instance, in Châteauneuf-du-Pape, insulate the roots of the vines and help the grapes ripen because they retain the heat in the evening and at night. But the heat can also be too much at times. The Rhône valley soaks up the summer sun, and although the mistral helps aerate the grapes, there's a risk of the grapes drying out and so producing less juice.

Ambre Delorme still remembers when things went wrong in 2017, when Domaine de la Mordorée's production fell by forty percent. Therefore, it's with great care that the three employees, each armed with large scissors, trim the leaves of the vines on this July day.

The leaves protect the grapes from the sun and ensure they don't dry out—but if there are too many leaves on the vines, the grapes don't get enough sun and so don't ripen. Consequently, they have to be trimmed, neither too much nor too little, a few months before the harvest. It's a careful balance.

A team of Spanish employees has worked for the Delorme family for years. Through close collaboration with Christophe Delorme, they were trained in the special principles embodied in Domaine de la Mordorée's production, and the head of the team, together with a few local wine consultants, has been a huge help to Ambre

Delorme since the sudden death of her father. Regularly taking off his cap to wipe the sweat from his forehead on this hot summer day, he is well satisfied. A little under half an inch of rain fell yesterday, and he says, "If it continues like this, it will be good. If we just get a little rain once or twice more before harvest, we'll be happy."

Ambre Delorme has gradually learned to live with the pressure. A pressure that comes with the constant uncertainty about what the result of the year's harvest will be. The crisis in 2017—just two years after her father's death—was tough and left her and her mother with financial challenges. Fortunately, the years that followed were more generous, and as Ambre Delorme gets to know her fields, vines, and grapes better with each season, she's becoming more resilient.

"If we make 1,600 hectoliters, then I know we can pay our bills. Things will work out," she says.

The 1,600 hectoliters correspond to just over 200,000 bottles—a small, exclusive production. Still, Domaine de la Mordorée produces wine within all the appellations of the area. Ambre Delorme doesn't hide the fact that it can be more challenging to sell the estate's Tavel wines than the wines from Châteauneuf-du-Pape, Côtes du Rhône, and Lirac. A challenge that, paradoxically, has become greater in the past ten to fifteen years as rosé wines have generally grown in popularity. For the boom has also led to a widespread perception of what a good rosé is—a "cliché" to use Ambre Delorme's words.

"It's not the easiest wine to sell nowadays because Tavel belongs to the rosé category. Most people go for a pale rosé that's easy to drink. And they always want the latest vintage. They almost want the wine before the grapes have come off the vines. That's not our approach. Our wine isn't hard to drink, but it's more like a light red wine. You can drink it all year round, it goes well with food, and we think it should be drunk after at least one year in the bottle."

To counteract the increasing popularity of rosés from Provence in particular, some Tavel producers are harvesting their grapes earlier and letting them ferment for a shorter time with skin contact—to achieve a paler rosé. This fueled debate among both the locals and wine enthusiasts about whether the producers should be following current trends or stick to their distinctive features. Ambre Delorme has no qualms:

"We'll never change our Tavel. We just need to work harder and spend more time educating consumers. That's why I never talk about rosé—I talk about Tavel."

Which is also why Ambre will continue to pick her grapes when they are fully ripe, and then have a maceration phase of between twenty-four and forty-eight hours. She emphasizes, however, that she's not pointing fingers at the booming rosé industry of large companies that spend gigantic sums on both technology and marketing for their more fashionable wines.

"There is a lot of marketing, and why not? There's a demand that you can go after. But it's another dimension. Here we take a more artisanal approach. We're not a big company with loads of employees and robots. We're just ten people giving it everything we have and more to keep the story going."

A wine with feelings

Back at the winery, we enter the main building where a large portrait of Christophe Delorme and the innumerable honors awarded to Domaine de la Mordorée's wines over the years draw the guests' attention.

The cellar is evidently not set up for visitors and resembles mainly a medium-sized factory hall. The focus is clearly on the production and storage of the wines. In a corner stands a pair of black rubber boots—but they aren't needed today. Cardboard boxes of wine are stacked on top of each other everywhere. One of the consultants—an oenologist—helping Ambre Delorme is doing a stock take of fourteen special wooden boxes to be sent to a vintner. To keep track, he puts lines on a whiteboard hanging on the wall. Next to it is a picture of the area's different soil types and a drawing of the woodcock, which gave its name to the vineyard.

The local oenologist helps cultivate the land too. In the absence of her father, he's the one Ambre Delorme turns to, to discuss new ideas and decisions about necessary investments. And here, five years after his death, it is still his philosophy that matters in the end.

"I'm not him, but we were very close. He's always in my thoughts, and when I have to decide something, I think about what he would have done. What's important—what is most urgent?"

She carries on her father's ambition to follow the rhythm of nature and cultivates the land according to Rudolf Steiner's biodynamic Demeter principles. A unique and strictly controlled way of farming that, in essence, means you not only refrain from using chemicals, you also try to supply the soil with energy. The soil must live, and so you have to stimulate, not kill, the bacteria in it—because bacteria are life. This is done by burying cow horns filled with cow dung and other alternative forms of fertilizer. For instance, a completely natural ecosystem in which insects fight disease is cultivated in the fields.

Rudolf Steiner's principles also mean taking the position of the planets and the moon into account—which the estate does. Specifically, for example, a lunar calendar determines when it's an auspicious day to work in the field. Or when it's a good time to bottle the wine. According to the lunar calendar, that's not today, when we are visiting. And that's why Mordorée's bottling plant is at a standstill, even though wine from last year's harvest is in some of the tanks, ready to be bottled.

All of this is rooted in the idea that the quality in the bottle comes from the quality in the vineyard—as well as a belief that the wine itself has a consciousness and an energy that can be transferred to both those who make it and those who drink it.

"We discuss our philosophy a lot. About the patience we want and get in the wine. And how we can feel the wine. Year after year, I hope the wines will become more and more emotional. And my big dream is that even people who aren't really into biodynamics will one day drink the wine and experience that something special is happening."

↓

"My big dream is that even people who aren't really into biodynamics will one day drink the wine and experience that something special is happening."

↑

Ambre Delorme

She finds that more and more customers are concerned about wine being produced without harming nature. And that this value impacts and determines which wine they want to drink—and so buy. In this way, Domaine de le Mordorée is riding a wave that is getting stronger and stronger, and which is also gaining a foothold among many rosé winemakers who see the commercial advantages of restructuring their production.

"For us, it's not about marketing. But we would like to talk about it and in that way help inform people. But it requires a bit of situational awareness. Some people would like to hear about it. Others just want to taste and buy some wine, and that's fine too. So we don't open a conversation by talking about the moon and the planets."

Ambre Delorme knows full well her values and balance sheet go hand-in-hand—and that both realism and common sense are needed. For example, she would like to buy a sorting table with a conveyor belt to sort the grapes when they come in from the harvest. However, she feels it's more important that she invest in some new and smaller tanks, so she can try different wines in smaller volumes.

But the most important thing is what goes on out in the vineyards—it's where she most strongly feels she's following in her father's footsteps.

"My mission is to continue and preserve what we have and what my father left to me. It's very important for me to continue on that path."

Therefore, she has no plans to stop producing the historic rosé wine, which accounts for approximately a quarter of Domaine de la Mordorée's production. She is proud to be from Tavel, she says. And therefore it's also in the small town that shares its name with what was once the world's most famous rosé that her future lies. She will keep making wine. But what the future holds on the private front, she doesn't want to speculate. Apart from wanting to move away from home one day. She hasn't had time for that yet.

"I want to build my own little house. But it can't be too big because I don't like cleaning."

Ambre Delorme's father warned her against making big decisions too early in life. But his sudden death forced her to. At the age of only twenty-two, she decided to continue her father's legacy.

The small town of Tavel in the Rhône region gives its name to one of the few appellations in the world where only rosé wine is produced.

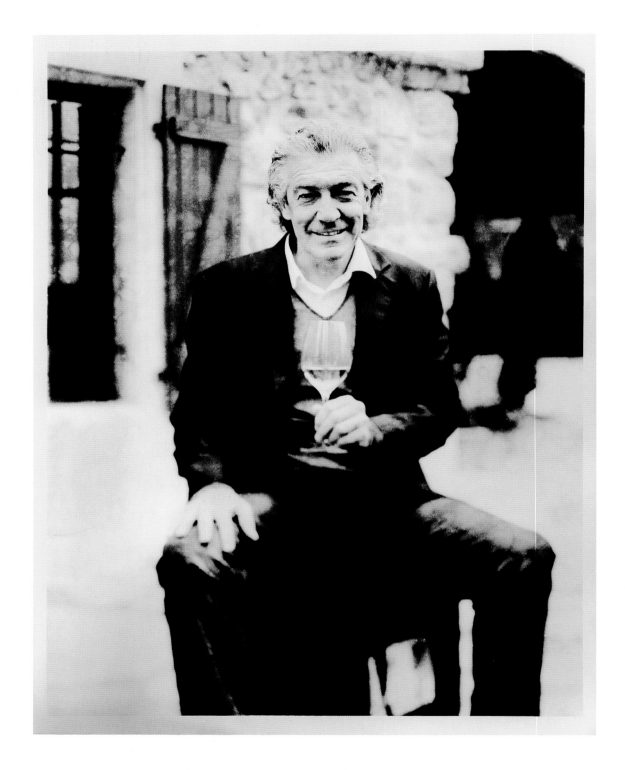

GÉRARD BERTRAND → GÉRARD BERTRAND

Languedoc's proud son went from rugby to rosé

Languedoc's proud son went from rugby to rosé

A rugby star has created a wine empire preventing Provence from patenting the southern French lifestyle and the best rosé wines. Today, it says "Gérard Bertrand" on the world's most expensive rosé.

It's not easy to tell, but our host has actually broken his nose three times. His rough, slightly rocking gait, which causes his broad upper body to move up and down in time with his long strides, is a clear sign that his body has endured strain over the years.

Gérard Bertrand crosses the lawn. He stands over six feet tall and is slim with long limbs. His thick hair, that is combed back and covers his neck, is peppered with gray. One hand effortlessly holds onto the neck of a bottle of wine as if it were a little stick.

The lawn is a bit uneven, there are light spots in the green grass. It's bordered by a fence to the vineyards as well as a pink-washed façade with cracks and dark moisture patches, which forms part of the estate. In the middle is the main building that runs along the garden. The building has freshly painted blue shutters. Most of them are open. It's afternoon on an early December day, so there is no heat to be kept out.

A canopy of thin bamboo branches covers a terrace with a dining table and six chairs. At the bottom of an outdoor stone oven, waste wood is ready to be set alight. Just inside is the kitchen where steel pots are stacked on top of each other on the stove.

Domaine Cigalus, nearly ten miles west of Narbonne in Languedoc, is home to Gérard Bertrand and his family. There are no house staff here. There is nothing here to show off or impress. Only the two dogs, Magnum and Socrates, break the stress-free silence with their restless energy. This is where the wine estate's owner recovers and finds new strength.

Most of his life has been an effort. He struggled with childhood shyness. He battled in rugby stadiums all over the world. And he has strived to create a wine empire out of almost nothing.

For Gérard Bertrand wasn't born with a silver spoon in his mouth. He had no fortune to start with as has been the case for many of his competitors. And he represented a region that produced a third of France's wine, but which hadn't received much recognition for it.

Like a lone wolf, he has advanced in a world of many traditions and fixed opinions and attitudes. And with an indomitable fighting spirit and a winning mentality, he has been at the head of impressive pioneering work on several levels for more than thirty years.

Gérard Bertrand has shown the world that world-class wines can be made in Languedoc in the southwest of France. He experimented with producing wine in new ways while respecting nature—and is now the world's largest producer of biodynamic wines. Not to mention he's the fly in the ointment for those who wanted to see Provence having a patent on the southern French lifestyle and the best rosé wines.

Gérard Bertrand spotted the potential of rosé wine before most others. Both as big business and as fine wine. He put himself on the line—with his own name on the wine, himself as the front man, and with the flair to build a bridge between his rawness and the pink wine's elegant subtlety.

The former rugby star accounts for a large portion of the booming rosé market. A significant percentage of Gérard Bertrand's billion-dollar business is based on his range of more than ten different rosé wines, several of which are internationally strong wine brands. And when it comes to the recent years' race among southern French rosé giants to make the world's best rosé wine, he has taken the lead—certainly when it comes to price. The name Gérard Bertrand adorns the world's most expensive rosé wine, which is produced on biodynamic principles and is, in many ways, the culmination of his multipronged pioneering.

"The price isn't important. What is important is how you enjoy it. I'm proud that Languedoc has been recognized for having the most expensive and iconic rosé on Earth," says Bertrand, who hasn't forgotten the terminology from the world of sport. "For rosé, we are in the top three in the world. I don't like to say we are number one."

Juggling rugby and wine

Gérard Bertrand was ten years old when his father first invited him to join the harvest. That was in 1975, two years after his father bought a vineyard in Corbières, the largest wine district in Languedoc-Roussillon—and, incidentally, the fourth largest in all of France. An area with an astonishing diversity of water, sunshine, wind, and mountains within its borders that stretches from the coast of the Mediterranean to the foot of the Pyrenees.

From the get-go, Georges Bertrand taught his son that making wine is about having control over "1,001 details." He mainly produced red wine, but rosé too. The Languedoc region has a tradition of large rosé production, and currently a third of all French rosé wine comes from here.

Languedoc

↓

43°10'03.3"N

3°06'50.1"E

↑

9^{30} *CET*

Bertrand senior approached the task with great zeal and an ambition to prove the area had the potential to produce high quality wines. Back then, the winegrowers in the district focused primarily on quantity and cultivated grape types with a high yield that typically ended as cheap table wine. But Georges Bertrand felt the diversity in the local terroir combined with some local grape varieties, whose value was underestimated, could produce quality wines that bore a much greater manifestation of where they came from.

His son witnessed the courage and stamina it demanded from his father to stand up to the many colleagues who didn't have the same ambition to bring about change that could help the region out of its inferiority complex. And young Gérard experienced the same uncompromisingness when Georges Bertrand coached the local boys' rugby union team that his son played on.

Rugby, the ruffian sport played by gentlemen, very popular in France, especially in the south, became Gérard Bertrand's great passion throughout his youth and early adulthood. He had both a physique and a mentality suited to the physically challenging game where bruised ribs and bleeding limbs were commonplace—and where he learned about both team spirit and persistence. It was the sport more than anything else that helped him develop from a shy boy into a man of staunch character.

He played rugby at the highest level for seventeen years—as a professional player who won several national championships, captained his team, and represented the French national team. But back then there was no great earning potential in the sport, and Gérard Bertrand had to help his father in the vineyard and the cellar on the side. He was able to take advantage of the rugby season being from November to May while the busiest months on his father's vineyard were from June to October.

He exploited that to the maximum when, at the age of twenty-two, he lost his father in a traffic accident. After only a few days of reflection, Gérard Bertrand decided to take over his father's wine production, and for the next seven years, he juggled two careers until he retired from rugby.

The sport chapter was over, but the experience gained from the many rugby matches defined him for the rest of his life. And it is from that experience of the demanding but noble game of rugby that Gérard Bertrand finds the words for putting his achievements into perspective.

"Rugby gave me the chance to transcend myself and push my limits. The sport also gave me self-confidence and a strong belief in my teammates. This has guided me ever since. In wine, as in rugby, faith gives you the courage necessary to go out into the world and discover what is needed and get on with achieving it."

The end of his rugby career thus became the start of the battle to continue his father's pioneering work. And Gérard Bertrand decided to think big in his efforts to promote the southern French lifestyle, the Languedoc terroir, and a biodynamic approach to wine production.

He wanted to take advantage of his knowledge of the wider world gained from his numerous travels as a rugby player, and so he targeted himself toward a global market. He wanted to use his good name as a sports star to borrow money from the bank so he could expand his business. He was ready to take big chances.

"It's important to be a fighter. I started from scratch and came from nowhere, and I didn't have many chances to be successful. But I always remember that success is proportional to the level of risk. Only if you are willing to take risks, do you have the chance to be really successful," he says, adding, "And you need a bit of luck along the way too."

One of the first times Gérard Bertrand experienced luck smiling on him was in 1990 when he was contacted by the sommelier of star chef Alain Ducasse. The sommelier asked if he could have Gérard Bertrand's rosé in large bottles—both Magnums of 1.5 liters and the nearly double-sized Jeroboam bottles. The young southern French winemaker was quick to take advantage of the opportunity and delivered the order, which became the initial little push toward the position within the rosé market that Gérard Bertrand enjoys today.

The perfect host gift

From the top of the cliff, it all comes together. In front of us is a view of the sea, to the side are the mountains bordering Spain, and behind us we can glimpse the old city wall of Narbonne. We are surrounded by 1,000 hectares of "garrigue" with low bushes, perennials, and wild herbs that can thrive in the hot and dry climate. Large lime-stones dot the hiking trails through the green landscape. The white stones illuminate the ground between the very long rows of vines in the estate's fields too.

We have arrived at Château l'Hospitalet, which Gérard Bertrand bought in 2002. It wasn't his first acquisition—in the previous years he'd acquired two other wine estates, including his current home, Cigalus. But this purchase in 2002 was by far the greatest mark of both Bertrand's great ambitions and his willingness to take risks. And with a price higher than his annual turnover at the time, he also seriously tested the willingness of his banking connections to take risks.

Under changing owners, Château l'Hospitalet has been a center for wine tourism for decades, and with its hotel, restaurant, and wine boutique, it has given Gérard Bertrand a unique opportunity to cultivate both the wine and the southern French "art de vivre." Thousands of guests visit the castle every year where the music-loving winemaker has also hosted an annual jazz festival since 2004 spanning five days in August.

It was in those years that Gérard Bertrand took a number of initiatives that became decisive for his current position—and that show he was one of the first to see the coming rosé revolution. In 2005, he launched the wine "Gris Blanc"—a rosé made from a blend of Grenache and the gray-brown mutation of the same grape, Grenache Gris. The grapes are picked manually and pressed directly so there's no skin contact during fermentation. This produces a fresh and fruity wine with a hint of bitterness in the aftertaste—and with a color so pale it could be mistaken for a white wine that has been aged for a few years and has acquired a little color.

To put this launch in a slightly larger perspective, it occurred two years before Sacha Lichine launched his first pale, dry rosé wines from Château d'Esclans in Provence. And a handful of years before the sale of rosé really exploded.

Château l'Hospitalet is a center for wine tourism, and with its hotel, restaurant, and wine boutique, the place has given Gérard Bertrand a unique opportunity to cultivate both wine and the southern French "art de vivre."

Languedoc's proud son went from rugby to rosé

In 2012, Gérard Bertrand had another innovative breakthrough—this time with the rosé wine "Côtes de Roses," which is sold over most of the world today. Likewise, it's a dry light wine in the mid-price range, but it stands out predominantly due to its bottle design. The bottle is shaped like a bouquet of flowers with its bottom designed as a rose. This has made the wine popular as a host gift—as an alternative to, well, a bouquet of flowers.

"These wines are all about enjoyment and celebration. Modern wine drinkers find wines to reflect their own lifestyle and wines that offer immediate delight to be shared with friends," says Gérard Bertrand by way of explanation of the success of the rosé wines.

He doesn't hold back from posing in a loose summer shirt and an alluring smile when the wines are being promoted. In his world, you can be both a former tough rugby star and the head of a rosé wine, which he himself drinks with pleasure—and has done so ever since he started drinking wine.

"We're all yin and yang. This means we all have something masculine and something feminine, and that's the beauty of nature. Human beings are complex."

Today, Château l'Hospitalet is the focal point of Bertrand's empire, which has undergone considerable expansion since his father's death. From one to seventeen estates in Languedoc-Roussillon. From 150 to almost 1,000 hectares of vines. From five to 450 employees. And from selling in three countries to being on sale in 182 countries worldwide.

For comparison, he has as large a vineyard area as the entire Bandol appellation in Provence. The turnover has reached around 200 million euro, and with a third of the turnover coming from rosé wine, it makes Gérard Bertrand one of the category's all-time star captains.

Gérard Bertrand's calm and friendly disposition tempts you to believe it's been easy. However, he's not shy about describing the first few years as laborious with huge worries, financial deficits, and sleepless nights, but with a strong-willed belief that things would turn around at some point. And they have done so in earnest since 2012 when Bertrand experienced a bottom line that wasn't red for the first time. Not least because of increasing sales of his rosé wines.

"I've struggled through all the years," he says. "Today people say, oh, Gérard Bertrand, he's very successful. But they forget that for twenty-five years I felt like a survivor because I didn't make money in all those years. Putting the South of France on the map was a long battle. And to make people really enjoy the area, the lifestyle, and the wines."

"I saw how rosé can go from being an ordinary beverage to a very serious product."

Gérard Bertrand

Languedoc's proud son went from rugby to rosé

Swimming with Bon Jovi

Innovation has been key for Gérard Bertrand, who listened carefully to consumers to meet their needs and desires. His ambition is to have something for everyone and for every occasion. This means Bertrand's rosé wines offer a wide range—from supermarket wines to top wines in contrastingly different price ranges, which have earned him a number of awards and accolades over the years.

"I got genuinely serious about rosé fifteen years ago. I started experimenting with aging rosé in oak barrels, like we do with white and red, and I saw how rosé can go from being an ordinary beverage to a very serious product."

In 2018, his innovative approach led to a new rosé breakthrough. In partnership with rock legend Jon Bon Jovi and his son, Jesse Bongiovi, Gérard Bertrand launched a high-end rosé wine aimed at meeting the huge demand for the pink nectar in the United States, particularly among wealthy East Coast Americans.

A mutual acquaintance introduced them, which led to Jon Bon Jovi and his son coming to Languedoc to make wine with Gérard Bertrand. The result was a wine entitled "Hampton Water"—named after the popular bathing area on Long Island where many well-to-do Americans, including the American rock star, spend their summer. The wine is a blend of Grenache, Cinsault, and Mourvèdre, and on the bottle is an image of a woman in a bathing suit diving headlong into a rolling sea.

With the wine, Gérard Bertrand and the Bon Jovi family became part of a trend of film and music celebrities who have started making their own rosé wines—or naming them at least. A trend that took off when Angelina Jolie and Brad Pitt bought Château Miraval in Provence in 2011 and subsequently launched their own rosé wine with the help of a top producer from Châteauneuf-du-Pape in the southern Rhône.

With "Hampton Water," Gérard Bertrand challenged the wines from Miraval—just as he did with producers like Château d'Esclans in Provence and Wölffer Estates on Long Island. And despite the producers remaining competitors, they have largely helped each other to get more Americans to drink rosé.

"When Brad Pitt and Angelina Jolie came to Provence, it was a huge opportunity for the American market. They got people to open their eyes to rosé, and rosé wine became trendy," says Gérard Bertrand.

We hear no criticism from him of the many other celebrities trying their luck in a booming rosé market and using the popular, photogenic wine to promote their own "good life." Because when it comes down to it, it takes something very special to succeed.

"Many people try, but few succeed. You have to work hard, you have to meet a lot of people, you have to be consistent in terms of both quality and marketing, and you have to tell the truth. At the end of the day, it's a question of commitment."

It's hard not to be impressed by Gérard Bertrand's own commitment.

Languedoc's proud son went from rugby to rosé

Clos du Temple is the world's most expensive rosé. The wine is stored in pyramid-shaped tanks before it reaches the oak barrels. In

Gérard Bertrand's temple, the forces of nature and his own know-how are blended.

Buried cow horns for better grapes

Water is boiling in two large pots with lids. The pots are on their respective gas burners, which stand directly on the floor in the workshop at Château l'Hospitalet. The gas is supplied from two cylinders even larger than the pots. In the boiling water are leaves and stalks from the comfrey shrub picked at another of Gérard Bertrand's vineyards.

The leaves and stems were dried and then stored in some of the glass jars on a shelf in the workshop. Just under an ounce of the dried herbs is added to each pot, which boils for exactly twenty minutes. The result is a brown-green herbal tea that is mixed with forty liters of cold water and then poured into two large wooden barrels just outside the workshop.

A whisk-looking utensil is mounted to each barrel to create a sort of whirlpool. First in one direction and then the other—and this eddying of the water, which is constantly forced to change direction, goes on for twenty minutes until the process is finished.

If we wondered why it's called biodynamics, now we know. The water in the barrels has been dynamized and is now ready to be sprayed over the vineyards to give new energy to the soil. The seventy pints of water mixed with the herbal tea is enough for a whole hectare, which measures around 12,000 square yards.

"It's 'root day' today," says Marc-Olivier Trompette, head of viticulture at Château l'Hospitalet. He's referring to the lunar calendar, which determines the timing of all processes in biodynamic wine production. "So, it's a good day to stimulate the roots of the vines by bringing organic life into the soil."

While Gérard Bertrand was at the peak of his rugby career—and in the period when he had taken over the family business after his father's death—he began to develop problems with his health. A mysterious disease had struck his liver. He lost weight and felt ill when he drank wine, which was both concerning and very inconvenient.

Discouraged that no conventional doctors could help him, Gérard Bertrand sought out a homeopathic specialist. Homeopathy believes that "like cures like," so if a substance causes symptoms in a healthy person, it can potentially—in very small doses—treat an illness in a person showing similar symptoms. After six months of treatment, Gérard was restored to health.

The powerful experience inspired Gérard Bertrand to study the Austrian philosopher Rudolf Steiner's principles of biodynamic agriculture. Doing so, he identified some clear coincidences with homeopathy, and he had, to use his words, "an epiphany." Therefore, he decided to test whether Steiner's holistic farming philosophy, with its thoughts on the interaction between soil, humans, and the supernatural forces of the cosmos, could strengthen his vineyards—and ultimately improve the quality of his wines.

He selected a vineyard of four hectares at Cigalus, which he divided into two. One half of the field was to be cultivated as it always had been while the other was to be worked following biodynamic principles with all that entailed—burying cow horns, spraying with dynamized water, and determining important events, such as pruning the vines, harvesting the grapes, and bottling of the wine, according to the position of the moon.

After just two years, the results were clear. The biodynamic vines had fewer diseases and their grapes had thicker skins, higher acidity, and were riper. The difference was most evident during the harvest—the taste of the biodynamic grapes was more intense.

According to critics, biodynamics is on par with pseudoscience, but Gérard Bertrand was convinced. And he immediately set about implementing a gradual reorganization of production, which has now made him the world's largest biodynamic wine producer.

"Of course we believe the planets influence the Earth. It's very important. How can we not believe that when nature has created humans? At the end of the day, we're not alone, we're under the deep influence of the cosmos."

Gérard Bertrand has been a pioneer in this area too. He made a significant contribution to the conversion on organic and biodynamic wine production, which is becoming more and more widespread among winegrowers, including the southern French producers of rosé wine in both Languedoc and Provence. Colleagues rarely shake their heads at his principles nowadays—because many of them have learned first-hand that it's the way to make better wines.

"Honestly, ninety-five percent of people in the wine industry are really open to this now. They know and trust these principles—maybe also because the best winegrowers in the world are committed to organic and biodynamic principles," says Gérard Bertrand, who mentions Domaine de la Romanée-Conti, in Burgundy, and Château Latour, in Bordeaux, as other examples.

However, the world's largest biodynamic wine producer continues his environmental activism without doomsday prophecies. It's his mission to both be a steward of the land and promote the southern French lifestyle, which also underpins the popularity of rosé wines. And he insists it's possible to live the good life and have a sustainable production.

"We remain optimistic, we don't want to be skeptical and negative. I believe the future remains bright if people are willing and prepared to change. And I think we will figure out how to make the changes," says Gérard Bertrand. "The combination of lifestyle and nature is very important to me. When it comes down to it, lifestyle is about staying alive."

That is why Gérard Bertrand continues to see opportunities rather than limitations.

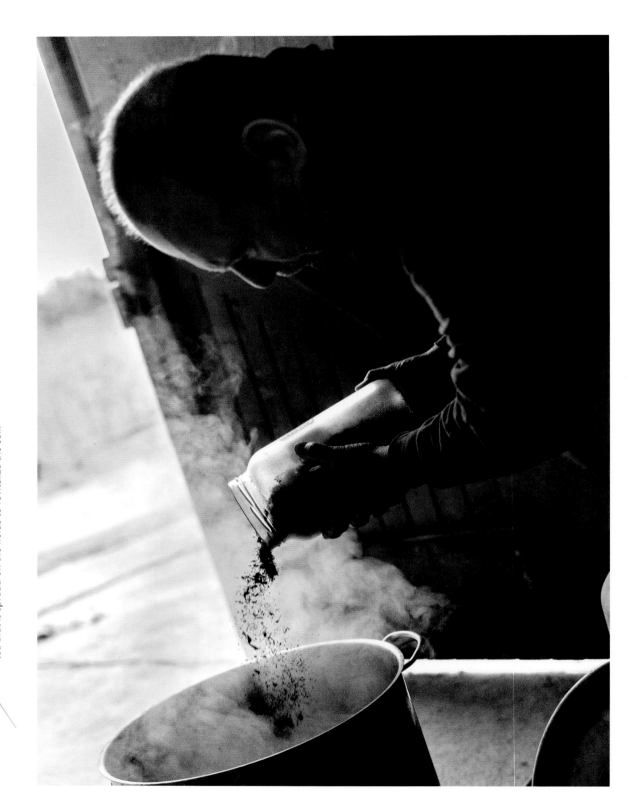

Biodynamic agriculture principles are followed at Gérard Bertrand. Here, comfrey is mixed with boiling water. The result is an herbal tea that is spread on the fields to revitalize the soil.

Languedoc's proud son went from rugby to rosé

Rosé should taste of terroir too

Two black lines run down the brown coat on the mule's back. The lines intersect just above the neck and form a cross. Jerome is the "master" of the mule, and together they're plowing the topmost vineyards at Clos du Temple. Radishes and mustard flowers are to be planted in the plowed soil because these plants protect the vines from the cold. The roots of the plants also provide more air to the soil and prevent the soil from eroding on the sloping fields when there's heavy rainfall.

We're almost at the top of the mountain, which is called "Château" because Château Cabrières used to be located here. The castle took its name from the wine district in which we find ourselves. Cabrières was once known for its particular rosé wines, which were also among the favorite wines of the Sun King, Louis XIV. But in recent years, most supermarket wines have come from here, which is why neighboring tongues started to wag when Gérard Bertrand came to the mountain in 2016 to realize his latest—and so far most ambitious—project.

We can look down over the site's eleven plots with a total of twelve hectares. A few grapes hang on the vines after the harvest a few months ago. The leaves are red, indicating they'll soon fall, and the vines are getting ready for their winter hibernation.

Just below is Gérard Bertrand's favorite parcel of Grenache grapes. The vineyard has a strong slope, which means the upper rows get much more sun than the lower ones, and therefore there's a two to three week difference between when the grapes at each end of the parcel are harvested. The soil contains both limestone and slate, which makes the area very special—and was one of the main reasons why Gérard Bertrand saw the potential of the place, which is completely isolated from the eyes of the outside world.

At the top of the mountain, a flat building can be seen. It's hard to spot at first. As we get closer, we learn why. The building is integrated into the landscape, built of stone from the area, and has small trees and bushes growing on the roof.

We have arrived at Gérard Bertrand's temple. It's here he's decided to apply the best of what the forces of nature and his own know-how can achieve. And the magnificent project is revealed in earnest as we step inside the building whose camouflaged exterior is counterbalanced by a spectacular multi-level interior.

In the basement are black pyramid-shaped tanks, the tips of which are painted gold. They are filled with the juice from the fall harvest, which is still fermenting. The pyramid tops point up at a ceiling covered with a metal plate with small holes through which light shines, creating the effect of a starry sky.

Around one hundred wooden barrels with a volume of 225 or 550 liters are housed in the next room. This is where the wine ages for six months. Under the barrels are small wheels so they can be turned easily—thereby generating movement in the wine, so the lees are moved around and give character to the wine.

From the barrels in the cellar is a glass ceiling up to the next floor where a grand piano resides—and from which there is a view of the entire valley. No one is playing the piano today, but dramatic medieval music flows out of the speakers, adding a further dimension to the experience.

Beside the grand piano is the wine.

The bottle has a square base, a symbol of the earth. A cylindrical punt at the bottom is intended to represent the connection between earthly and heavenly forces. Lines of gold circle the neck of the bottle to emphasize the gentle curves of the area's hills. And at the top is a blue ribbon, a tribute to King Louis XIV and his love for the rosé wines from Cabrières.

It's "Clos du Temple"—the world's most expensive rosé wine.

"For me, the temple is something multidimensional, and it was important for me to create a multidimensional experience with this wine," says Gérard Bertrand.

The wine is made from four red grapes—Grenache, Syrah, Cinsault, and Mourvèdre—as well as the white Viognier. The result is a wine with a soft, creamy texture, notes of peach and apricot, and a lively minerality.

"I want to put rosé in a new perspective," says the man behind the wine. "The link between the unique terroir of limestone, slate, and aging potential puts this wine into a new category of 'grand vin rosé.' Its multidimensionality stems from terroir, time, and transcendence being at the core of the wine. Sometimes a wine has the capability to transcend your life and send you somewhere."

"Clos du Temple" is the latest statement from Gérard Bertrand about the impact of biodynamics on the wine. About the wine's spirituality. And about the rosé category's potential as a wine that has earned its place on the top shelves.

The wine costs around €200.00 euro, making it the world's most expensive rosé. Still 30,000 or so bottles sell out every year. Though Gérard Bertrand keeps some bottles from each vintage for himself to experience how the wine, which according to his own expectations has aging potential for at least fifteen years, develops over the years. The most important thing for him is to show what is possible—and to be recognized for it.

"Many people inspire me to develop my own principles as a wine grower, as a winemaker, as a wine drinker. It has been a long journey, but I'm happy to have come through these three decades and finally have my wines recognized as some of the best in the world."

"Clos du Temple" underscores Gérard Bertrand's mission that wines should taste of where they come from—and that applies to rosé wine too.

"The most important thing is to bring out the taste of a place and not the taste of a thing. This is the big change in the rosé industry—people are now delving into the details to reveal the taste of terroir. You can make rosé in the cellar—just like you can make red and white. But if you want to make a premium wine, you have to take good care of your terroir."

He's confident the rosé category will continue to grow in the coming years—both in terms of reputation and distribution. Even if the establishment does still frown on it a little.

"The experts are important. But at the end of the day, it's the consumer's taste that makes the difference."

A mule is used to plow the earth between the vines. Radishes and mustard flowers are to be planted in the plowed soil because they protect the vines from the cold.

According to some critics, biodynamics is pseudoscience, but Gérard Bertrand is convinced. Today, he's the world's largest biodynamic wine producer. The wine "Clos du Temple" is his latest statement about the impact of biodynamics on the wine, the wine's spirituality, and the great potential of the rosé category.

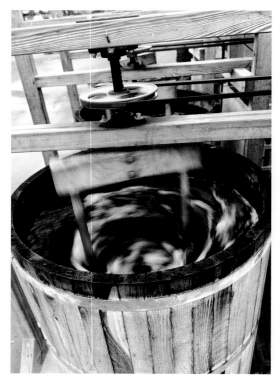

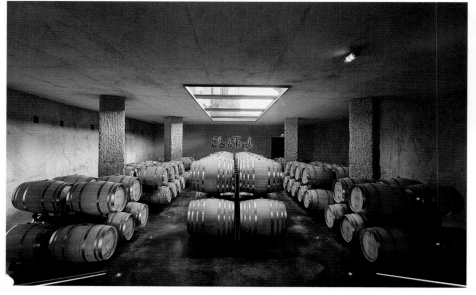

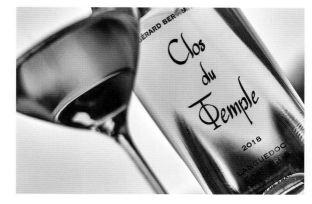

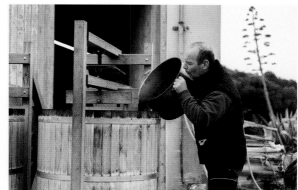

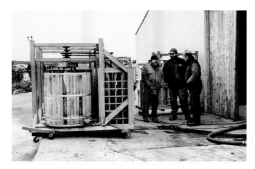

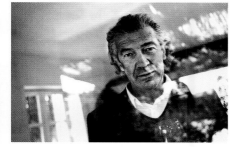

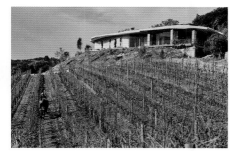

Rosé makes a perfect apéritif. But rosé also pairs very well with food—as has always been done in the South of France.

Drink rosé with food

Rosé equals sun, summer, and fun experiences. The perfect wine to enjoy on the terrace, at the beach, or by the pool.

A glass of rosé is also an ideal apéritif before sitting down to dinner. But in fact, many options are available for serving rosé wine with food—as has always been done in the South of France.

The core ingredients of southern French cuisine, such as olive oil, garlic, tomatoes, and various herbs, play very well with dry, fresh rosé wines, which in almost all cases can replace a white wine for light meals of fish, shellfish, vegetables, and white meat.

Many people are brought up to believe red wine is for meat and white wine is for fish. But the choice isn't so straightforward nowadays. We have a lot more options. Partly due to our changing eating habits and partly due to the many more good rosé wines available on the market that make great gastronomic companions.

Rosé wine lies somewhere between red and white wine, which gives the wine a versatility that makes it easy to pair with food, whether it's fish, meat, eggs, or a vegetable dish where the wine's fresh acidity cleanses the palate of vegetable fats. It also means a group of friends at a restaurant who have each ordered their preferred dish from the menu, but would like to drink the same wine, can find a happy medium in enjoying a bottle of rosé.

With the changes in our eating habits, considering rosé as an accompaniment to food has become more obvious. An increasing focus on the climate and global warming, for example, has led many consumers to eat less red meat, which pairs very well with a red wine with a lot of tannins. This, in turn, makes them more likely to replace the red wine with a lighter wine, for example a rosé.

Ethnic food is often characterized by being fairly spicy—a challenge a rosé wine can handle more easily than many other wines given both its acidity and sweetness. The same is true for meat marinated in a BBQ sauce with a lot of sugar.

A sweeter rosé can be a good choice for a dessert, for example with berries, where the aromas of the wine are reflected in the sweet course.

For Asian dishes, such as sushi, the drier, paler rosés are often a popular choice. A slightly stronger rosé with a good structure matches well with poultry or grilled meat, for example lamb. Whereas a more complex rosé wine, perhaps aged in oak barrels, might be worth trying with a piece of cheese.

Rosé has a knack for adapting. The wine doesn't necessarily demand a lot of the food you serve it with, which makes it suitable for both vegetarian and vegan dishes too. So a good rule of thumb—if in doubt, choose a rosé!

BRAUNEWELL-DINTER → STEFAN BRAUNEWELL, FRANK DINTER,
CHRISTIAN BRAUNEWELL

From local tradition to global inspiration

Germans drink a lot of rosé. Still, German producers continued to represent conservative virtues. But one day, a man knocked on the door of Braunewell in Rheinhessen, kickstarting a true rosé adventure.

On our way up to the small town, we drive through fog that has settled over the valley on this Saturday morning in October. We now have a view of slopes with their patchwork of sharply defined plots in autumnal colors. The vineyards surround the town's soccer stadium from where the lazy silence of the weekend is broken by a referee's whistle and enthusiastic shouts from the children on the pitch.

Coming into a suburban estate, we pass a newspaper delivery boy on a bicycle and a woman out walking her dog. First a tractor, then a Porsche come driving in the opposite direction.

The flat modern building is at the end of the detached houses. With neighbors on one side and endless rows of vines on the other, the entrance is marked by a free-standing limestone wall with a logo, the letters of which are cast in iron.

In the parking lot, an elderly gentleman in a blue fleece sweatshirt is pruning the shiny, elongated leaves of some Oleander plants in large pots. Two at home free-range chickens peck around him.

"He likes to make it look like he's doing something when we have guests," says Stefan Braunewell.

He laughs. It's his grandfather he's referring to. *Opa*, as he's affectionately called, continues to work as if he hasn't heard anything. He follows along but doesn't interfere. He doesn't do that much anymore.

Rheinhessen

↓

49°55'34.2"N

8°09'04.5"E

↑

10⁴⁵ CET

From local tradition to global inspiration

Weingut Braunewell in Rheinhessen, Germany's largest wine region, is a typical family business. Today, three generations are involved. But the heritage stretches all the way back to the time when the Huguenot François Breiniville—a French Protestant—fled France due to persecution by Catholics. His escape stopped in Essenheim in 1655 where he got his own small farm—and where his descendants have lived ever since on top of the hill at the end of town.

The history of Braunewell parallels the history of German wine—with a respect for the local grapes and traditions and with a natural sense of responsibility to make the wine demanded by locals. That's how it's been since Adam Braunewell—that is, Opa—bottled his first wine back in the 1960s. Nowadays, the newly renovated winery, with its tiled driveway leading the first guests of the day directly into a modernly designed wine cellar, is testament to all that has happened since then.

The development gained momentum particularly in the last fifteen years as the two brothers, Stefan and Christian, took more and more control. They are among the many young winemakers in Germany who have taken over and given their parents' businesses a new lease on life. Quietly, but very deliberately, they have tried to find a new balance between tradition and innovation. Between local and international.

Part of the tradition is about making wine for every taste, and with a range of forty different wines, Braunewell's local customers don't have to look elsewhere for their needs. Certainly not all those happy customers who swear by the winery's popular white wines made from local Riesling and Grauburgunder grapes, which account for around sixty percent of Braunewell's production.

As for innovation? That has happened more subtly. Stefan and Christian Braunewell are both wine graduates. One's CV lists apprenticeships in South Africa, Austria, and Bordeaux in neighboring France while the other has been in Burgundy in France, Austria, and New Zealand. But they both returned to Essenheim and cast fresh eyes on the family's wine production. The brothers have also recognized the necessity of embracing the conservative habits of both the customers and their own family so as to change them.

This applies not least to the production of rosé. The international rosé wave was started roughly at the same time as Stefan and Christian's takeover of the family business, and additions have been made over the years. But it wasn't until one of their regular customers from the city knocked on the door one late summer day in 2014 that Braunewell's rosé adventure was really kickstarted.

The customer had just returned from a summer holiday in Provence, and he'd had a brainwave.

A national identity

Germany is, in many ways, a great rosé nation. It's where most rosé is consumed after France. But in the country, local production of rosé has lagged behind the crisp white wines and elegant red wines for which Germany is so well known. In fact, the Germans consume more than double the rosé they produce.

This has led to a massive import of pink wine from France and Italy in particular, all while conservative virtues cause German producers to hold back and not jump on the rosé wave in the same way as their colleagues in many other countries have. But rumblings are underway. German rosé wine is on the rise, and over the course of a decade, production almost doubled in the country.

As a genre, however, German rosé is still new. Many methods have been tried, so it's still difficult to get a clear definition of German rosé wine, but an increasing number of producers are able to combine the immediately fresh and summery, which characterizes a modern rosé wine, with a serious approach to production. And all while they fight together to give their wines a national identity in a worldwide and much sought-after category.

Germany is first and foremost a white wine country, but today the nation actually has the largest planting of Pinot Noir—in German *Spätburgunder*—worldwide. This is a result of the rising temperatures, which help German wine producers make fully mature red wines of high quality. But it also enables the production of rosé wine, which differs from the more traditional German rosé wines made from German grapes such as Dornfelder, Portugieser, and Regent.

Even use of the Francophile word "rosé" alone is groundbreaking in Germany. *Weissherbst* and *Rotling* are designations for Germany's more traditional rosé wines, which are made in different ways. Weissherbst is made from just one grape, whereas Rotling is a blend of blue and green grapes vinified together and typically gives a darker rosé. The last category includes both *Schillerwein* from Württemberg and *Badisch Rotgold* from Baden.

Braunewell has had three different versions of Weissherbst—made from the traditional German red wine grapes Dornfelder and Portugieser as well as Spätburgunder. The wines, which were sold in one-liter bottles, had a lingering sweetness that, together with ever-present acidity, made them juicy and very easy to drink.

"To be completely honest, Christian and I think Weissherbst is a slightly boring wine, and when we started taking over, we actually wanted to get rid of it. So we had a big discussion about it in the family—about whether we could or not," says Stefan Braunewell.

It was back in the mid-2000s when the rosé revolution had slowly begun to evolve in France and the USA, in particular. In fact, it was precisely at the time when Sacha Lichine from Bordeaux bought Château d'Esclans in Provence and really accelerated development.

The Braunewell brothers, then in their early twenties, were ready to take the family vineyard by the horns. Through their wine studies and visits abroad, they had encountered rosé wines more exciting than their own being made all around the world. And which, for instance, were characterized by blending several different grape varieties.

Yet they knew many of Braunewell's customers were happy with the slightly sweeter and easy-to-drink wine they had made thus far. And if the brothers were quick to forget this, both their parents and grandfather were happy to remind them.

The matter was put on the agenda of the Braunewell's family discussion, and after debating back and forth, the family landed on a pragmatic way to cover all bases. Braunewell would stick to its Weissherbst, but Christian and Stefan were given permission to try to make a rosé wine with more international flair.

"Back then there was a demand for rosé. Everyone talked about rosé, but no one was really making it in Germany," says Stefan Braunewell. "As a student, I entered a sommelier competition in Paris where we had to evaluate some rosé wines. Seeing how much the wines differed from what we made at home was very interesting. Maybe it was the first step toward a new focus on it?"

We're now sitting in the vinothèque where a lively atmosphere has spread as more patrons have arrived. English, Dutch, and German are spoken at the tables, and there's red wine, white wine, and rosé wine in the glasses. The large picture window offers a view of the tall vines just outside. The vines are much taller than we have seen in other wine regions. Then again, there's more space between the rows, so the sun's rays can hit the lower part of the vines better.

At the end of each row of vines, a small sign displays the grape variety and its properties, so guests can take a stroll and have a look—and perhaps even learn a little. And a spotlight at each row stands ready to be turned on and illuminate the vines when it gets dark later. For wine is also about creating a good atmosphere. Half of Braunewell's wine is sold directly at the winery—the concrete result of all that is being done to attract guests and give them a good experience.

Just outside the window grows St. Laurent, an old Central European grape variety, which is most widespread in Germany and Austria today. It can be difficult to grow as it flowers early, ripens unevenly, and has a fluctuating yield. In terms of taste, it's somewhat similar to Spätburgunder—with red berries and a slender structure. And it was one of the grapes Stefan and Christian Braunewell used when they made their first rosé in 2006.

They blended St. Laurent with Merlot and Syrah as well as a smidgen of the local varieties Portugieser, Dornfelder, and Regent. A total of six different grapes, all of which were picked early, i.e. a tad unripe, and from fields that were actually meant to be used for red wine—with the ambition to make a rosé with more bite, more tannins, and a longer taste. A wine that could pair well with food, but which was still a classic summer wine to be enjoyed in a large glass with ice.

"We always thought it was a really good rosé," says Stefan Braunewell.

He pours the wine, which bears the very descriptive moniker "Summer Rosé." That first year Braunewell produced 2,000 bottles, today production has increased tenfold. And with good reason—both the customers and the three generations of the Braunewell family are actually quite satisfied with how it turned out.

"But," he adds, "then Frank came by."

Weingut Braunewell is a typical family business. Three generations run it together now. But the heritage stretches all the way back to the time when the Huguenot François Breiniville fled from France.

"I piqued their interest"

Frank Dinter parks his white Mercedes at the edge of the vineyard. It doesn't do well on the smooth grass roads and steep inclines that define Braunewell's thirty hectares of vineyards located within a three-mile radius of the winery.

Rheinhessen is "the land of 1,000 hills" and measured in height above sea level, Braunewell's vineyards stand at 460 feet, which presents both challenges and opportunities in production. We're gathered at the top of one of the slopes with a good view over the area of vineyards, the river Selz, and a cluster of houses in the neighboring town of Elsheim.

Over the years, many of the local residents worked at an Opel factory in the nearest larger city, Mainz. They worked for the factory in the mornings and then toiled in their vineyards in the afternoon. It's not like that anymore. Whereas 125 families once worked with wine in the area, only six families remain. And Braunewell is the local market leader.

The soil is rich in limestone, especially on the top of the hillside. Frank Dinter has come across us at a point where the slope is so steep he has to jump between two transverse rows of vines. It exposes some soil with white lime, which can be dug out in large pieces with bare hands. The lime gives minerality and acidity to the wines. The wind at the top of the slopes helps give the Spätburgunder grape an extra-long ripening time too, so it can better release its potential and produce wines with elegance, depth, and fruit.

It's here we find the specially selected plots of grapes, which are currently exclusively used for rosé wine. Because Braunewell is no longer only making rosé from grapes whose primary purpose is to supply juice for red wines. And they can thank Frank Dinter for that.

He's a marketing manager in a German energy company, and lives in Essenheim, but travels frequently to France, which also gives him an excuse to cultivate his interest in wine further. Often, the trip takes him all the way down to southernmost France, and interspersing Dinter's familial obligations during the holiday are visits to Domaines Ott, Château d'Esclans, Minuty, Miraval, and other icons of Provence's rosé.

"We've tasted a lot, and for the most part they're good," says Frank Dinter. "When we're on vacation, we always drink rosé with our meals. It made me think about how we always drink either red or white wine when we eat in Germany. And I became fascinated by the fact that no really good rosés are made in Germany."

One late summer day in 2014 when Frank Dinter and his family had just returned from vacation, he dropped by Braunewell where one word about wine with Stefan and Christian led to another, which, in turn, led to a concrete proposal:

"Why don't you make a good rosé? I asked them. They laughed and said there was no market for it because German rosés are so bad—and it would be very expensive to make a good rosé. So I said then make a wine that's so good it's worth paying for. That's when I knew I had piqued their interest."

From local tradition to global inspiration

With the ambition of taking German rosé to a new level, brothers Stefan and Christian Braunewell partnered with Frank Dinter to make Germany's best rosé.

Frank Dinter was right. He had piqued their interest and ignited a spark in the brothers, who once again went to the family and got support for taking rosé wine to a new level. But they had one condition when they returned to Frank Dinter. They wanted him to be part of the project. He said okay, and the brand Braunewell-Dinter was born with an ambition to make Germany's best rosé. Whatever the cost.

By separating the new rosé brand from Braunewell's traditional production, the two brothers and their good friend gained a few extra degrees of freedom in their mission to do something no German winemaker had managed to achieve so far. They agreed it was an experiment and if it went wrong, it wasn't to rub off on Braunewell.

"It was also about Braunewell being known for good quality at moderate prices. We don't have the most expensive wines. And we wanted to give our rosé the opportunity to hit a different price point," says Stefan Braunewell.

So armed, the three new partners were ready to challenge the consumers' perception of what a German rosé wine could be—and cost. They wasted no time. They shook hands in September 2014 and already the following month had selected the first vineyard to produce the grapes for their new rosé. A high-lying parcel with Spätburgunder grapes, which sloped to the southeast and so received a little less heat and sun than the more southwest-facing fields.

Before long they had wine to bottle. Except they had no bottles. So they began searching around the globe and landed on the so-called Paris bottle, which is used for both Ruinart Champagne and the rosé wine from Miraval in Provence. And in a bold move, they didn't glue a label directly onto the bottle. Instead they hung it around the neck of the bottle on a piece of string. All to signal that a very special German rosé wine had come into the world.

The ambition wasn't only to make the best rosé wine. The trio also wanted their wine to taste like where it came from. So even though the role models were the titans of Provence, who, for instance, inspired them to age their rosé wine in oak barrels, Braunewell-Dinter went for a taste that was their own. Which meant, it was only right to select the German version of Pinot Noir as the main grape.

"Spätburgunder has the ability to absorb the distinctive aromas from the limestone and the herbal flavors. We wanted the wine to show our passion for the climate and the region we come from. That's also why it's important the grapes are only picked when they're ripe," says Stefan Braunewell.

The result is spot on. They sell out of each vintage even before the season is over—as popular rosé producers in other wine countries have increasingly been reporting over the past ten to fifteen years. And from the get-go, they received positive feedback from the established wine community.

The highlight came in 2020 when the 2018 vintage of Braunewell-Dinter's flagship rosé, "der Rosé," was first voted Germany's best rosé by the German Wine Institute—and later that year won The International Rosé Championship, having been selected by a jury of several renowned wine critics.

It comes down to balance

Twisted glass tubes inserted into the stopper of large wooden barrels in the warm and slightly damp cellar emit bubbling sounds. The heavy smell of yeast indicates clearly that fermentation of the year's harvest is underway. It's the juice from the grapes picked a few months ago being turned into wine at the beginning of December.

The first fermentation, where the sugar has turned into alcohol, took place in refrigerated tanks. The excess heat from the cooling system is now being used to keep the temperature up in the cellar and thereby help the malolactic fermentation, which is in progress in the bubbling wooden barrels. During this process the malic acid in the wine is converted into the softer lactic acid, which makes the wine rounder and creamier.

Maintaining the acidity in the wine is an ever-greater challenge for rosé producers in warmer wine regions due to global warming because the grapes ripen faster and develop more sugar. So, more and more producers choose to block the malolactic fermentation, typically by adding sulfur.

This is less of a problem for producers in cooler wine regions. And at Braunewell, it also means they don't need to pick the grapes until they are fully ripe—and that both fermentations can be carried out, which gives the wines greater complexity as well as aging potential. For the same reason, both maceration—where there is skin contact in the first hours of fermentation—as well as the original saignée method, where light juice "bleeds" from the grapes before they are used for red wine, are used.

These traditional methods of making rosé are increasingly being deselected in warmer wine countries where the grapes are pressed immediately and where there is only skin contact during the pressing itself. This is done to avoid the wine getting too many tannins and too much color and so losing its elegance. But at Braunewell-Dinter, they use all three rosé methods to achieve the perfect wine.

Christian Braunewell has stuck a large pipette into one of the bubbling wooden barrels. The barrels contribute minerality and round off the wine further as it gets a little oxygen. In return, the barrels steal some of the fresh fruit flavor from the grapes, so this part of the process is a careful balancing act.

He draws up some wine so we can have a taste. The wine smells of gunpowder smoke—or like when you strike a match. It's the limestone from the sloping fields penetrating right up our nose. The wine still has a high acidity because the malolactic fermentation isn't yet complete. The three partners are very satisfied. The summer brought a lot of rain, and they worried it would dilute the taste of the terroir—but that doesn't seem to be the case.

However, there are still challenges to overcome before the wine can be bottled. One of them is time. Aging on the lees—the yeast residues—gives flavor to the wine. But having the wine ready for spring is pressure. Demand for rosé explodes then—and it's always the latest wine that's in the highest demand. It's the same frustration that several other rosé producers, including Daniel Ravier from Domaine Tempier in Bandol, express. Even at Braune-well, they have to compromise a little.

"It's a challenge for us to get the wine on the market at the right time, and at the same time ensure the quality by leaving it on the lees long enough. It must have fruit, but it must also be a real wine, a serious wine, so it has to have taste notes from here, some tannins, something creamy, but also acidity. A little bit of everything, but not too much of anything," says Christian Braunewell.

Another challenge is blending the final wine. What is the right balance of grape varieties? How much of the wine should have been aged in wooden barrels—and for how long? And how large a portion must come from wine made using the various methods of making rosé wine. For Frank Dinter and the Braunewell brothers, it's one of the highlights of the year, but it's also the most demanding part of the process of achieving the perfect wine.

"Many rosés start with something big, but soon after you don't have much left in your mouth," says Christian Braunewell. "You need balance from start to finish. You should be able to love drinking it young but also be able to drink it when it has aged. It must be good all the time—when it's young and when it's old. It's really hard."

Emotions often run high when the three partners strive to reach the right blend—and it can be necessary to meet many times before they agree on the year's recipe for success. Stefan Braunewell wants some bite, his brother goes for the refined notes, and Frank Dinter wants something with an edge.

"I want a rosé that surprises me when I put it in my mouth. It should annoy me a little. And it should make me think, 'wow, what's going on here?!'"

For the two professional winemakers, having an amateur involved in the process is invaluable. It gives an extra dimension to the tasting and ultimately a better opportunity to hit a style that quality-conscious rosé consumers love, emphasizes Stefan Braunewell.

"We try to keep Frank out of the daily operations. If he tastes too many wines with winemakers, he'll lose his view of wine. It's good for us to be challenged by an outsider."

Quality doesn't need to be complicated

Today, rosé makes up twenty percent of Braunewell's total production. This includes the wines made in partnership with Frank Dinter. This range consists of "der Rosé," which also comes in a sparkling version, as well as its little brother "Im Namen des Rosé" (In the Name of Rosé). And then there's Braunewell-Dinter's latest flagship, "der Rosé Gold," where the first vintage from 2020 came on the market in May 2022 after nineteen months in small oak barrels.

The share of rosé wine is greater than before—but less than what it will be in five to ten years. Because with the increasing focus on quality by those who make and drink rosé, the rosé wave will continue to advance in the wine world. And the traditionalists can look forward to being challenged more and more in the coming years, according to the Braunewell brothers.

Certainly because part of the popularity of the rosé category stems from the longer summers we have due to climate change, which creates a greater demand for rosé. And the fact we are eating more vegetables and white meat also plays a role. But at the heart of what is driving the rosé wave is a changed approach to wine from new generations of wine drinkers in particular.

"It's very telling that in the land of the wine's birth, France, people drink more rosé because it's a wine that's not so complicated. Many people, especially the young, aren't interested in detailed discussions on rosé—terroir, the variety of grapes, and so on. They still want minerality, but I don't think that's what they talk about when they talk about the wine. What they do talk about is quality. It's an exciting development to be a part of," he says, adding, "It doesn't have to be that complicated."

Despite Braunewell having made one of Germany's best rosé wines, France will still be part of their history. It was there that Frank Dinter got his idea. And it's also there that they strive for the ultimate recognition of their wine.

"My big goal is to see our rosé in Provence," says Frank Dinter. "The day a restaurant in Provence sells our rosé will be a proud day for us. We're trying but we haven't succeeded yet. The French are very proud. They've laughed at us. But we keep going."

Stefan and Christian Braunewell are among the many young winemakers in Germany giving their parents' business a new lease on life.

The international rosé wave was started at the same time as their takeover, but the brothers' rosé adventure only really took off in 2014

when the first batch of "der Rosé" came into the world.

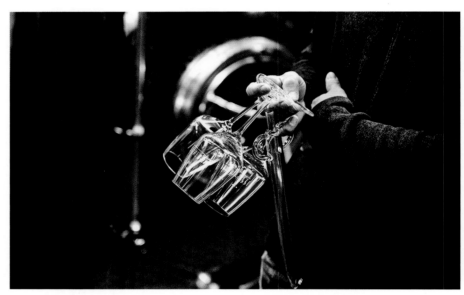

From local tradition to global inspiration

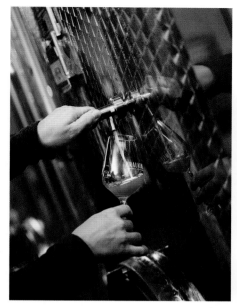

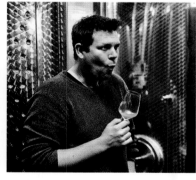

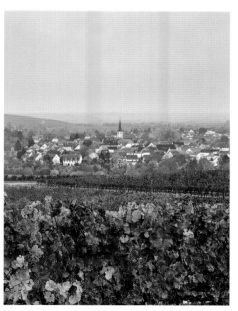

From local tradition to global inspiration

The high point for Braunewell-Dinter came in 2020 when their flagship rosé was announced as Germany's best rosé and later that same year won The International Rosé Championship.

BORN ROSÉ BARCELONA → JANA ROBLES

A Barcelona state of mind captured in a rosé

A wine's origin is about where you drink it and who you drink it with. That's the philosophy behind Barcelona's very own rosé wine that reflects the city's lifestyle and has made the wine a pop culture phenomenon.

Excited, Jana Robles lifts a hand from the steering wheel and points up to the blue sky as she continues to navigate her pale blue SUV through the traffic of the beautifully captivating city. It's the middle of the day, and the sun's rays are trying to penetrate the tinted glass of the car's sunroof.

We've driven by department stores, brand flagship stores, and supermarkets on the busy Diagonal Boulevard, which cuts through Barcelona, and have just passed the city's most famous street, La Rambla. Now we're heading down toward the Gothic quarter where people and pigeons are flocking around the fountain in Plaça de Catalunya. Cafés, restaurants, and street vendors gather at the city's cathedral—creating the mix of historical weight and vibrant life that epitomizes the Spanish metropolis.

Our driver is the city's best guide. She laughs as she reminds us of what she has repeatedly told us.

"What did I say! The sun always shines in Barcelona."

In Barcelona, the sun shines 320 days a year. Even on this winter's day, the mild weather brings life and activity to our tour, which continues toward the sea and harbor that for centuries have helped define the city.

We continue along the edge of the old town, El Born. In the Middle Ages, it was the center for the aristocracy who built lavish palaces there—but after a downfall in the twentieth century, the neighborhood is

Barcelona

↓

41°24'03.3"N

2°07'51.0"E

↑

14³⁰ CET

A Barcelona state of mind captured in a rosé

now one of the trendiest in Barcelona. Home to artists and entrepreneurial artisans, with winding, cobbled streets of designer shops and bars that unfold to reveal a vibrant nightlife once the sun goes down.

The neighborhood stops at the six-lane Passeig de Colom where tall palm trees attract the sun's rays and form a shining green avenue down to one of Barcelona's most famous monuments, a nearly two-hundred-foot-high statue of Columbus. The boulevard marks the transition to the stylish port area, Barceloneta, which used to be a charming abandoned industrial area and home to the local fishermen, but which today offers beaches, bars, and expensive apartments. And the marina—our destination.

Through the rolled-down windows we catch the scent of salt and sea. Jana Robles parks the car about 160 feet from a yacht where a group of people are standing expectantly. She hops out of the car and waves as she opens the trunk to take out two cases of wine.

The name on the boxes is Born Rosé Barcelona.

For it was born in Barcelona. It's named after the city's most progressive and dynamic district. And it's a rosé wine.

It's her own wine. Jana Robles has made Barcelona a city of wine. Not by planting vines in the city's parks or by installing vinification equipment in their cellar. But by launching a wine that mirrors Barcelona, its values, and the welcoming lifestyle that thrives in the city where the sun—almost—always shines.

Because at Born Rosé, it's not about vineyards and grape varieties but about experiences and moments. About pulling the cork out of a bottle and seeing what happens. In this way, the young brand is joining a trend that has grown up around the rosé boom in recent years where the wine has gained status as a marker of the good life. An inclusive, unpretentious, and uncomplicated wine aimed at those going for quality and good experiences but who don't necessarily want to swish wine or talk about terroir when drinking a glass.

They don't want that at Born Rosé either.

"We want to change the whole way of thinking about wine," says Jana Robles. "If more people enjoy the wine without having to think about the technicalities, and we're a part of that revolution, then we're happy."

Spain's strongest brand

Born Rosé is one of the world's first digitally native wine brands. There are no physical premises to visit—only a website ensures direct contact with customers all over the world. Their philosophy is completely different from that of classic wine houses. They believe a good wine doesn't need to have a special history, a specific origin, or a special grape. That's why the only thing written on their bottles is the brand's name, the year of the wine, and "Barcelona"—even though the wine isn't made in the Catalonian capital at all.

"Many customers just want to enjoy wine," says Jana Robles, who is the CEO of Born Rosé. "For us, the origin of a wine isn't about where it comes from, but about where you drink it, and who you drink it with. Hopefully, the wine will help create a memorable moment."

Jana Robles comes from a family who owns wine businesses and restaurants and has a background in sales and marketing. When she co-founded Born Rosé in 2019, she had worked in the baby products industry, had come home from a job in China, worked in Amsterdam, and was ready for something new.

She originally founded Born Rosé with Ferran Vila, who is educated in wine production and worked at a traditional Spanish winery, and Guille Viglione who is an advertising partner and also has a close relationship with the gastronomic world. Today Jana is running Born Rosé with other colleagues—all women and all from Barcelona, living with their families in the city.

These Spanish women have poured all their energy, expertise—and savings—into realizing their ambitions of creating something new that could capture their great love for their hometown and at the same time take advantage of the city's position as probably Spain's strongest brand.

Those behind Born Rosé got their motivation from following the rosé revolution and the disruption the younger generation of wine drinkers, in particular, have spawned by taking a liberal approach to conventions and traditions and increasingly being seduced by a more immediate desire for pink elegance.

For new rosé drinkers, elegance equals pale, bright, and dry wines with a crisp acidity—like they are produced in rosé wine's land of birth, Provence. And Born Rosé found its inspiration largely in the southern French region, which is associated with a somewhat similar lifestyle as Barcelona. And where producers, such as Château d'Esclans, Domaines Ott, and Miraval, are points of reference for the new Spanish producer when it comes to the style of the wine.

"The brand was created out of the realization that Barcelona—our city, the city renowned for summer, sun, and good vibes—didn't have its own rosé. We wanted to start a rosé revolution from right here in Barcelona," says Jana Robles.

And so the founders developed a recipe that's well on its way to becoming a success. Starting with a city that's not known for wine, they took a wine known for the same values as the city of Barcelona and combined them with the goal of making Spain's best rosé.

Spain has to play catch-up

The Spanish have a long history with rosé wine—or *rosado*, as the wine is called in Spanish. After neighboring France, Spain is the country that produces the most wine in this category. It's predominantly wine at the cheap end, which hasn't garnered much recognition, but that many consumers have liked. This applies both in Spain and abroad to where a large share of Spanish rosé wine is exported. In fact, around forty percent of all exported rosé is from Spain.

Rosé wine has been the specialty of the small northern Spanish wine region of Cigales—with around half its total wine production dedicated to rosé wine. Among the larger Spanish wine regions, Rioja and Navarra have accounted for the largest volume.

From around 1950, Spanish producers began to copy their French colleagues and produce rosé according to the saignée method—that is when the wine is made from the juice of grapes that are ultimately to be used for red wine. And in the 1970s and 1980s, there was demand for easily available, fruity rosés with a certain level of color from the late-picked red wine grapes.

Until the 1980s in Navarra in particular, almost all vineyards were planted with Grenache, which was used to make a cheap, fruity rosé. Today only about a quarter are. This is partly because demand for darker rosés has fallen.

The focus has long been on volume, but an increasing number of producers are starting to make wines with more of their own style and reflection of the area they come from—whether they are made from local or international grapes.

It has contributed to a growing Spanish rosé boom—the Spanish themselves are beginning to appreciate rosé wine and not just as an anonymous thirst quencher. And they are prepared to pay a higher price for a rosé wine. Several southern French producers have spotted the potential in the Spanish market that hasn't been fully exploited yet. And naturally, that's an interesting development for the country's own producers too.

"The Spanish market is growing much faster because we're so far behind and have some catching up to do," says Jana Robles.

Born Rosé's ambition is to have the whole world as its marketplace. Today the wine is sold in more than 25 countries on four continents. However, Spain is the biggest market—their home city, Costa del Sol, the coast south of Barcelona, and the vacation islands of Mallorca and Ibiza are the greatest rosé magnets.

"When we started, our pale rosé wasn't very popular in Spain. Now a lot of brands are into pale rosé. So it's good news for the category, and even if we end up with more competitors, it's still good news for us. Our customers recognize our rosé as luxury."

Born Rosé aims to give quality-conscious consumers what they want—in a way that is best described as wine populism. Many resources are used to get to know the target group—and to constantly find new ways to reach them. This is done by collecting and analyzing extensive data on their consumers' behavior. And then, prior to launching new products, they test them on their defined customer profile: A woman in her thirties, relatively wealthy, who likes brands, and loves wine. They call her "Sophia" and in all their most important markets—Spain, Germany, the UK, Benelux, and the USA—they have identified several similar people who they then invite to form focus groups.

A Barcelona state of mind captured in a rosé

A group of employees and good business contacts enjoying themselves at yet another Born Rosé event where the brand's product is supported by what is at its heart—having fun.

Here the participants taste the wine—first in a black glass so as not to be influenced by the color and then in a regular wine glass. In this way, a large number of women in several countries are helping to determine the wine's taste, color, and bottle design—and the process clearly reveals how important both color and design are.

Every detail that can strengthen the relationship between the customer and the product is to be utilized. To support the wine's relationship with Barcelona, the rosé bottles from Born Rosé are inscribed with patterns inspired by the designs on the flagstones of the city's streets. And to really target "Sophia" as best as possible, the brand has developed a rigorous visual branding consistent across all platforms, including social media—and where it's difficult to find a picture where pink colors aren't dominant.

Over time, the Born Rosé team have had to define another profile to supplement "Sophia." One they hadn't expected from the start—a man.

"Fifty-five percent of our customers are women. But that also means that around forty-five percent are men. We can see this from the data we get from the people who visit our website and buy our wine. It's a very positive surprise," says Jana Robles.

Nerdy climate stuff

A select group of employees and good business contacts are waiting at the dock. On the water bobs the white yacht ready to welcome another Born Rosé event on board where the company's product is supported by what is at its heart—having fun together.

It's not just for fun though. The boat company De Antonio is one of Born Rosé's regular partners, and together they have a strategy to brand themselves and each other on Barcelona also being about water and beaches, which supports the products they each have to offer.

The boat is loaded with the two cases of wine and a large platter of Black Iberico serrano ham, and ten minutes later, we're on our way out of the inner harbor at Barceloneta where a luxury superyacht passes before we're out on the open sea. The first wine bottles are uncorked and set in their place under the boat's sunroof on the specially designed table where four recesses match the dimensions of the bottles.

A new skyline of the city comes into view, the focal point of it all. Barcelona's cathedral appears again. The narrow towers of Gaudí's unfinished church, the Sagrada Família. Right next to the cathedral is the Torre Agbar glass tower, which is shaped like a giant penis—and is rarely called anything else by both locals and tourists. This is also the case onboard the boat where the passengers hold a glass of rosé wine in one hand while they point to buildings they recognize with the other—all while trying to keep their balance on the gently rocking boat.

The wind is blowing out on the Mediterranean, sending breezes across the coast. With the many hours of sunshine, the hot temperatures in the summer, and the correspondingly mild winter, the climate is very reminiscent of Provence's. Which means it's also a good place to produce rosé.

Born Rosé's wines are produced about eighteen miles farther down the coast—in one of Spain's most

important wine regions, Penedès. Agreements have been made here with wine producers who get their grapes from local winegrowers and who, in collaboration with Born Rosé's own team of oenologists, strive to create the exact wines the many "Sophias" around the world would most like to have.

The total production is approaching half a million bottles. The wines are made from the world's most popular rosé grape, Grenache, as well as the local Tempranillo, and the production is one hundred percent organic. The grapes are cooled before they are pressed, and the juice is allowed to remain in contact with the skins for three to four hours, so the wine acquires a delicate amount of color and a hint of tannins. The result is easily accessible wines that feature a style very reminiscent of a good rosé wine from Provence.

This applies to Born Rosé's standard rosé, which also comes in a sparkling version—and both the still and sparkling wine are also sold in the latest craze in rosé wine packaging—cans. Even Born Rosé's top wine, "503," named after the name of the wine's color, Pantone 503, comes that way. The wine, which accounts for only five percent of the production, is made exclusively from Grenache grapes from the high-altitude wine region of Terra Alta.

Jana Robles delights in sharing all this. And those interested can read about the process on Born Rosé's website—just click on "Wine Nerd Stuff" on each product page. The message to customers is quite clear: "Don't worry about it—just hurry up and open a bottle."

"Yes, the wine is from Penedès, and it's organic. But we like to skip over that," says Jana Robles.

It's a philosophy far from the thinking of most other wine brands, whose storytelling is tied to an area, a terroir, and often a family history stretching several generations. Born Rosé's founders are painfully aware they have certainly challenged some very traditional conditions in the relationship between wine producers and their customers. Especially considering they started out with prices at the high end of the market.

"We don't have a winery; we don't have a family. Will the market accept that? We weren't sure, so that approach was a gamble on our part. But the good thing is that ninety-nine percent of the population understands it," says Jana Robles.

Can't be taken too seriously

Recent years have demonstrated numerous examples of wine consumers not only understanding the trend but following suit. Several addressless wine brands have popped up—and they have built up a strong position and a good business by promoting rosé as both a wine and a pop culture phenomenon, particularly on social media.

The American influencer and entrepreneur Joshua Ostrovsky—better known as "The Fat Jewish—is one of them. With brothers David Oliver and Tanner Cohen, creators of the popular Twitter profile "White Girl Problems" as well as two bestselling books of the same name—he launched the brand Babe Wine, selling rosé in cans. Babe Wine did not make much of an effort to tell you where the wine came from but was so successful that the brand—with the motto "wine used to be sooo boring"—was acquired in 2019 by the Belgian beverage giant Anheuser-Busch InBev.

Another example is Yes Way Rosé, which began life as a hashtag on Instagram in 2013. Two women—Erica Blumenthal and Nikki Huganir—who, by their own admission, knew nothing about wine at the time—shared their enthusiasm for rosé wine. And based on rosé being not just a drink, but a lifestyle, it developed into a community of like-minded rosé fans. And it all culminated in the two women launching their own brand, selling rosé wine in collaboration with southern French winemakers—with the message that we shouldn't take ourselves too seriously.

Similarly, SoMe phenomenon Rosé All Day is also a hashtag on Instagram, Facebook, and Twitter where hundreds of thousands of rosé lovers share their passion by sharing photos of the wine. Rosé All Day has developed into a lifestyle brand appearing in the fashion world, at music festivals, gala performances—and which now also sells rosé wine in collaboration with southern French producers, in this case from Languedoc-Rousillon.

These brands communicate directly with consumers—their relationship is driven more by shared values than by a specific interest in wine. Such is the case with Born Rosé too, which is aggressive in its approach to social media where all brands regardless of size have a voice and an opportunity to communicate directly with end users.

However, some believe this development is at the cost of quality. Born Rosé has to contend with this opinion too, explains Jana Robles.

"We have to constantly prove that we aren't a gimmick wine. Mostly we just send samples to people and make sure they taste it—and the moment they do, the wine speaks for itself."

As part of Born Rosé's somewhat rebellious approach to the old world of wine, they don't want to be known for having won medals or for having received a certain number of points in some critic's review of their wines. But in order to reach a position of freedom to do this, they decided to enter the ring on par with the traditionalist from the start. Which is why in 2020—the year after their launch—they entered their rosé wine in The Global Rosé Masters competition, held annually by one of the most influential wine trade magazines, The Drink Business.

The wine was developed by a group of wine professionals in collaboration with Ferran Vilà—and was subsequently tested by hundreds of "Sophias" throughout Europe. And it turned out to be a winning formula because the wine took a gold medal in the competition where all the wines are blind tasted by professional sommeliers and other wine experts. Several other award—and top reviews from recognized wine critics like Jancis Robinson—have since followed for Born Rosé.

Being "cool"

After a few hours at sea, the yacht arrives in port. A passenger is seasick and has to go home. The rest of us continue to El Born where we sit at a bar serving Barcelona's very own rosé wine—and is thus entitled to the term "cool place." It's a moniker Born Rosé gives to all the places—bars, restaurants, wine shops—where their wine is sold.

It's important to be "cool"—to appear as a brand consumers want to identify with. It's not "cool" to be on sale in a supermarket. Nor to give a discount, which therefore happens very rarely. Then again, it's pretty cool to be on the wine list at Michelin star restaurants and exclusive beach clubs in Europe and the USA. Asia is on the list of future markets. And if it contributes to Spanish wine gaining greater recognition in general, the Born Rosé partners will be happy.

"The Italians and the French know how to sell themselves and their products—wine, olive oil, food—much better. If we can contribute to raising the quality of Spanish and Catalonian wines and become better at selling them, we'll be happy," says Jana Robles.

Born Rosé has no plans to make wines other than rosé. The company's digital mindset plays perfectly with rosé's target audience—and the partners are convinced this wine category will continue to grow.

"When we set out, we came in on a wave. It's a great wave that is still going strong and growing. Rosé is becoming a standard category. It's no longer 'the new kid on the block,'" says Jana Robles, who dreams of challenging the region that originally inspired them to get started.

"One of our visions is to show the world that we can make rosé as good or better in Barcelona as they do in Provence. And I think we're going to achieve that. Because like I said, the sun always shines in Barcelona."

Born Rosé's wines are a Barcelona state of mind in a rosé. They took a city not known for wine, and a wine known for similar values as Barcelona and combined them. The goal is to make Spain's best rosé—which is sold in both bottles and cans.

A Barcelona state of mind captured in a rosé

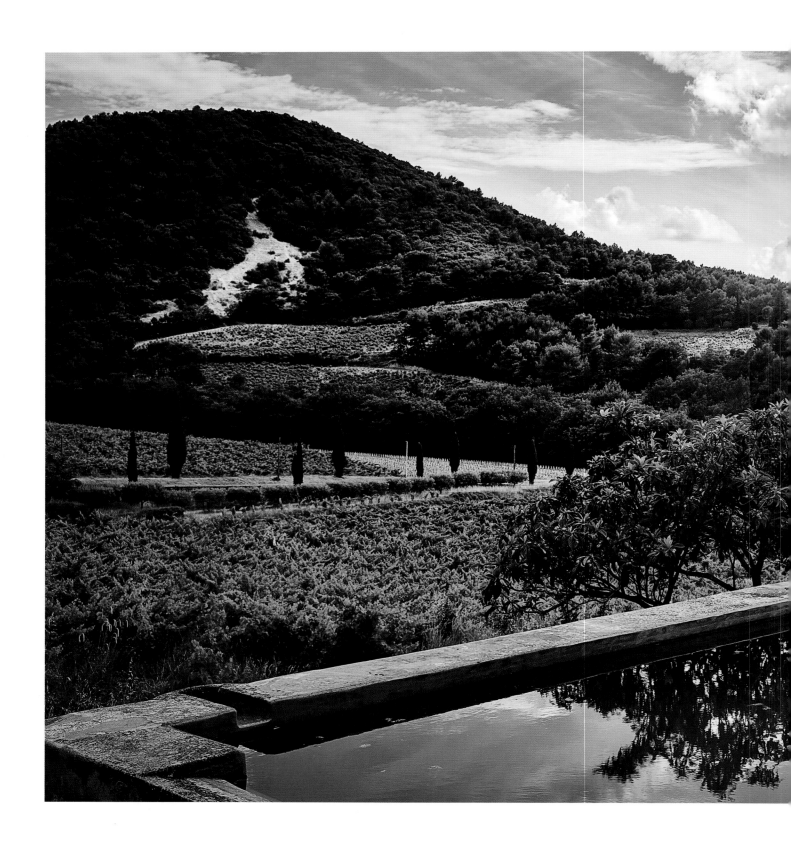

At many vineyards, basins are set out to collect rainwater. This allows the precipitation that falls to be utilized. It's a measure that is part of the increasing awareness of the environment among winegrowers.

The pink wine is often green

When you enjoy a good glass of wine, you can be seized by a romantic notion that what's in the glass is a natural product.

But as in the rest of agriculture, using chemical agents in the vineyards has been widespread among winegrowers for decades. In fact, the practice was so prevalent in wine-renowned France that it has damaged the environment and biodiversity. Thankfully, there's an ever-increasing awareness among farmers to cultivate the grapes in a way that doesn't harm nature. This includes the farmers whose grapes are used to make rosé wine. Several of them have particularly good reasons for sticking to natural products when they treat their soil, vines, and grapes.

Most vineyards with rosé wine grapes are located in areas with a warm, sunny, and dry climate. Many of them are located by the coast, which means sea winds regularly blow over the vines—for example on the Mediterranean or American West Coast. Along with the dry climate, the wind helps to dry the vines quickly after a rainfall. This reduces the risk of the grapes being affected by fungus, which in turn, lowers the need to spray the vines with pesticides.

In rosé wine's birthplace, Provence, the mistral keeps the plants dry. And in this area, where over ninety percent of wine production is rosé, an avowed policy among the winemakers is to make their production more sustainable.

In 2022, twenty-two percent of wine production in Provence was certified as organic. A further thirty-seven percent of the production was designated *Haute Valeur Environnementale,* which means the wines have a "high environmental value." They are more sustainable wines produced with an increased focus on biodiversity, the reduced use of pesticides, and limited water consumption. The goal of the association of wine producers in Provence is for one hundred percent of the production to be either organic or HVE certified by the year 2030.

There are producers who have always banned any use of chemical products in their vineyards because that's what yields the best grapes—and so were organic long before it became fashionable to be so. And then there are wineries who can see the commercial advantages in restructuring their production, so it's organic or biodynamic because customers are increasingly interested in drinking—and therefore buying—wine that has been produced without damaging nature.

The world's largest producer of biodynamic wines is Gérard Bertrand from Languedoc, who is also one of the behemoths of rosé wine. For him, it's not only about avoiding doing harm to nature but also about revitalizing the earth.

ANNA MARIA ABBONA → ANNA MARIA ABBONA

Piedmont sends hope of a brighter future

Little cracks in a conservative wine culture in Piedmont signal a future in which rosé wine earns a better reputation here too. For Anna Maria Abbona, it's about following the climate agenda.

For months the grapes have been looked after and cared for. Now they have given everything they had in them. Green stems and seeds break up the almost black mass of grape skins being pressed into small plastic containers and then driven into the adjacent workshop so as not to be in the way of the work in the wine cellar.

The vineyard is built into a ravine. A narrow road leads down to the entrance of the cellar where Franco Schellino has jumped onto a tractor with a new pallet of red boxes of harvested grapes that he maneuvers into the cellar and to the wine press where his son, Lorenzo, is ready to receive them. Standing on the tractor bed, he grabs the plastic boxes with bare hands and starts emptying them directly into the press.

With satisfaction, he notes there's no grape juice left at the bottom of the boxes. This means the grapes are of a high quality and haven't started to press themselves—not even given that they were picked yesterday.

The full boxes are too heavy for his father, who dismounts from the tractor and instead grabs a sprayer to squirt an enzyme that helps the grapes release their aromatic compounds directly into the press. He's also the one who regularly pours steaming dry ice down to the grapes to keep the oxygen away and the temperature down—and the grapes' acidity level up.

No advanced technological aids are found here. Father and son are dab hands; they know exactly who does what. Occasionally their conversation develops into something that might sound like an argument to outsiders. But don't worry about that, Lorenzo Schellino laughs: "It's just the way we talk. My father doesn't hear very well.

So we have to shout a little louder."

The passionate exchange between father and son as well as the hum of the wine press, which uses air pressure to press the juice out of the skins, can be heard on the terrace directly above. Here the conversation is between two groups of guests who have booked a wine tasting. The well-mannered host is Lorenzo Schellino's older brother, Federico. He talks about the wines as he moves between the tables and pours the wines into glasses.

From the terrace, guests have a view of a landscape of rolling hills with vineyards, forests, and abundant hazelnut bushes. The winery itself is located on top of one of the hills, and with good visibility on this sunny September Sunday, medieval villages and feudal castles can be spotted in the picturesque landscape embodying Piedmont in northwestern Italy.

Inside are two long wooden tables and a small bar where the winery's assortment of wines is lined up. Here Franco Schellino's wife, and the brothers' mother, is getting ready to leave. Her name is Anna Maria Abbona, and it's her name on the wines. She's on her way to the nearest town, Dogliani, to participate in a public meeting, which she herself initiated as chair of the local wine producers.

On the agenda is a theme she's passionate about: The survival of the small villages in the area and biodiversity in nature. For it's far more relevant to preserve the local culture and ensure sustainability in agriculture than to give wine producers the opportunity to earn even more money from making wines that are so popular around the world.

"On the whole, the families here have enough money to buy everything they need," she says. "So my vision is more about a sustainable life than about money and success. That's more important for the new generations and for the area."

A special vision for the future has driven Anna Maria Abbona for more than thirty years. During that time, she's developed into a recognized wine producer from the Langhe region. With a focus on originality and authenticity, she has primarily become known for developing quality wines from the local Dolcetto red wine grape.

Her vision for the future includes a desire to make rosé a more widespread and recognized wine in an area where red wines have traditionally almost monopolized the attention. Not to follow popular fads in the wine world but because Anna Maria Abbona and her colleagues want to focus on making wines that more closely match a diet with less of the fat and red meat that pairs so well with the strong, tannic red wines from Piedmont.

"I think rosé is the right way for the future. We have to think more about what we eat, and that means we have to think more about our wines, so they go well with vegetables, fish, and white meat. It doesn't mean we have to stop making red wine, but rosé offers an alternative to round off production in Piedmont."

Piedmont

↓

44°29'14.1"N

7°57'25.0"E

↑

10³⁰ CET

A call changed everything

The vineyard, located six miles south of the village of Farigliano and the same distance from Dogliani, is Anna Maria Abbona's childhood home. It was here that, as a child, she witnessed her parents working hard on the then two hectares of vineyards with Dolcetto grapes, which they sold to the local cooperative. It was a life where there was only just enough money for basic necessities, and which she wanted to escape quickly once she was old enough to move away from home. She studied art and design and worked for a few years as a graphic designer at an agency.

A call from her father in 1989 changed everything. It was immediately after the Italian wine industry was hit by a huge scandal when twenty-three people lost their lives after a producer cut his wine with methanol. This affected the demand for industrial Italian wine in the years that followed, and Anna Maria Abbona's father now found it difficult to sell his grapes. He was calling to inform his daughter he had decided to tear out the vines and sell the vineyard.

It was a turning point for Anna Maria Abbona and her husband, who also comes from a wine family. They decided to quit their jobs and take over the winery in Farigliano with the ambition of taking advantage of the white calcareous soil, the good climate, and the old vines to revitalize the entire area.

"I was a twenty-five-year-old with a vision. I didn't think it was the right time to sell. It was the time to think anew and create a project for the future. A project focusing on protecting the area by making good wines from the local grapes."

Succeeding at making good wines from Dolcetto proved more difficult than expected—the grape had traditionally been used to make a cheap wine drunk only by the locals. And which, incidentally, stood in the shadow of other grape types, such as Barbera and Nebbiolo in particular, which is used for the coveted Barolo and Barbaresco wines.

But Anna Maria Abbona was proactive. She learned German and started traveling to promote her wines, and in the late 1990s everything started to turn around. She was given the opportunity to buy more land and invest in a new cellar. And a new milestone was passed when, at the end of the 2000s, she bought two hectares in the Barolo municipality of Monforte d'Alba, from which she began producing top wines that have further contributed to her recognition and success.

Anna Maria Abbona looks out the window and points toward some old houses on the other side of the road that run through the small village. Recently the previous owner of the houses died, and she bought them. Not because she has specific plans for the houses but simply to avoid them being bought up by others who might think less about protecting old villages and preserving biodiversity.

This fear stems from the high-altitude vineyards in the area becoming more and more attractive due to global warming. The heat accelerates the ripening of the grapes and sends their sugar content skyrocketing, making it harder to make complex wines. For example, Abbona's vineyards in the Farigliano area are several hundred feet higher than the average Barolo vineyard. Therefore, many producers have a desire to come up in altitude to compensate for the rising temperatures. Plus, there's more wind here than in Barolo too, which has a cooling effect.

Many of the producers have large financial muscles at their disposal. Therefore, at today's meeting, Anna Maria Abbona is going to argue yet again for increased regulation to prevent all the land from being converted into vineyards—as well as for ensuring a balance of the crops that are typical for the area. New rules will also contribute to ensuring continued life in the villages—a requirement that's a direct extension of the vision for the future she and her husband formulated back in 1989—and which has been their guiding compass ever since.

A study trip to Bandol

The vines are blooming with large green leaves to protect the grapes from the heat. Even so, there are wrinkled, partially dried grapes in some of the bunches. It has been a hot and very dry summer, and this has stressed the vines. They don't have as many grapes as usual. Neither are the grapes as big as they usually are. This means less juice and so less wine. What the grapes do have though is a lot of flavor.

"Fortunately, all the plants have green leaves. That's a good sign. We had a year when the leaves were yellow—that's bad," says Federico Schellino.

On a break from the wine-tasting guests, he's driving us around the hilly area. Some of the vineyards are so steep we understand well why one of the tractors we saw at the winery needed to have continuous tracks instead of wheels. We pass a cluster of old houses. Federico Schellino's great-grandfather lived in one of them—no one lives there nowadays. The oldest vines are over one hundred years old. He stops at a south-facing field with Nebbiolo grapes.

The vineyard sits high in the terrain and its soil doesn't give much power to the grapes, which is why it's been selected as a rosé field. That also means it's typically harvested a week earlier than the other Nebbiolo parcels used for red wine.

"I helped plant this vineyard when I was sixteen," says Federico Schellino.

That was back in 2006. Since then he has studied finance and marketing and worked for wineries in both New Zealand and South Africa before returning to Piedmont to become part of the family business.

Federico Schellino was among the first to advocate for rosé wine being made—for which the Nebbiolo grapes from "his" vineyard are used. Anna Maria Abbona admits she has always been fascinated by rosé. A fascination that got free rein when she visited her cousin who lives in Provence—specifically the town of Menton, close to the border between France and Italy—and tasted the good, local rosé wines there.

It was difficult to find a good rosé wine in Piedmont. And when, around 2009, she realized there was a surplus of funding and energy in the family business for a new project, she persuaded her husband to take her on a one-week study trip to Provence where they visited wineries such as Domaine Tempier in Bandol, one of the pioneers of rosé wine, renowned for its gastronomic wines made from Mourvèdre grapes.

"My idea was to try to find a rosé wine with the same color, elegance, and complexity," explains Anna Maria Abbona. "So when we came back from Bandol, we decided to make a rosé wine with Nebbiolo because as a grape it's very elegant and it has so much complexity. We can't be compared to Bandol because it's by the sea and the soil is different, but we wanted to find a way to become a Langhe house for rosé."

A cheekier wine

Lorenzo Schellino unlocks the wheels of the mobile wine press to drive it out onto the middle of the tiled floor in the wine cellar. He presses a button that causes the bottom of the machine to open, and the pressed grape skins fall to the floor so they can be more easily cleared out of the way before being sent to the local cooperative to be used for grappa.

The grapes for rosé are pressed twice—the first light press releases a fine and elegant juice while the second gives more structure to the wine. The whole thing only takes twenty minutes—much faster than rosé producers who press for two or three hours so the juice can absorb a bit of color and tannins from the skins. But the Nebbiolo grape is so rich in color and tannins, the rosé wine can't not get any—even if the pressing happens so quickly and there's no maceration either. Plus, they don't have any temperature system to cool down the grapes and the juice and thereby control the wine's absorption of color and tannins at the small winery.

Lorenzo Schellino finds inspiration in the producers who make rosé by blending wine from several grape types—currently the most widespread method. Specifically, he's contemplating trying to blend the Nebbiolo grapes with some young Pinot Noir grapes the family planted a few years ago.

"I want to make our rosé even better," he says of the wine, which ages in steel tanks for six months before it's ready. "I'd like a little more 'kick' in the nose, and when you take a sip in your mouth—something that makes you say 'wow.' Our rosé is a bit serious; it should be a bit cheekier."

Lorenzo Schellino has a good grasp of developments outside Piedmont. Like his four-years-older brother, he ventured out to see the world and had no real plans to become part of the family business. He trained as a chef and worked for three years as a sous chef at an Asian Michelin restaurant in Frankfurt—with good prospects of one day becoming head chef in a top international restaurant.

In picturesque Piedmont, red wine will always be *numero uno*. But more producers are starting to explore the rosé category, which also matches our changing eating habits.

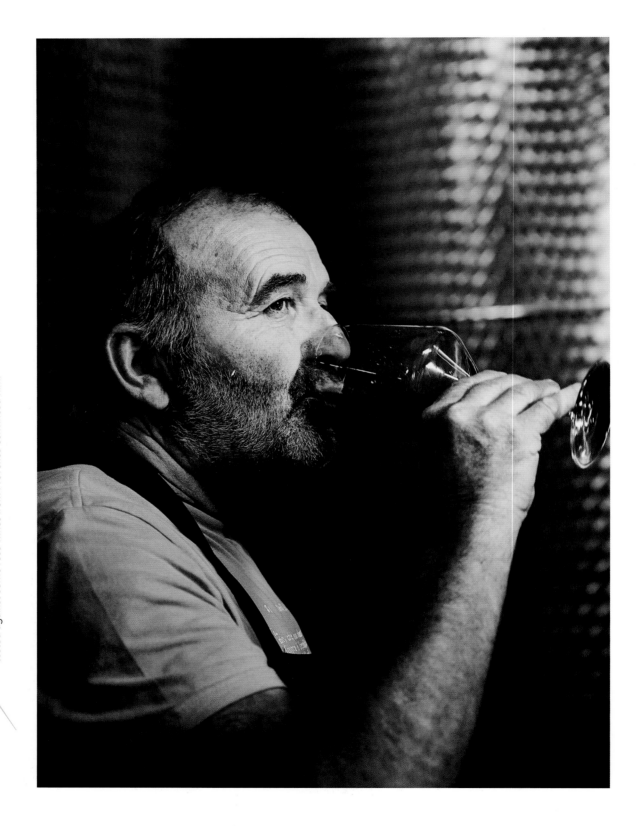

For a long time, Anna Maria Abbona's husband was against the family producing rosé. But a blind tasting where their own wine was tested against some rosé wines from Provence convinced him.

But then Anna Maria Abbona called her youngest son in Frankfurt and told him she had bought more land. So she needed more help, and if he was ever thinking about coming home, now would be a good time.

"There was no pressure, but for me it was a bit of a now-or-never situation," says Lorenzo Schellino, who decided to return to his birthplace to make his parents' visions his own—as well as add some of his individual ideas.

"Our parents encouraged us to travel. That's made us open-minded. We like coming home with new ideas. It's important for maintaining your passion, but it's also a constant battle with tradition."

This applies to rosé too. Here, he lets us in on a secret. For a long time, his more traditional father was against the family starting to produce rosé. Franco Schellino believed it would be far too difficult to enter the market. He was also afraid it would damage Anna Maria Abbona's reputation and affect the sales of their other wines. It was only when the family held their own blind tasting where they tested a sample of their wine against some good Provençale rosé wines that he allowed himself to be convinced.

Their father's concerns weren't unfounded. Piedmont has a very conservative wine culture, and for most, rosé equaled an awful, cheap residual product from red wine production—made using the saignée method. This gave the rosé category a bad reputation, which it still struggles with.

Neither has it been easy for Anna Maria Abbona to sell her rosé wine locally—production has therefore continued on a limited scale. But in the northern Italian wine region, signs of a development similar to the dramatic boom in other parts of the international wine industry are emerging.

For example, one of Barolo's true superstars, Roberto Conterno, bought the winery Nervi in Gattinara in northern Piedmont, from which he produces various wines, including a rosé he decided to put his own name on. A better seal of quality for the rosé category is hard to imagine. The wine is also made from Nebbiolo but with the addition of approximately ten percent of another local grape, Uva Rara.

"When we started out, people weren't ready for rosé. But now the market is getting there, partly because we started. We helped change the market," says Federico Schellino. He adds that his grandfather—who's still going strong—has a favorite wine now: Rosé!

"If he's in a bad mood, we give him a glass of rosé."

Floral notes and minerality

Red wine will always be numero uno in Piedmont. The good conditions for making fantastic red wines—and charging a good price for them—continue to be of paramount importance for most producers. And when it comes down to it, it's also the red wines that draw the many wine tourists to the area.

But Anna Maria Abbona hopes for a brighter future—in the literal sense too. This will be achieved by more producers in the area beginning to explore the rosé category and more consumers demanding the pale, elegant wines that match their changing eating habits.

"It was mostly for pleasure that I started making rosé in 2009. Today, I think rosé is the way of the future," she says. "I hope we can make more rosé in the future. We have to grow the market, so we need more people to come and ask for rosé. We still have many visitors who say 'no, we don't drink rosé.' But fortunately, I can see there's greater interest all over the world. It's crucial that rosé gains a better reputation—here in Piedmont too."

Anna Maria Abbona is very excited about her son's idea of making rosé from Pinot Noir, which has fewer tannins in the skins than Nebbiolo. But the Queen of Dolcetto doesn't expect this grape, which started it all for her, to produce juice for a rosé wine.

"It's a little too fruity. I don't care for that in a rosé. I'd rather have elegance and complexity. I want the floral notes and minerality I can get from Nebbiolo. That's my idea."

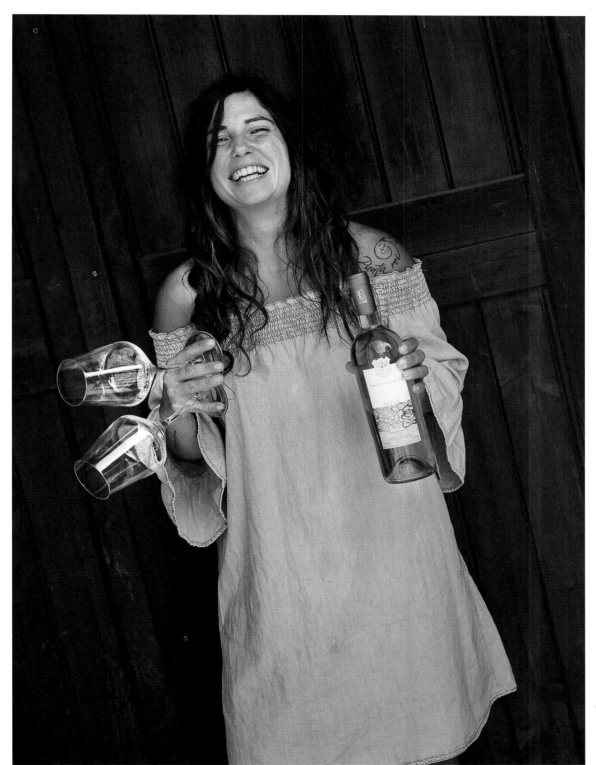

Many guests still say no thank you to a glass of rosé. The category has had a poor reputation, but it's turning around.

"When we started weren't ready now the market partly because we helped change the

→ Frederico Schellino

out, people for rosé. But is getting there, started. We market."

Piedmont sends hope of a brighter future

At Anna Maria Abbona, wine production is a family affair. At their parents' request, the two sons, Federico and Lorenzo, traveled widely and returned home with new ideas.

Thank you

Thank you to everyone who encouraged our project—wine experts, producers, friends, and family. Thanks to our Danish publisher, Gyldendal, for supporting the first edition of the book—and to Interlink Publishing for bringing it to an American audience. Thank you to the creative team for giving the book its unique visual identity. And most of all: A huge thank you to all the participating winemakers and producers for opening the door when we knocked. The Rosé Revolution lives on. .

Rasmus Emborg & Jens Honoré,
September 2024

Further reading

Claude Flanzy, Gilles Masson, Francois Millo: *Le Vin Rosé.* Féret. • Elizabeth Gabay: *Rosé—Understanding the pink wine revolution.* Infinite Ideas. • Victoria James: *Drink Pink—A Celebration of Rosé.* Harper Design. • Katherine Cole: *Rosé All Day.* Abrams Image. • Larry & Ann Walker: *A Guide to the World's Best Rosés.* Board and Bench Publishing. • Jennifer Simonetti-Bryan: *Rosé Wine—The Guide to Drinking Pink.* Sterling Epicure. • Gérard Bertrand: *Wine, Moon, and Stars—A South of France Experience.* Abrams.

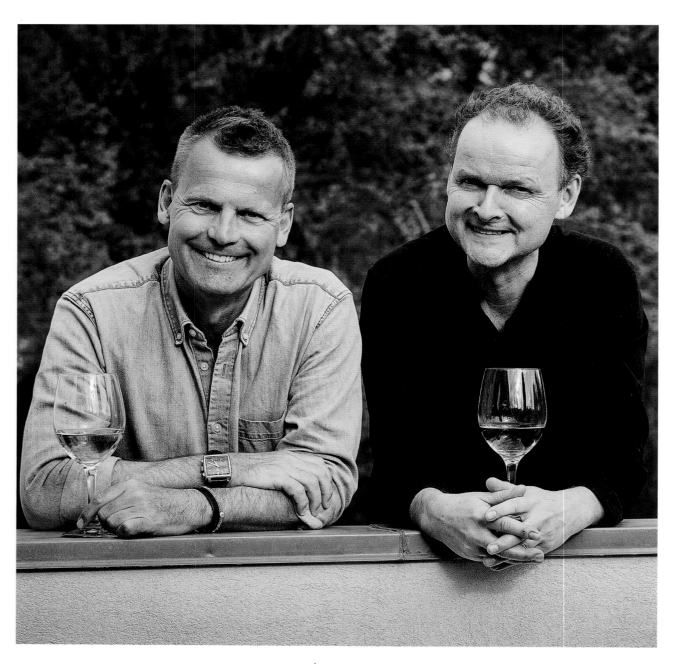

JENS HONORÉ & RASMUS EMBORG

Biographies

Rasmus Emborg

Rasmus is a journalist who has worked within the Danish media industry for thirty years and with some of Denmark's leading publications, such as *Politiken*, Avisen.dk, and *Børsen*. Today he's the Editorial Director of Watch Media with the editorial responsibility for the company's activities in Denmark, Germany, Norway and Sweden. He also runs his own business, working on book projects, courses, and lectures. Rasmus is the author of the book *Ølbrødre* (*Beer Brothers*, Gyldendal, 2019) about twin beer brewers, Mikkel Borg-Bjergsø and Jeppe Jarnit-Bjergsø. He and his wife own a small vineyard in Provence, France. The grapes are mainly used for rosé wine, and the production takes place at a local cooperative.

Jens Honoré

Jens is an advertising photographer who has worked with many clients over thirty years. Jens works regularly with the Roger Federer Foundation and SOS Children's Villages, an Austrian NGO for children, for which he is also an ambassador. In 2018, he published *A Place to Dream* for SOS Children's Villages and in partnership with Jens Vilstrup, he published the book *Farvel til en Sort/Hvid Verden* (*Farewell to a Black/White World*, Gyldendal) about the UN's 2015 Sustainable Development Goals. He also contributed to the book *Building a Dream* about LEGO owner Kjeld Kirk Kristiansen's realization of LEGO House. In 2021, he published *Alles Ret* (*The Right to Food*, BOOK LAB) about homeless people's relationship with food. Jens has been living in in New York, USA, for many years, and as a wine enthusiast, has followed the trend of Americans' increasing enthusiasm for rosé wine, with great interest.

First American edition published in 2024 by

Interlink Books
An imprint of Interlink Publishing Group, Inc.
46 Crosby Street
Northampton, Massachusetts 01060
www.interlinkbooks.com

Library of Congress Cataloging-in-Publication Data available
ISBN 978-1-62371-662-2

Original Danish title: *Rosé Revolution*
English translation: Sinéad Quirke Køngerskov
Editor English edition: Judy Roth
Design & Art Direction: Olga Bastian
Illustration & Art Direction: Mette Lehmann
Graphic Designer: Inge Lynggaard Hansen
Image processing: Kim Møldrup, Pigmentum

Printed and bound in China

9 8 7 6 5 4 3 2 1

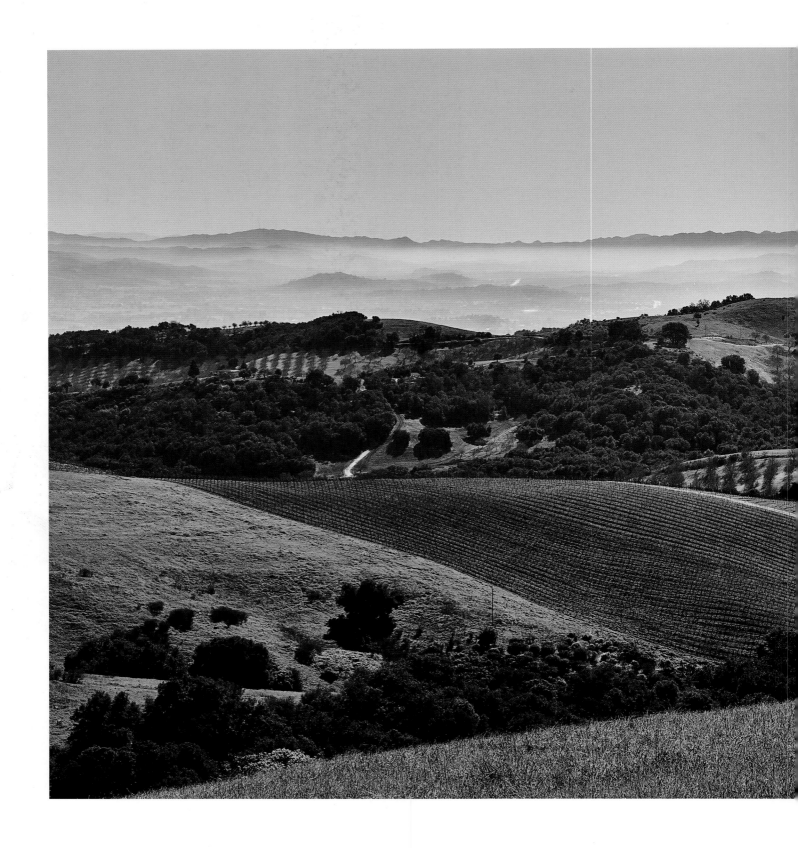